John Maeda MAEDA @ MEDIA

Any copy of this book issued by the publisher as a paperback is sold subject to the condition that it shall not by way of trade or otherwise be lent, resold, hired out or otherwise circulated without the publisher's prior consent in any form of binding or cover other than that in which it is published and without a similar condition including these words being imposed on a subsequent purchaser.

First published in the United Kingdom in 2000 by Thames & Hudson Ltd, 181A High Holborn, London WC1V 7QX www.thamesandhudson.com

© 2000 John Maeda

All Rights Reserved. No part of this publication may be reproduced or transmitted in any form or by any means, electronic or mechanical, including photocopy, recording or any other information storage and retrieval system, without prior permission in writing from the publisher.

British Library Cataloguing-in-Publication Data A catalogue record for this book is available from the British Library

ISBN 0-500-28235-8

Designed by John Maeda Printed and bound in Hong Kong by Dai Nippon

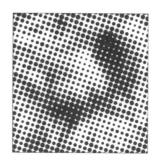

To Kris—I love you more than all the 0s and 1s in the world.

Art is primarily a question of form, not of content. Paul Rand

table of contents

Pins	striped	Suit	s Ni	chola	s Ne	grop	onte	vii	vi	V	iv	iii	"1	init	1	2	3	4	5	6	7	8	9
10	11	12	13	14 2	be	gin	17	18	19	20	21	22	23	24	25	26	27	28	29	30	31	32	33
34	35	36	37	38	39	40	41	42	43	44	45	46	47	48	49	50	51	52	53	54	55	56	57
58	59	60 3	el	ecti	ric	dot	65	66	67	68	69	70	71	72	73	74	75	76	4	re	act	ive	81
12	83	84	85	86	87	88	89	90	91	92	93	94	95	96	97	98	99	100	101	102	103	104	105
106	107	108	109	110	111	112	113	114	115	116	117	118	119	120	121	122	123	124	125	126	127	128	129
30	131	132	133	134	135	136	137	138	139	140	141	5	рар	oer	145	146	147	148	149	150	151	152	153
154	155	156	157	75 6	sta	itic	161	162	163	164	165	166	167	168	169	170	171	172	173	174	175	176	177
78	179	180	181	182	183	184	185	186	187	188	189	190	191	192	193	194	195	196	197	198	199	200	201
202	203	204	205	206	207	208	209	210	211	212	213	214	215	216	217	218	219	220	7 <i>fo</i>	ur	cole	ors	22
226	227	228	229	230	231	232	233	234	235	236	237	8	onli	ine	241	242	243	244	245	246	247	248	249
50	251	252	253	254	255	256	257	258	259	260	261	262	263	264	265	266	267	268	269	270	271	272	273
74	275	276	277	278	279	280	281	282	283	284	285	289	no	ise	289	290	291	292	293	294	295	296	297
98	299	300	301	302 1 C) n	ow	305	306	307	308	309	310	311	312	313	314	315	316	317	318	319	320	321
22	323	324	325	326	327	328	329	330	331			11	spa	ice	337	338	339	340	341	342	343	344	345
46	347	348	349	350	351	352	353	354	355	356	357	358	359	360	361	362	363	364	365	366	367	368	369
70	371	372	373	374	375	376	377	378	379	380	381	382	383	384	385	386	387	388	389	390	391	392	393
94	395	396	2 0	om	pu	ter	401	402	403	404	405	406	407	408	409	410	411	412	413	414	415	416	417
18	419	420	421	422	423	424	425	426	427	428	429	430	431	432	433	434	435	436	437	438	439	440	441
42 ć	acki	nov	vle	dgn	nei	nts	449	450	451	452	453	454	455	456	457	458	459	re	fer	end	es	464	465

At the age of sixteen I was determined to be an artist. My determination helped convince my high school to accept art as a substitute for athletics. My father was less easily convinced and suggested that I attend M.I.T. because I had scored the highest possible mark on my college entrance exams for math. The idea was that I should study architecture, because it was a blend of my two childhood skills. I was not convinced.

I shared my dilemma with the headmaster, who told me the following story: "I like grey suits and I like pinstriped suits, but I don't necessarily like grey pinstriped suits." What kind of advice was that? I ignored it and attended architecture school anyway, which was a fine education, one I would not trade back had I to do it all over again. My engineering classmates learned how to solve problems, I learned how to ask questions.

One question was how to change the world. A well designed building here and there was an unlikely means, except in history books. But designing the tools designers would use felt like a lot more leverage. And, M.I.T. being the birthplace of computer graphics, I was brought quickly to the idea of computer-aided design, under the influence of a self-made mathematician named Steve Coons.

Steve had figured out how to mathematically "loft" ships and airplanes (the long

gentle curves which literally required lofts to be laid out and drawn at full scale) on a standard size sheet of paper. Believe me, in the 1960s, bringing computers and design together required pure faith, because the two seemed to bring out the worst in each other. Furthermore, the intellectual space itself seemed to be fully occupied by either failed artists or failed scientists. For the next thirty years, the signature of the machine was invariably stronger than the humans. Witness the near irrelevance to date of computer art—all those unseemly pinstriped suits.

This is changing for many reasons, three of which are germane to this book: visual thinking, graphical expression, and simplicity.

Visual thinking is more a part of our lives than ever before. The personal computer, the internet and modern-day printers bring us into regular contact with drawings, diagrams, and photographs. Increasingly, we make or process them ourselves. Children manipulate lines, shapes, color, as well as still and moving images, like no generation before.

We're not only digital, we're visual.

Graphic design is emerging as an every-day tool for communications. After a period of graphical cacophony, which resulted from limitless options (fonts and layout galore), we have entered into a period of far more subtle design, constrained by the continuing need to inform. Making things quick and

easy to understand is a requirement, now more than ever.

Besides, we're all fed up with complexity. Software has turned into a compost heap of useless options, expired releases and non-sensical interfaces. In fact, computers have become harder to use in recent years, not easier. They're also less reliable.

We've all had enough of this. It is time to rethink our digital world and to listen to new voices. John Maeda is one of them. He deconstructs the digital world with the earned authority of an M.I.T.-trained computer scientist and a card-carrying artist. Being ambidextrous with Eastern and Western cultures, he can see things most of us overlook. The result is a humor and expression that brings out the best in computers and art, and in so doing—in my mind—is the grey pinstriped suit we have all been looking for.

Nicholas Negroponte

Jerome Wiesner Professor of Media Arts and Sciences Director, M.I.T. Media Laboratory

Through my various constructions I struggle to address the conflict between simplicity and complexity.

Simplicity always occurs naturally. You can choose to look for it, or let it find you. A person who creates basic forms knows that the conscious construction of simplicity occurs only when the artistic medium permits. Creating what seems most natural—that is, elemental—can be a most unnatural task.

Complexity results when you attempt to reduce an already simple situation or form. Each action or motion leads incrementally to a set of less simple possibilities. Each step further into the process you take creative decisions or make additions that at the time seem relevant, but which accumulate to the point where the only available choice is to fail.

The computer breeds complexity. The computer industry forces it to be faster, better, and more powerful than its at-that-second incarnation. But consider a computer that is untainted by software, incapable of operating: It would be no more capable of imposing complexity than the grains of sand from which it is made (silicon). How do we allow the machine to exist in its natural uncorrupted state, while unlocking its seemingly endless potential?

I began my quest to answer these questions as the diligent apprentice to my Japanese craftsman father, whose primary wish was that his children be educated so as to not toil as he had. His beliefs, founded in practice, not theory, mandated me to pursue higher education in only one of my favorite studies: mathematics, rather than the arts.

I entered the Massachusetts Institute of Technology in 1984 with the first-generation Macintosh in hand. I tried to secretly switch my major from computer science to architecture but my father caught on to me and I was stopped. The graphical computing boom had just begun and visually sensitive technologists were in high demand. While developing my programming skills, I came across the work of American graphic designer Paul Rand, and I realized what I wanted to do for the rest of my life. When the late Muriel Cooper, who pioneered many of the first designer-centered computer graphics, suggested that I wouldn't find the visual education I was looking for at M.I.T., I left for art school in Japan. It was then that it became clear to me just how much the fields of art and technology are segregated, making it difficult for those who seek to understand both.

My stance has been that neither is more important than the other; the two complement each other in a necessary union of relevant vision united with relevant construction. To assume that the only model for art technology is through collaboration between the artist and technologist, is to gamble the entire future of our culture upon the custom of figuratively grafting artists' eyes and senses directly onto technologists' hands and minds. I am told that the beauty of such a collaboration is a result that neither the artist nor the technologist can expect. I fail to see the merits of an approach based upon mere serendipity.

True digital forms are ephemeralnon-existent in the physical realm. To truly appreciate them we must entertain an eve for the invisibleto see into the expansive electrical conscious of the computer. Our ability to comprehend its multidimensional thinking patterns will require intense inquiry into the very nature of computation. The common perception of the computer as an object with screen, keyboard, and mouse, or for that matter any other alternative physical form factor regardless of size, style, or weight, must defer to the computer's rightful identity as pure conceptual mass.

My work over the past decade reflects a single person's attempts to dismantle our understanding of the computer. To give the conclusion up front, I have realized that it is too vast a problem to solve alone. I have chosen the only possible solution I can, to focus on arts, design, and computation education—what I refer to as "post-visual arts education"—with the hope that the upcoming generation, ably equipped, can craft a significantly deeper understanding of the medium.

John Maeda Lexington, Massachusetts

1 init My mother and father were wed in Japan in an arranged marriage. In 1957 they moved to the United States, where they settled in Seattle. As the main cook of a small Japanese restaurant Maneki, my father often made the short walk to the local tofu factory to pick up the order for that day. The owners of the shop had no children and, impressed by my father's hard work, they offered him the business. Thus began a six- and often seven-day-a-week ritual of waking between the hours of one and two in the morning to be the primary automaton at the center of the laborintensive process of continually lifting, stirring, frying, soaking, and molding all manners of soybean-based substances. If he was lucky, he ended work around five in the afternoon-at least that was what his faithful employees, his wife and children, hoped and prayed. "Dad, we need a break!" He would retort in guttural, yakuza-style Japanese, "A break? Aren't you a man? If not, then cut it off!" Thus, although I was unquestioningly diligent in service to his work, I had a natural preference for going to school, a paradise where all I had to do was sit in a warm room and pay attention to the teacher.

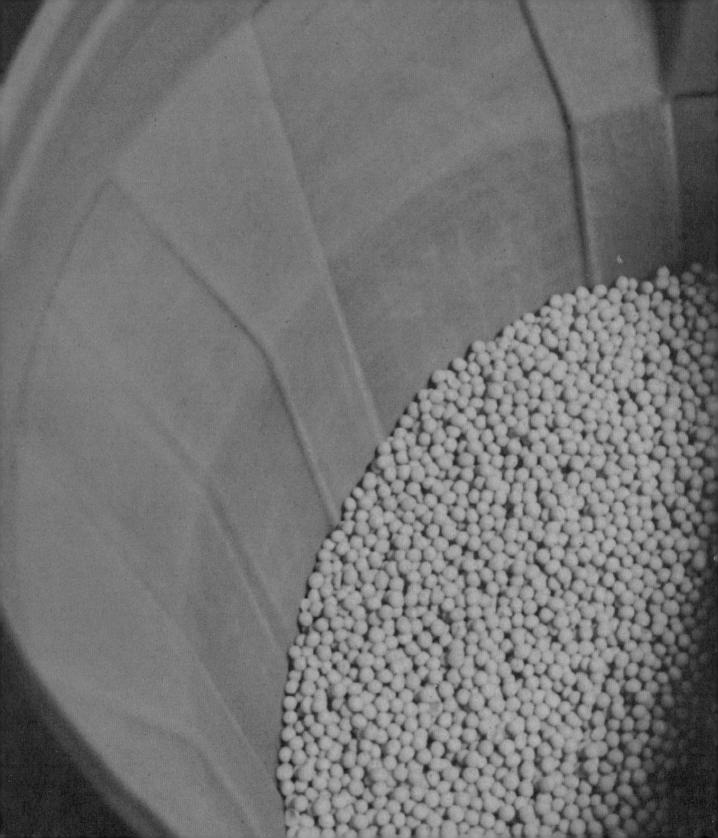

Tofu begins as soybean seed that usually comes in 60-pound bags from either Kansas or South Dakota. Always a soft yellow-green color and hard like little rocks, the beans are poured into large containers to be soaked in water overnight.

The beans grow larger and softer with soaking, and are then placed into a grinding machine. A tiny trickle of water through the machine aids the flow of beans past the grinding action of two rotating, roughly textured stone plates.

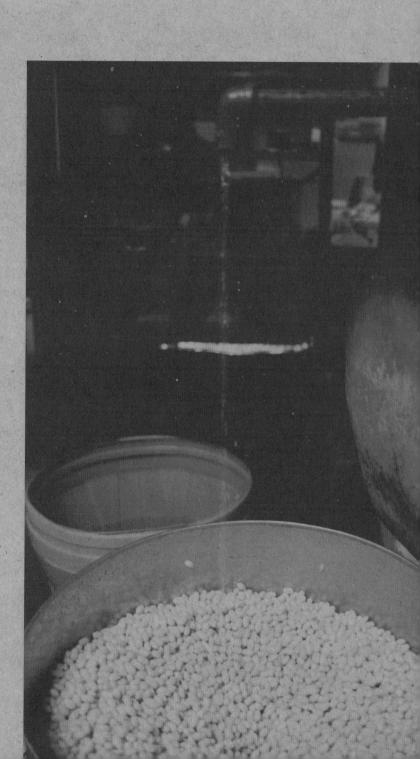

The beans leave the grinding machine as a thick white slurry that gives off a rich, sweet smell.

The mixture is moved into a large copper vat of boiling water by scooping it out a gallon at a time with an aluminum saucepan. It is heated until the ground beans are thoroughly dissolved.

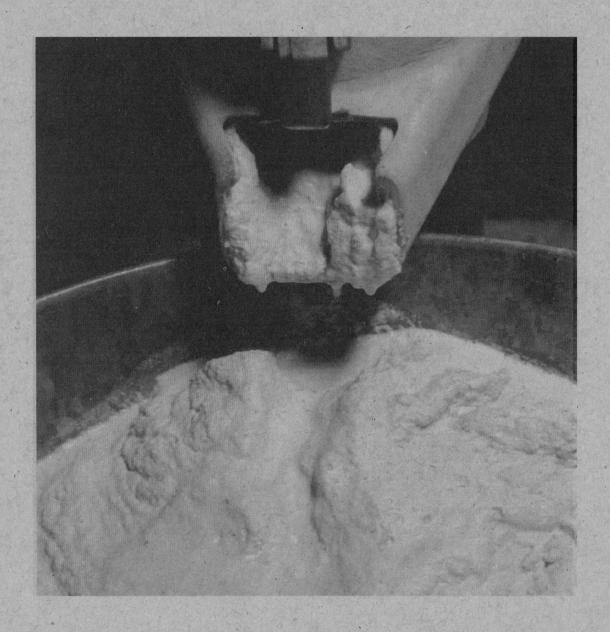

5

LIVERPOOL JOHN 4609ES UNIVERSIT

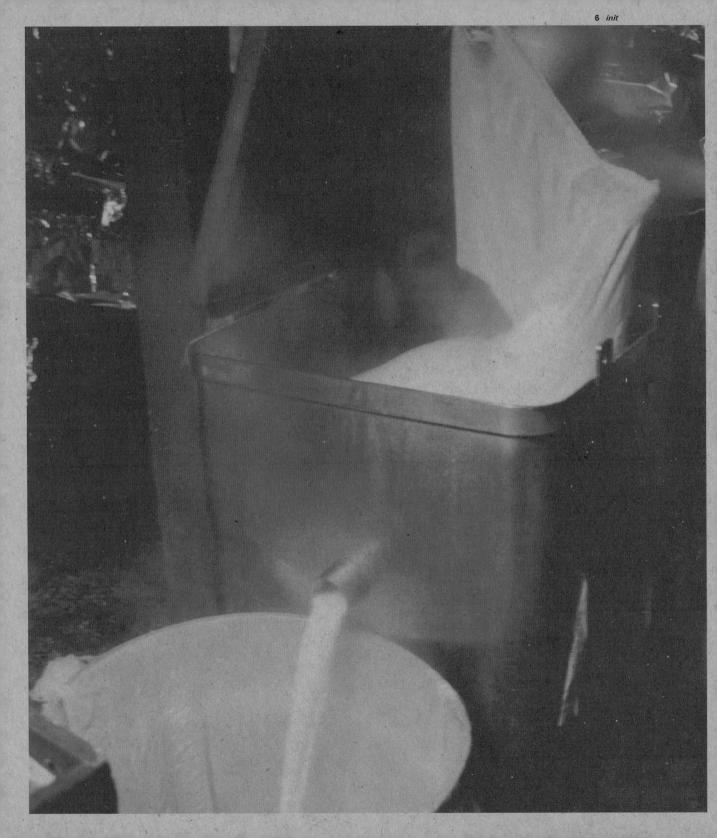

The boiling mixture is scooped out of the vat, again a gallon at a time with the saucepan (ignoring the intense heat), and filtered through a coarsely woven cotton bag. The filtered liquid then flows through another, more finely woven nylon bag. The liquid that results is commonly referred to as soymilk, which is subtly sweet but not nearly as sweet as the sugar-laden commercial product available in supermarkets.

An extract of seawater called nigari is gently stirred into the soymilk, and is allowed to slowly permeate the mixture.

About fifteen minutes after the addition of nigari, small clumps of soybean coagulants form, giving it the consistency of cottage cheese.

LIVERPOOL JOHN MOORES UNIVERSITY
LEARNING SERVICES

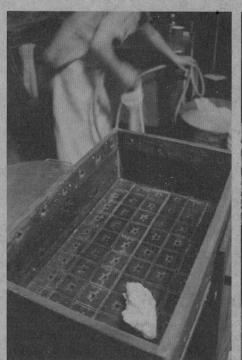

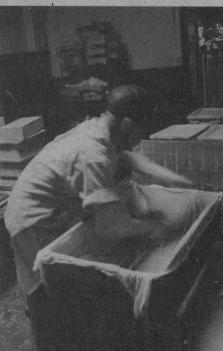

A damp cotton cloth, called a kire, is unfolded to line the inside surface of a cherrywood box dotted with half-inch holes on all sides:

Through the holes most of the liquid from the soybean-curd mixture will escape. On the main interior face of the box are sixty special holes, each of which has five notches around its edge. They are ultimately used to imprint a star logo on the face of the otherwise plain white tofu block.

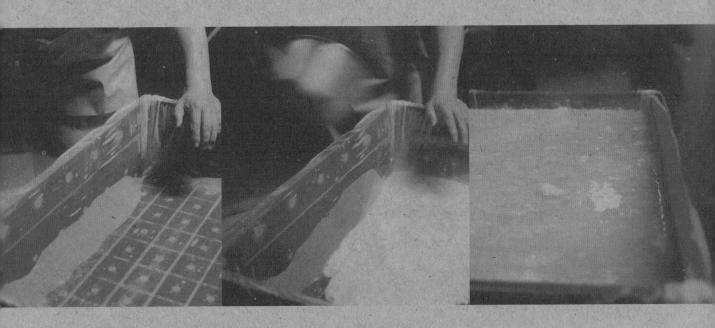

A grid of bamboo floats atop the liquid surface sandwiched by a wooden lid whose weight presses the mixture of the mold. Fifteen minutes later greater pressure is applied with concrete and water weights that add up to between 30 and 50 pounds.

LIVERPOOL JOHN MOORES UNIVERSITY LEARNING SERVICES

The tofu is now sufficiently firm. It is carefully carried in its box across the room and gently lowered into a large stainless-steel bin of cold water.

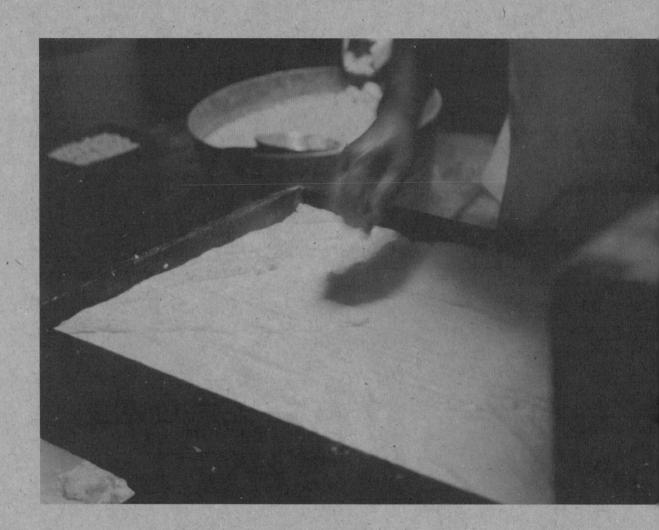

The tofu stays afloat in the buoyant box. A deft flip and it is turned over in the water. The box is removed, revealing sixty irregular stars on a smooth white surface that is perfectly aligned with the face of the water. It is held by the lid that was originally used to begin the pressing process.

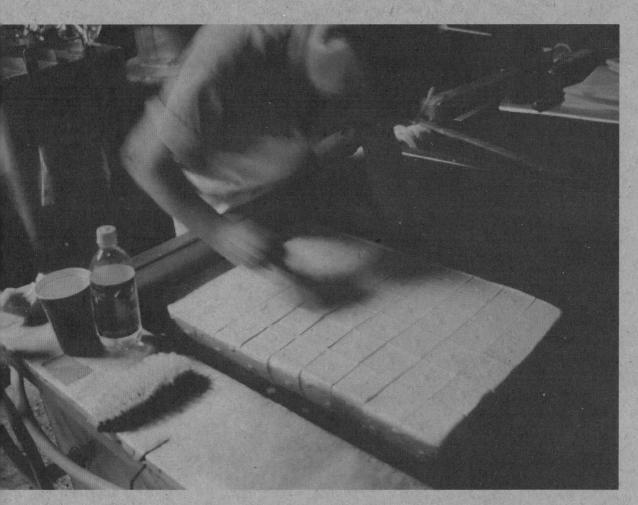

The kire is removed, and the large cake is cut expediently to reveal sixty newborn blocks of tofu that gently fall to the bottom of the bin. The wooden lid is removed from the water, ready to press the next batch.

The coldness of the water cures the tofu, hardening it just enough to be lightly handled and packed before the customers arrive.

This entire process is repreated eight to ten times, each cycle taking an hour. Other tofu products are being made concurrently in the same painstaking manner, but let's save those stories for another day...

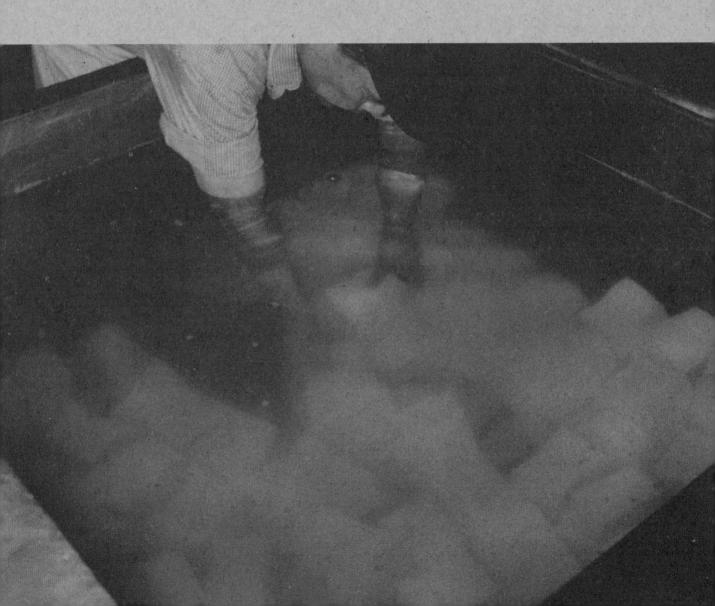

2 begin On the cargo ship where my father worked his way up from shining shoes at thirteen years of age to working as a staff cook in his midtwenties, he had heard of two schools, "Harvard" and "M.I.T." Some time later he would ingrain into his children that they must go to these schools, wherever they might be. Thus from elementary school age my mission was to attend "M.I.T.," which we thought was in California. I remember telling my middle-school teacher that I wanted to go there. One day she pulled me aside and quietly said, "John, I'm sorry that's not possible because you are Oriental." Surprised that I could no longer go to M.I.T., I informed my mother of the bad news. She was upset for a reason that I didn't understand at the time, and told me I still had to go. I managed to make it there, only to find out that M.I.T. wasn't a place where I could explore my artistic leanings, which suited my father quite well, as he often warned that I would never "be able to eat drawing pictures." Computers had just become graphical, and there was much demand for icons. An accidental encounter in the library with a book by Paul Rand put me in my place, and gave me an objective toward which to aspire forever.

]10 PRINT "MAEDA" PAEDA

The first computer program I wrote was a basic accounting system for the tofu store. There were several restaurants and businesses that came to purchase tofu and other tofu-associated products, sometimes on a daily basis. I created a very long program that had twelve sets of about thirty input and output entries that corresponded to each month, which took forever to type. In addition to drawing, typing was my other hobby so it didn't really bother me. The program worked fine.

My math teacher in high school,
Mr. Moyer, often suggested that I take
his programming class. "Nonsense," I
thought to myself, "I have two whole
years of practical knowledge behind
me." One day I finally went to one of his
classes, where he introduced a
construct called "FOR ... NEXT" that
allowed the repetition of a similar task
over and over in a very simple way.
When I went home and discovered
that I could replace ten thousand lines
of program statements with about
fifty lines, I was dumbfounded. I began
to study the computer in earnest.

An infinite loop demonstrates a fundamental happening in a computer program. Do something once, then do it again and again until interrupted by either human intervention, systemproblems, or the loss of electrical power.

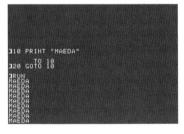

The slightest change in program instructions can result in error or, better yet, significant variation in program output. For instance, the addition of a single punctuation mark, in this case semicolon and comma, respectively reshapes the output pattern.

In the English language we expect punctuation to change the meaning or nuance of what is written, so it is hardly surprising that it has the same effect on a program. The minor addition of an extra letter space offers a bit of unexpected zest.

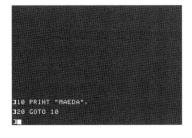

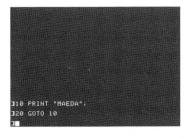

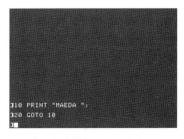

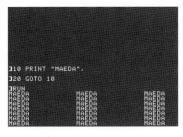

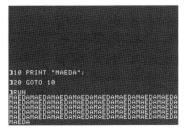

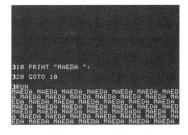

LIVERPOOL JOHN MOORES UNIVERSITY Aldham Robarts L.R.C. TEL. 0151 231 3701/3634

```
/* medialab.c: build fake noland pattern itm */
#define NumGrays 9
#define NumColors 15
#define TileSize 24
#define InterSize 1
#define BigInterSize (InterSize*3)
static unsigned long grays[NumGrays],colors[NumColors],graybackpix,blackpix,whitepix;
static char *graynames[] = {"gray97","floralwhite","ivory", "gray95","floralwhite","ivory", "gray95","gray97","floralwhite"); static char *colornames[] = { "royalblue", "slategrey", "aquamarine", "limegreen", "yellow", "rosybrown", "slategrey", "hotpink",
 "orange", "pink", "tomato", "violet", "darkorchid", "forestgreen", "white" };
static void MakeMediaLabColorMap(void)
 int i,j=0;
 blackpix = j++; whitepix = j++;
 for(i = 0; i < NumGrays; i++)
  grays[i] = j++;
 for(i = 0; i < NumColors; i++)
  colors[i] = j++;
 graybackpix = j++;
 // allocate pixels a la XWindows ...
void DrawMediaLabMural(int w,int h)
 int x,y = ystart,yc = 1,goodrand;
 MakeMediaLabColorMap();
 XSetForeground(graybackpix);
 XFillRectangle(xstart,ystart,w,h);
 /* first draw the tiles */
 for(;y<(ystart+h);) {
   for(x = xstart; x < (xstart+w); x+=(TileSize+InterSize)) 
    XSetForeground(grays[GetRandomNumber(NumGrays-1)]);
    XFillRectangle(x,y,TileSize-1,TileSize-1);
    XSetForeground(blackpix);
    XDrawLine(x+1,y+TileSize-1,x+TileSize,y+TileSize-1);
    XDrawLine(x+TileSize-1,y+1,x+TileSize-1,y+TileSize-1);
   y+=(InterSize+TileSize);
  if (!(yc%2)) y+=BigInterSize;
  yc++;
  /* now fill in horizontal interstices */
 y = ystart; yc = 1;
 for(;y<(ystart+h);) {
   for(x = xstart; x < (xstart+w);) {
    XSetForeground(colors[GetRandomNumber(NumColors-1)]);
    x+=GetRandomNumber(TileSize*3);
    goodrand = GetRandomNumber(TileSize*3) + 4;
    if (!(yc%2)) XFillRectangle(x,y+TileSize,goodrand,InterSize+BigInterSize);
    else XFillRectangle(x,y+TileSize,goodrand,InterSize);
    x+=goodrand;
   if (!(yc%2)) y+=BigInterSize;
   y+=(InterSize+TileSize); yc++;
 /* now fill in vertical interstices */
 y = ystart; yc = 1;
 for(x = xstart; x < (xstart+w); x+=(TileSize+InterSize)) {
   y = ystart;
   for(;y<(ystart+h);) {
    v+=GetRandomNumber(TileSize*2);
    goodrand = GetRandomNumber(TileSize*3);
    XSetForeground(colors[GetRandomNumber(NumColors-1)]);
    XFillRectangle(x+TileSize,y,InterSize,goodrand);
    y+= goodrand;
 XSetForeground(blackpix);
```

Visitors to M.I.T.'s Media Laboratory are greeted by a four-story-high atrium dominated by a color-tile composition by the premiere American colorist Kenneth Noland. As a graduate student at the Media Lab, I often stared at the wall to attempt to read the pattern, but never could. I thought it would be interesting to create a program to generate a similar result. To my surprise, a reasonable approximation was built with a simple page of program text. Was it the same? No. Was it similar? Yes. Was it right? No. It would take me the entirety of a decade to figure out exactly why.

The process of automatically generating simulacra of pre-existing artwork by computer programs began as early as 1965 with pioneering computer artist A. Michael Noll's

rendition of a work by the reknowned painter Piet Mondrian. Such attempts inevitably focused the public's perception of computer art towards its cheap-trickery aspects, making it impossible for ongoing experiments in its superspatial qualities to be properly noticed. The emergence of digital painting systems quickly made computer programming irrelevant.

Commanded by the late M.I.T. Professor Muriel Cooper to "go away" (to art school), I had the fortune of starting over as a designer. I followed my love Kris to Japan, where I was fortunate to land at an art school with scarce computer resources. Disconnected from e-mail and other electronic parasites, I rediscovered my mind, paper, and pen.

The most difficult concept to master in design is not the actual execution of a design itself but the more practical aspect of finding a client willing to take a risk on your ideas and in the best of circumstances, leave you alone. Like the rest of my peers, I persevered designing name cards, stickers, and all things printable, and confirmed for myself the maxim that if you persistently do good work, more work will naturally come your way.

A confluence of reactions towards the elegant interactive forms of artist Toshio Iwai, the critical anti-design tirades of cognitive scientist Dr. Donald Norman, and a personal fatigue from the computer display screen sparked my interest in thinking about physical manifestations of digital information. I began to write and illustrate concepts in this area, which I called "dynamic form," specifically three-dimensional form:

Prior to the development of modern technology, artifacts produced by humans obeyed an intuitive relationship between size and complexity. A small object corresponded to a simple function, whereas a larger object was associated with a proportionately more complex function. This simple relationship arose from the macroscopic nature of technology at the time and is significant because it extended two sacred promises, one to the user and one to the industrial designer. The first is that the user would be able to

construct a priori impressions of an object before actually using it, that is, literally sizing up the nature of the object at first glance. The second is that industrial designers would have a suitable amount of visual and tactile design space. Both promises had as a prerequisite the luxury of a space for the user to assess functionality, and a space for the designer in which to express that functionality.

Today objects we make rarely extend these promises because the majority of them are not space-oriented on the

outside but space-oriented on the inside, at incredibly tiny scales. This inner-space is a consequence of the successive miniaturization of integrated circuit technology, which can realize topological complexities equivalent to entire cities within raindrop-sized volumes. In a society where personal living space is gradually decreasing and mobility is at a premium, smallness is indeed a desirable property for objects to possess. On the other hand, small implies a cramped design volume, which has eliminates many

traditional means of expression for the industrial artist.

The contemporary solution to the reduction in design volume has been to compensate for physical space with virtual space. We decorate the surfaces of objects with elements equipped with mechanisms for change, like indicator lamps or general display screens. These components have powerful consequences because they imply that spatial restrictions can, in theory, be overcome. Each element can freely hide and display a multitude of possible visual

surfaces. Hence, although we might consider an object restricted in a spatial sense, its dynamic surfaces allow the object to transcend those restrictions through expression along the neverending dimension of time.

Dynamic surfaces are prevalent in our world, making our society sensitive to searching for the display screen of a device when trying to determine its use. This fixation with what I term skin dynamism, or the ability of an object's surface to change, results in shifting the focus from an object's body (which once defined its function) to its outer skin (which was once simply an artifact). Consequently, computer screens continue to grow larger and more dominant-signalling a decrease in the significance of the bodies on which these dynamic surfaces lie, and gradually rendering them meaningless.

that do not design dynamic from sketch has been used in dense, sport are But he need the automorphisms of sourcesyl sketching

Notherly in con in the computer, Method through one lossy over the loped.

But interface is still poor, i.e.

Idous of adaptive from from orbitists life, Inciding from time agreent travels like a living creature.

bits hardina model the dalger can use. (1. g. god into the daliger for the half of build good into the half of build good food daliger daliger

sa'd programming, a physical roudel of crite!

[Hour manufact

poetreatal clocking, building from from local speciforalism of type and humania. Edynamic Drud Chamania.

vandlinging. Shimple substant to

connection law of motion will be useful in whiching later, flavor of shortan.

budy language gerane in humanis

establishing the below of touching us beeing

by B (DETHUR'S APTORUMENT PRECIPIE - 2 ROT TOLITY BY) 1865 1867 Story for all foren CS Las for form 5,

e problem - no get

what the

Hus Abso.

to Certai

While designing the cover for a book entitled *Dynamic Form*, I created a small piece of software to densely depict the cover image with ten thousand words. This process interested me more than the book itself and led me to create more visuals in this programmatic style. *→*

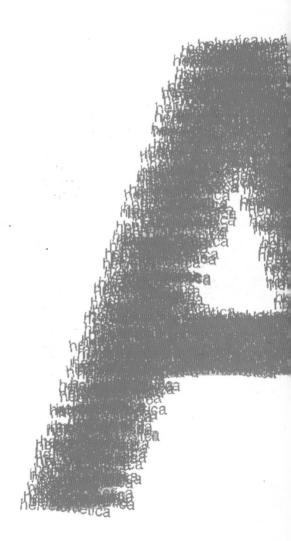

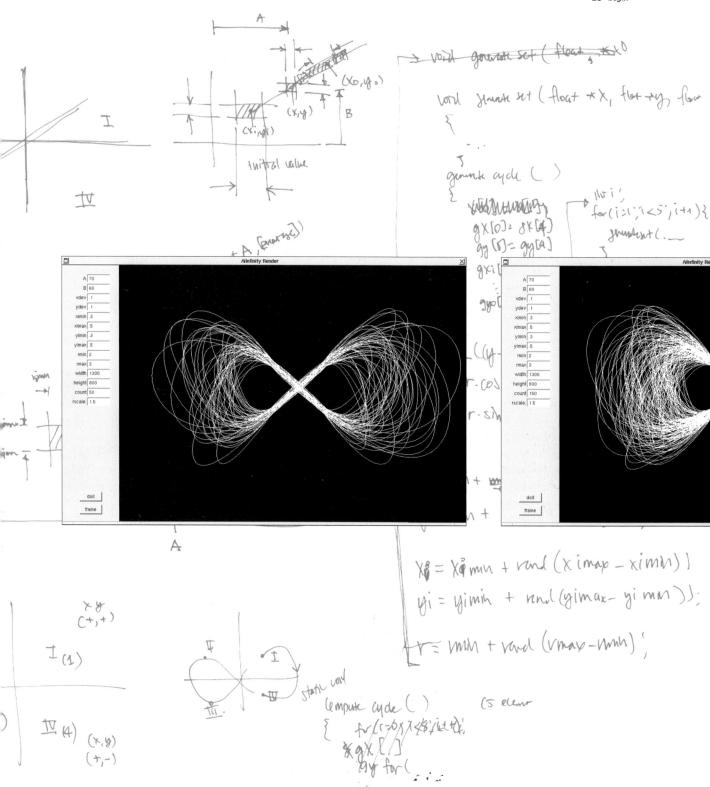

Bunto (

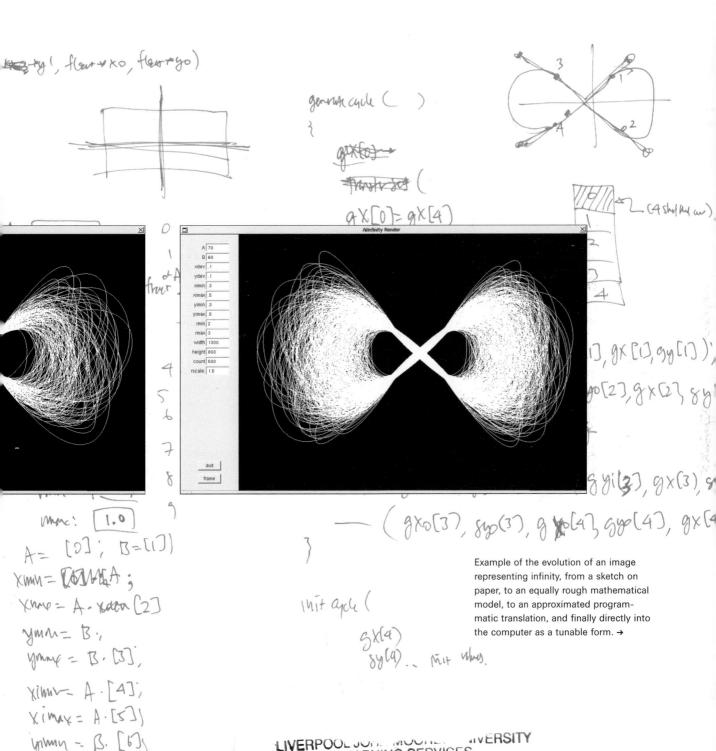

JIVERSITY LEARNING SERVICES

yilmy- 17- [7]

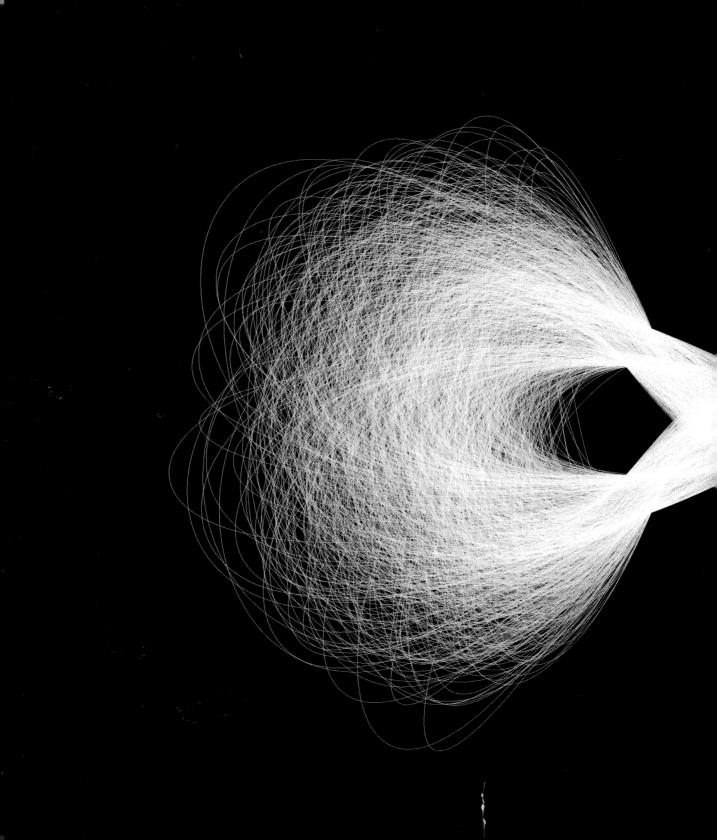

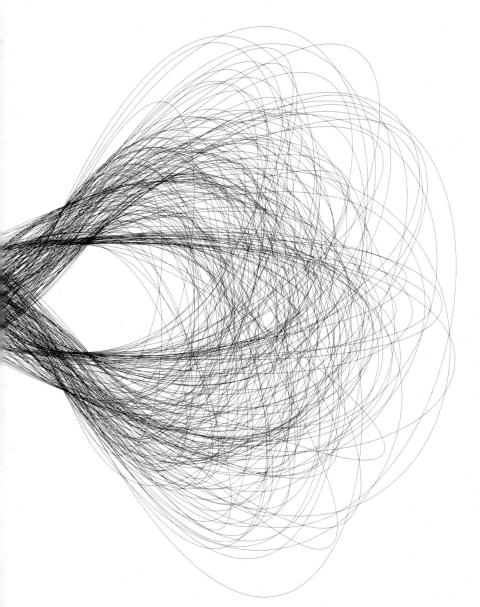

Whether instructed to stroke ten thousand cycles or even just a few hundred, the computer never complains. It always complies.

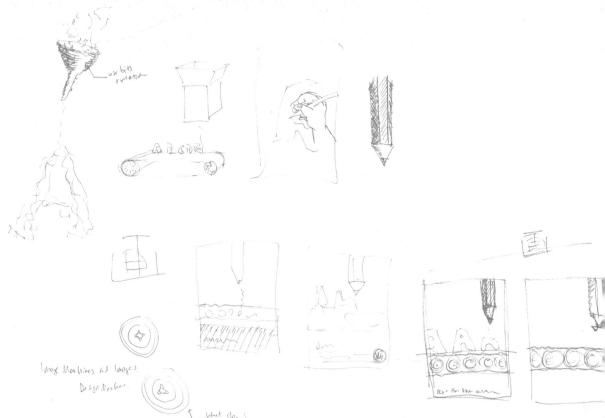

Once encoded as a programmatic form, the computer becomes a literal design machine, capable of rendering endless variations on a basic theme. The foremost challenge in operating such a powerful tool is the same as with the simplest tool: there must always be a clear initial concept that can guide the process to a relevant outcome.

For the "Design Machines" exhibition I created a B4-size booklet demonstrating ideas in computer-generated complexity. One feature of the show was a NeXT computer that converted whatever stood in front of it into colored type. →

our hands are the primary obstacle to advance in ent

t^digifal graphic∗arts, 🐷 🤘

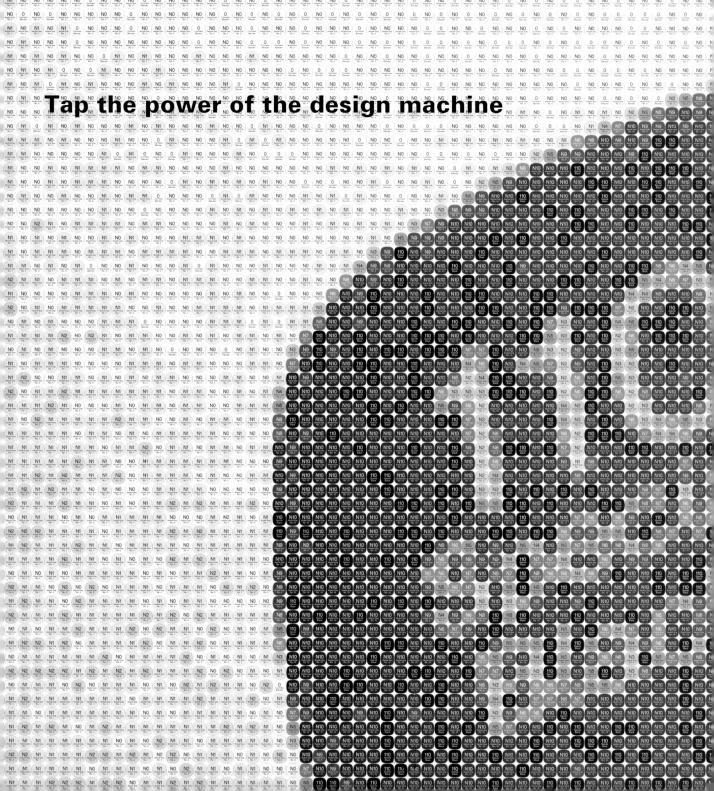

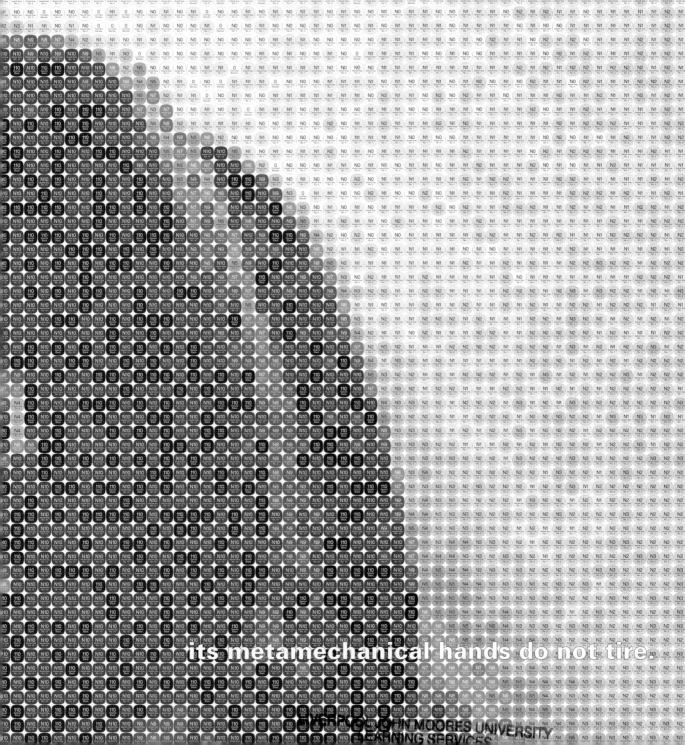

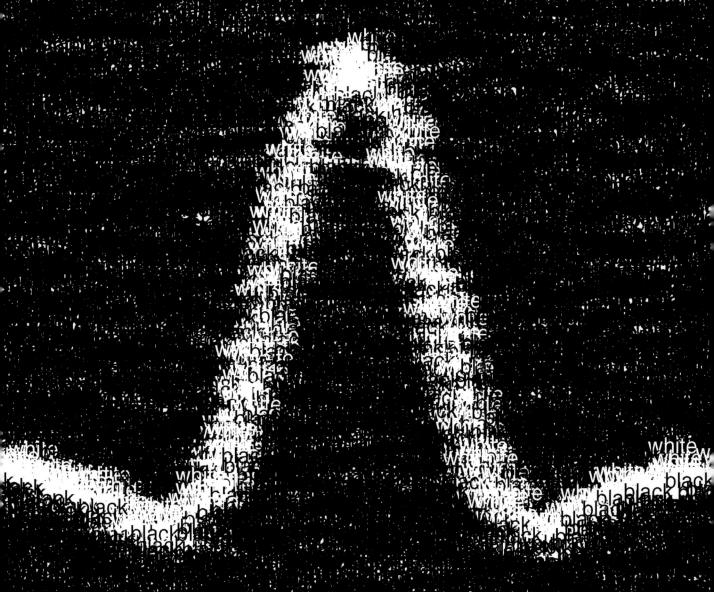

design the lens through which it translates raw information into your own visible language

escape the monotony of demonstration

engage in a pure discourse of style

LEARNING SERVICES

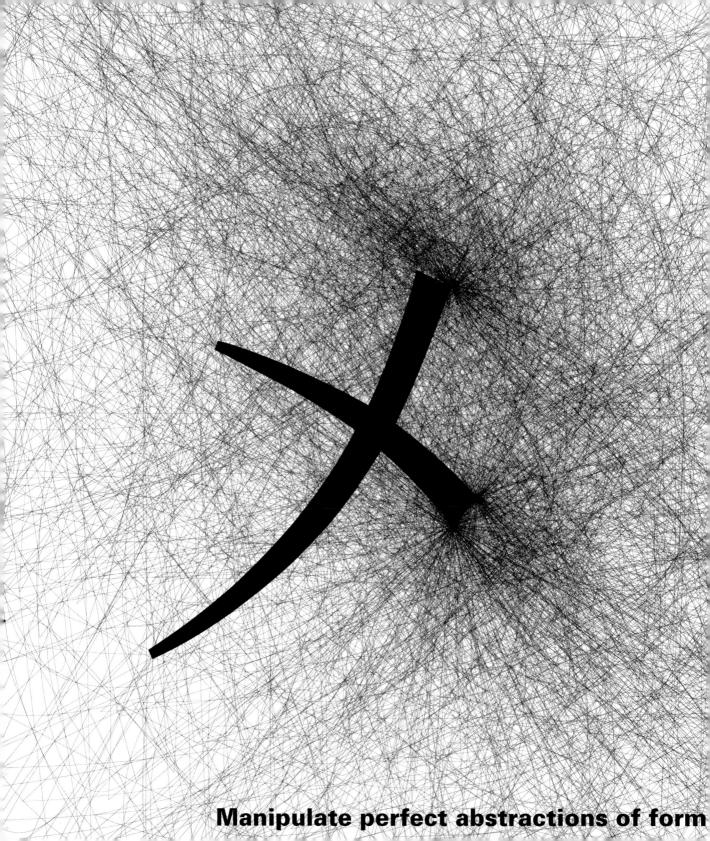

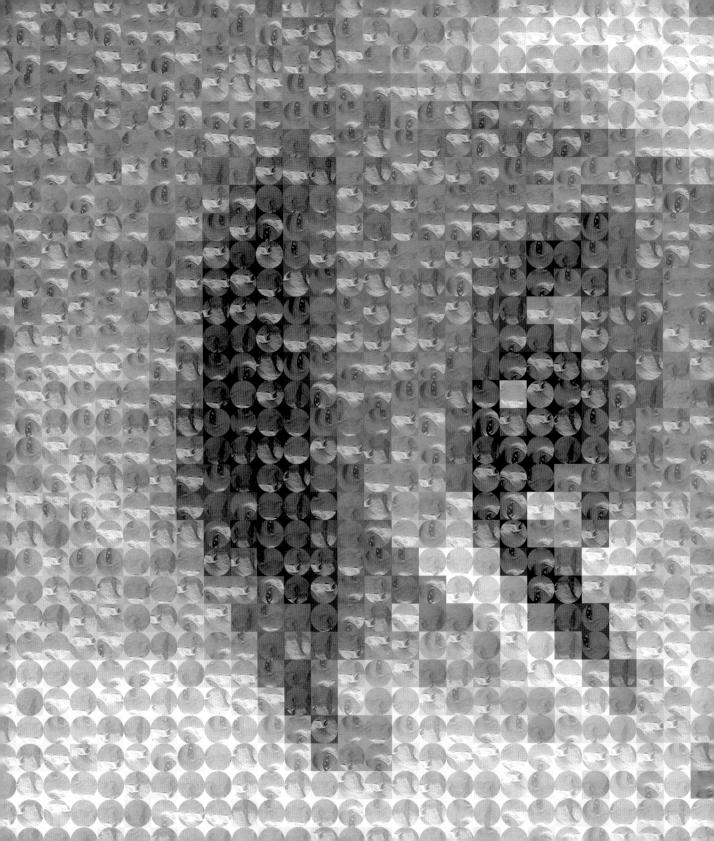

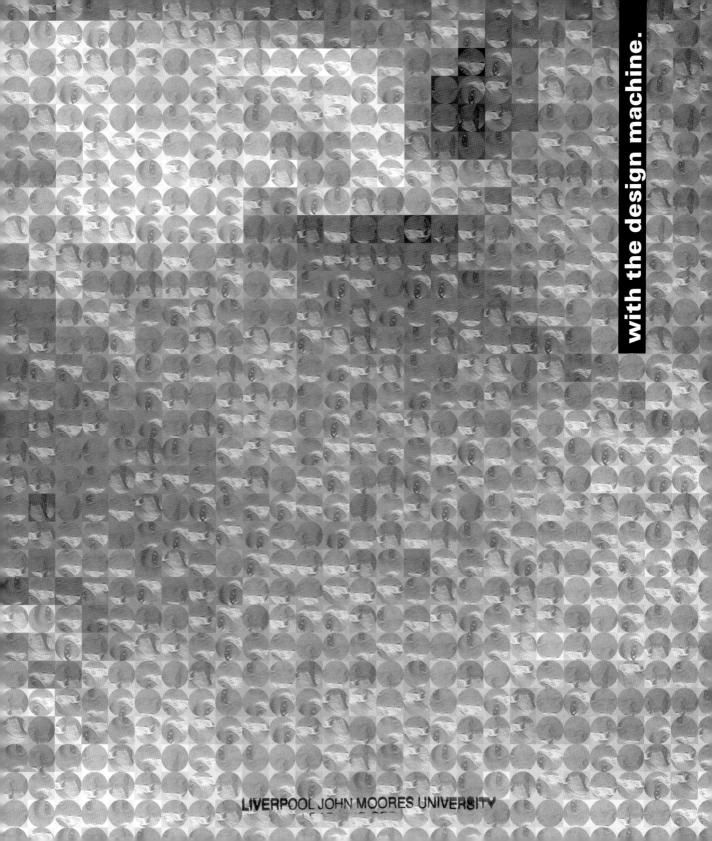

Each page of the booklet directly corresponded to a simple program specifically designed for that page. →

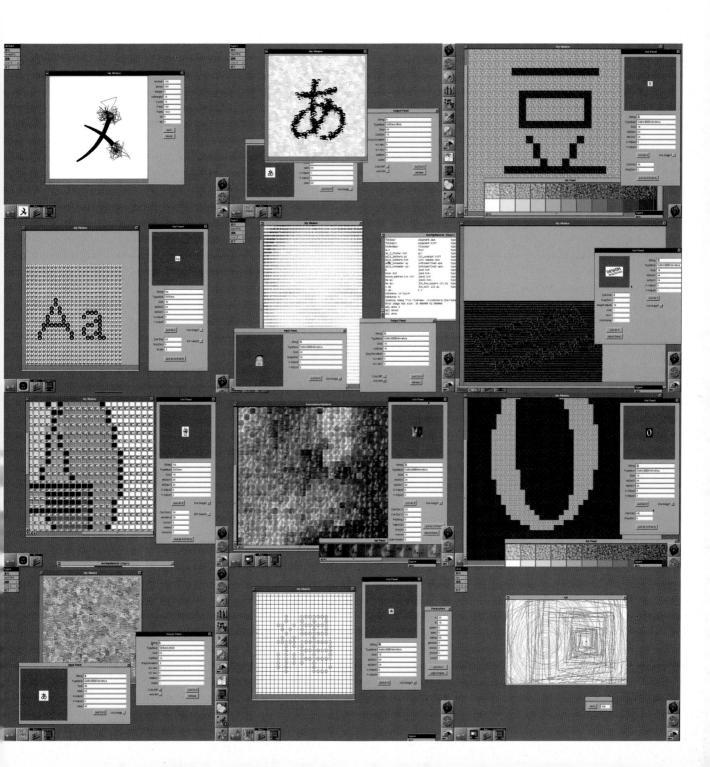

Each circle, triangle, and square was rendered until every pixel on the canvas was painted.

Generating complexity for complexity's sake is similar to shouting complete nonsense at the top of your voice.

Both are embarrassments that are best avoided, but when you are young it is the best way to attract attention. The Human-Powered Computer Experiment set out to reveal the traditionally invisible spirit of the computer in its true form as a living machine. →

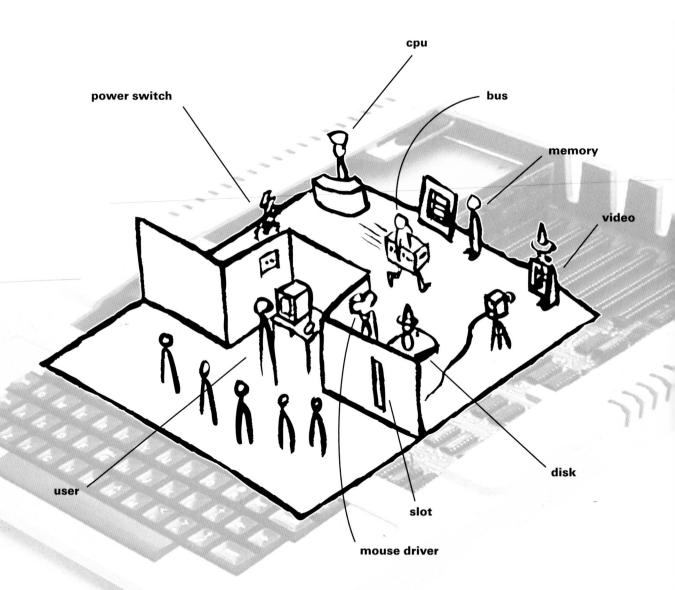

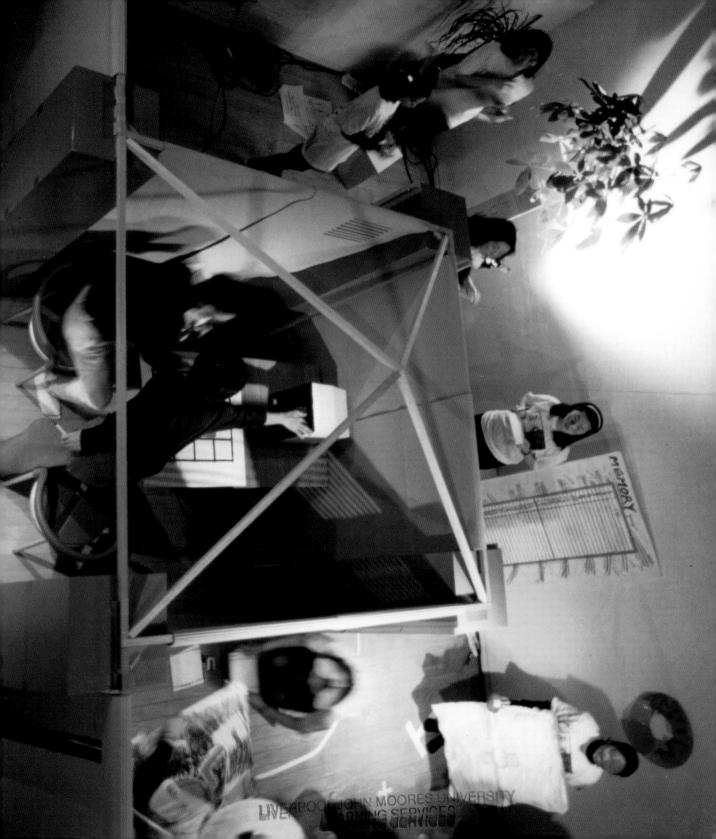

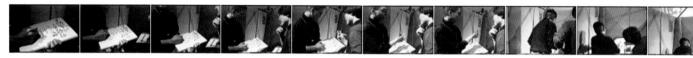

A problem is too difficult to solve so we turn to the computer for help.

The computer is turned on!

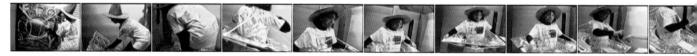

The disk drive receives the disk and immediately wears it. The program enscribed on its cardboard platter spins and is read from the beginning.

The CPU begins to take a central role by dispatching new instructions.

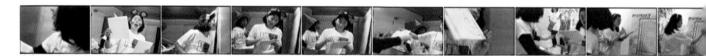

The CPU has requested to find the user's mouse position; the mouse manager takes a quick peek. That position is carried to memory.

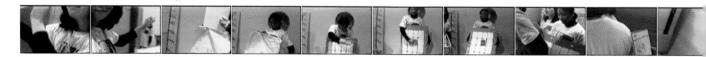

The video manager updates itself accordingly.

Lights come on and the assistants come into view. They pick up a giant floppy disk, which is inserted into the computer.

The bus has arrived and data is transferred from the disk to memory. The computer is beginning to start up.

The bus is the sole messenger of all information inside the computer. Back and forth it travels between CPU and memory.

The CPU dispatches the instruction to draw a cursor where the mouse has now moved.

The parts of the computer come out to greet the users. Hello!

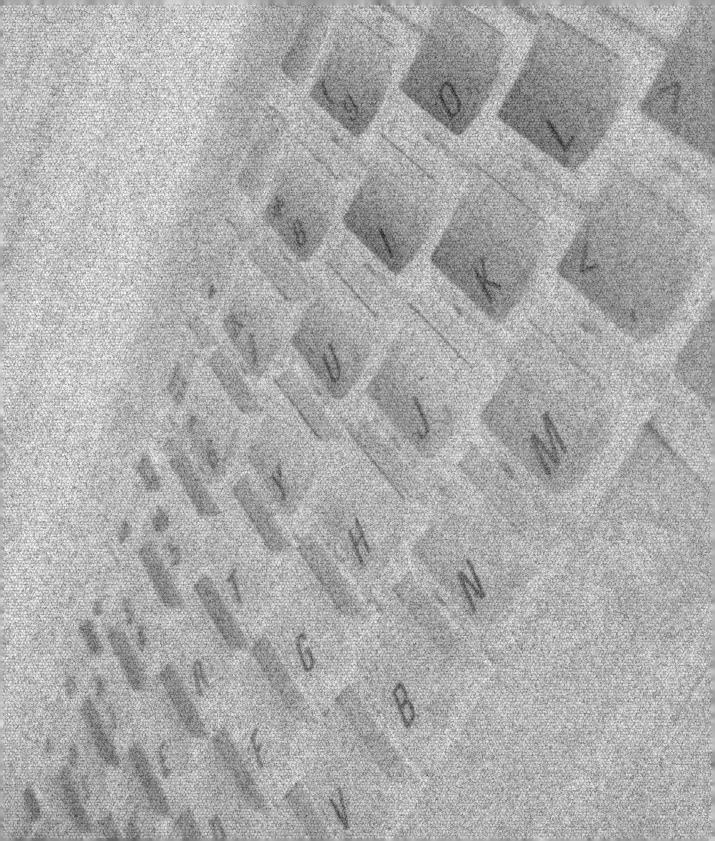

The experience of seeing a living computer in action evoked the image of a beehive. Not just one beehive of course, but a million beehives of busy electrons traveling incredible distances at speeds beyond our perceptual capacities.

Imagine if the computer we touch everyday were viewable through special glasses that reveal this alternative reality. We would see something like a shimmering material of pure electric thought, perhaps incomprehensible but at least several universes away from the dreary click, keypress, and drag that we associate with modern computing.

We go so far as to provide the analogue to the "hand," which, oddly, cannot ever be used to hold onto the pencil.

Certainly it could be designed to behave in such a manner without any great effort. But then again you already have a hand, and it is gripping the mouse.

The mouse is a unique device that we cognitively morph into whatever function we please. The more options that can be chosen, the more powerful a tool it appears, but as with all things that grow more powerful, it becomes more uncomfortable.

In the Illustrandom experiment, I built a system for creating forms with unstable spatial properties over time to show just one example of how the medium of the computer can differ from that of paper. \rightarrow

grade is not properly for desper

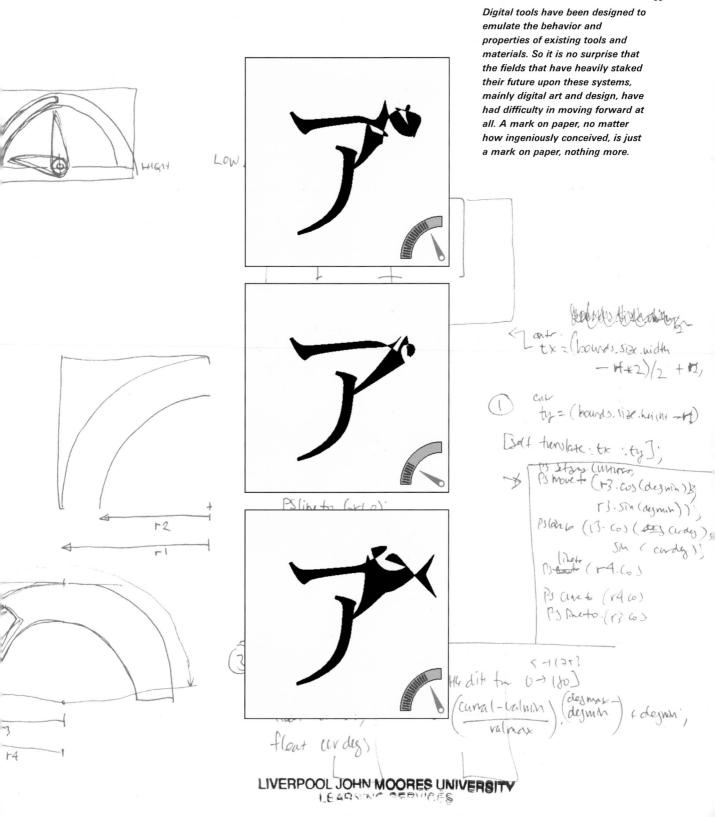

Because the traditions of art and design presuppose a material with a single fixed state, our critical instinct is to reduce anything with variability to a single instance. A sole solution is always chosen because a piece of paper, plastic, or stone cannot simultaneously assume multiple forms. A static material enforces a thought process with only one conclusion. Thus it is difficult to appreciate and, more importantly, evaluate an artistic statement of change. A natural reaction is to command the form to be frozen-for it to assume a single instance. But another instinct supports our willingness to let it go-when we realize it is alive.

At the present, to render a dynamic, computerized form static for critical or evaluatory reasons is decidedly less sacrilegious than taking a mobile by Calder and welding all of its joints to make it immobile. As our understanding of and appreciation for programmatic forms grow, we will regard a similar act of digital paralysis as equally offensive.

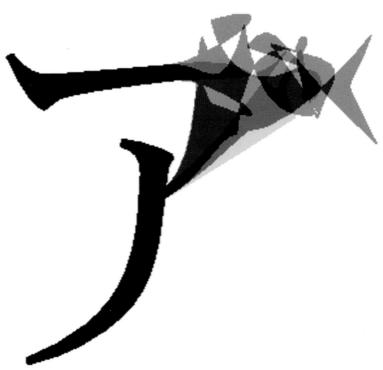

3 electric dot During the day, on a completely black surface, a white dot appears like a bright star of hope. As night falls, attempts to resuscitate the star with liberal amounts of white paint inevitably lose to the will of nature. The light of fire enables us to see after the sun has hidden, but its roar and crackle continually warn us of its immediate hunger for fuel. Our uneasiness has been resolved for the present by removing the flame from plain sight, hiding it in power plants where massive forces of fire, heat, and fission translate to electrical power. Transported through a giant maze of mostly hidden cables, it eventually reaches us through an unassuming two- or three-prong jack in the wall. Fed through a mating plug, electricity flows directly into an exposed filament that is safely enclosed in glass that begins to glow-thus the miracle of the light bulb, an electric dot impervious to night and irrespective of white pigment. Elsewhere, another plug mates and a significantly more complicated process forces a beam of electrons onto a plate of glass covered with a chemical that glows when energized, resulting in the mass production of bright electric dots that illuminate the otherwise invisible mind of the computer.

A pixel is a perfectly square dot, or at least that's the way we like to approximate it on paper.

The average "real" pixel you might encounter on a CRT display (cathode ray tube) is never a perfect square, it's more like a fuzzy dot.

If we stepped back twenty years to look at a pixel, we see that a fuzzy dot is clearly preferable to an electric smudge.

Today liquid-crystal displays (LCD) are increasingly prevalent, providing unsurpassed quality in shape and light consistency of the electric dot.

Yet, when viewed in closest proximity, we see that the white pixel is a mere electronic illusion of red, green, and blue glowing elements of oblong shape.

modern pixel

vintage pixel

LCD pixel

When the nature of the glowing mirage is revealed, a fleeting beauty can be perceived not in the actual viewed form but in the marvelously elaborate process of revealing a single number out of the millions of numbers in the computer's mind.

Turn the monitor of your computer off for a moment. Are the pixels you see gone? Certainly their visual presence is, but their electrical presence is not. This is verified by turning the monitor back on—nothing has changed.

By the act of turning the computer off, however, you know that the pixels are now truly gone. Not just the visual trace of the pixel, but the existence of the pixel itself.

A dot of ink on paper is an indelible part of our world. It is a promise always fulfilled. We do not fear for its immediate demise or that it can be lost with the flick of a switch.

> It is safely rooted in the fibers of the paper as an impression that is not trivially erased.

But in many ways it is just as virtual as the electric dot on the screen. Its existence can be compromised at any time.

> And if not destroyed by fire, the black hole of human consumptive habits always awaits.

Alone a pixel is powerless. It is a character that only has value when seen as part of a large crowd.

Today we often complain of small screen sizes. A classic 13-inch monitor displaying 640 by 480 pixels is insufficient for most people's visual expectations. Consider how that represents 640 times 480 pixels—a total of 307,200 individual light-producing elements updated 60 times per second.

If you were to count from 1 to 307,200, estimating it would take an average of one second per pixel, then 307,200 seconds adds up to 5,120 minutes, which is more than 85 hours, or three and a half days, of counting continuously. And that's just for one frame of pixels.

Not to mention the enormous range of colors that any pixel can assume—16 million! To get a sense of that many colors, imagine a set of 64 crayons extending for 262,144 rows, where each crayon is different. In a crayon factory this might be an everyday occurence, but dispel that thought for now and be amazed ...

... or not.

4 *reactive* My science teacher made us memorize that "an organism is something that reacts to a stimulus." At an age when big words serve as a façade for intelligence, I filed it away as important. Many years later I was in the midst of a struggle to reconcile my romantic notions of design as represented by designers like Paul Rand, with the considerably less idealistic realization that design was nothing more than another way to make a living. I had recently found two traditionally opposing camps of thought—namely non-designers and designers—in implicit agreement that the methods and manifestos of design were no longer adequate. Researchers maintained that the same sentiments for designing a cup or spoon could not scale to modern information-rich objects; proper designers maintained that "form follows function" was irrelevant when an object's functions could number in the thousands. The interdisciplinary approach to design had emerged and interaction design was born. Not only had the object of design become more complex, but the process of design had become more complex as well. Driven to deep depression, I reinterpreted my teacher's words: any living thing *reacts*, even a computer.

My first attempt at creating reactive graphics began with a simple program that translated between cursor motion and color. A graph at right displays the amount of cursor movement at any given instant in any direction, while color tokens to the left define a visual map that correlates specific ranges of motion to specific colors. When the entire screen is filled to correspond to the motion of the cursor, a single reactive pixel is perceived. This concept is simulated on the following five pages. →

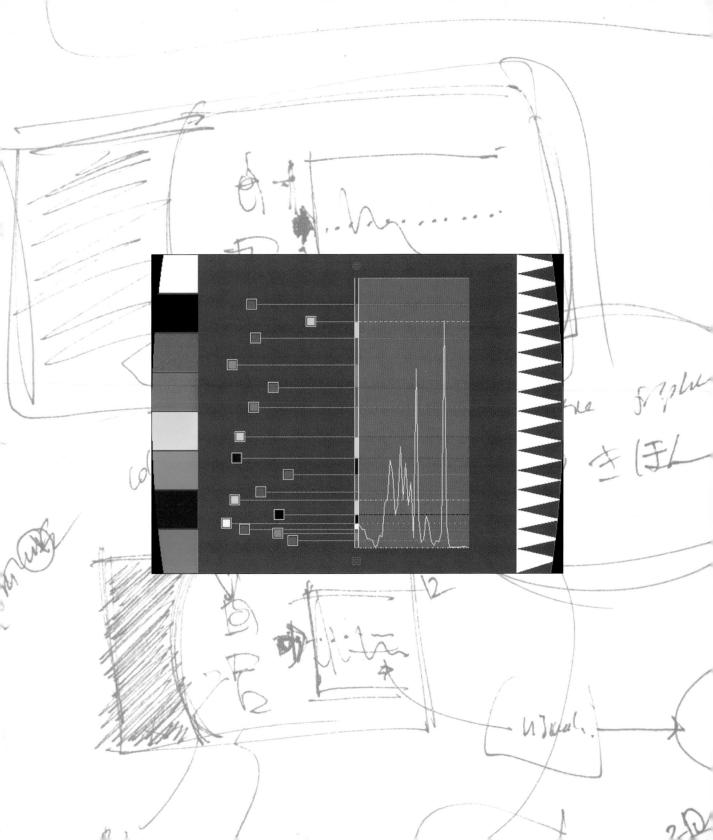

The cursor is still.

The page is pink. →

A slight move changes the page to green. →

k

A greater motion turns the page to blue. →

An even greater movement turns it to yellow. →

Remaining stationary returns the page to a healthy pink.

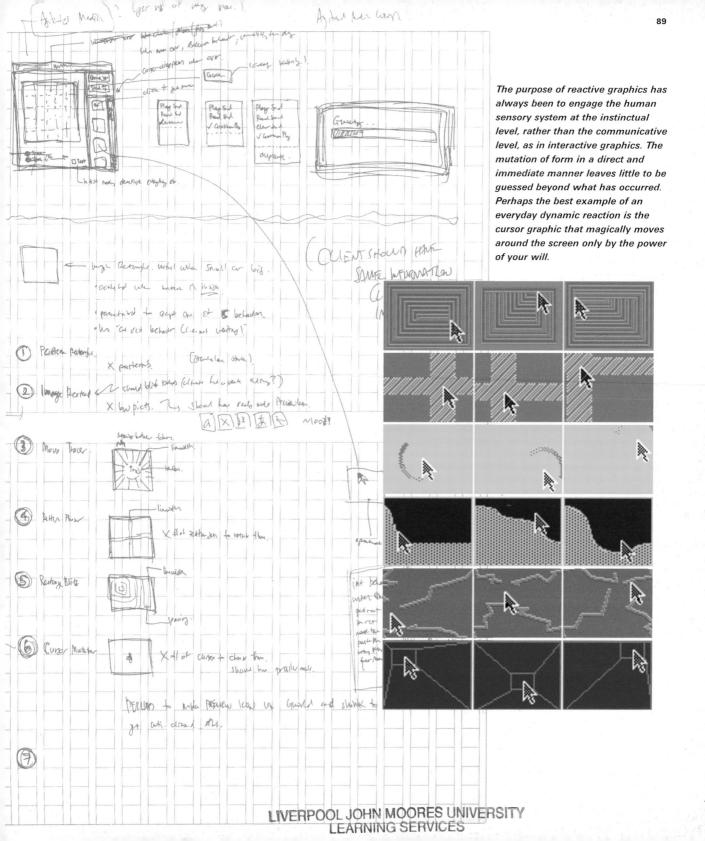

Given the diversity of the reactions I created and observed, it seemed possible to develop a new visual language to describe such systems. The issue of unstable inks was examined as a system.

Color is selected and painted.

As the cursor strokes the surface, the rectangular fibers react and become unstable in color value for a brief moment.

The digital medium is unbound in time and in space. A rectangle can be instructed to move every second for eternity. Furthermore, it can be commanded to move off the viewing canvas on to infinity. To draw effectively on such a material requires not only a new set of tools but a new kind of mind.

At the conclusion of developing this system for programming intelligent inks, I realized that unless there is a good idea about what it's for, any sophisticated tool is ultimately hindered.

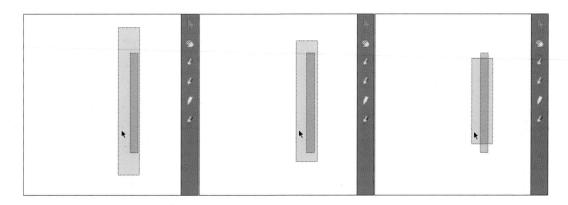

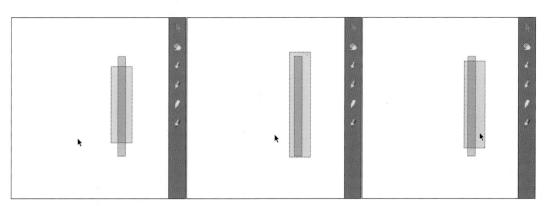

Rectangles painted with blue ink are programmed to travel continually to the right, shrink vertically when the mouse is near, and otherwise expand vertically.

LIVERPOOL JOHN MOORES UNIVERSITY LEARNING SERVICES

In recent years the media has crowned certain people as "Photoshop gurus" or "Photoshop masters." I found these appellations to be oxymorons—who is really in control, the tool or the master? To illustrate this point, I created a simple paint system in which the relationship was inverted. It is the tool, not the hand, that clearly appears to be in control.

I heard a software evangelist at a design conference say, "The world wide web is like the California goldrush. As you all know, miners couldn't crawl into the mines with their regular clothing, as it would easily get torn. Thus jeans were invented. They also needed specially designed pans for panning for gold. We are the company that makes those tools you need to strike it rich." Stated differently you could also hear it as, "Whether you find gold or not, probably not, we're going to make money from you anyway." The issue of financial gain aside, there is no doubt that digital artists and designers worldwide are indentured in some way to the art director of international renown, identified by the scarlet letter A.

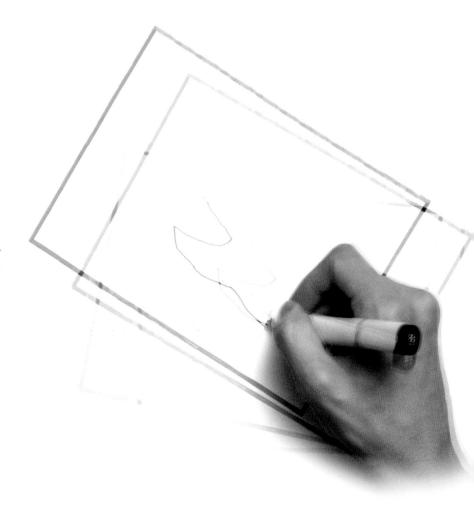

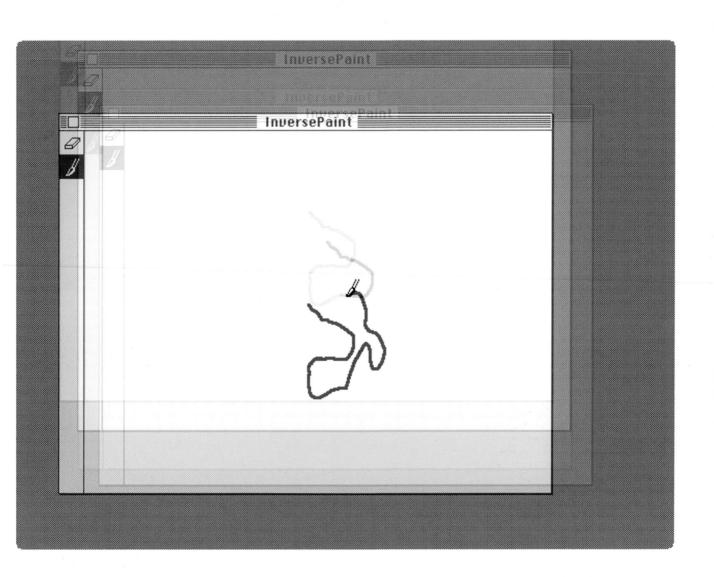

Staring into a bowl one day, I thought it would be useful to experience the phenomenon of painting as restricted to circular movements.

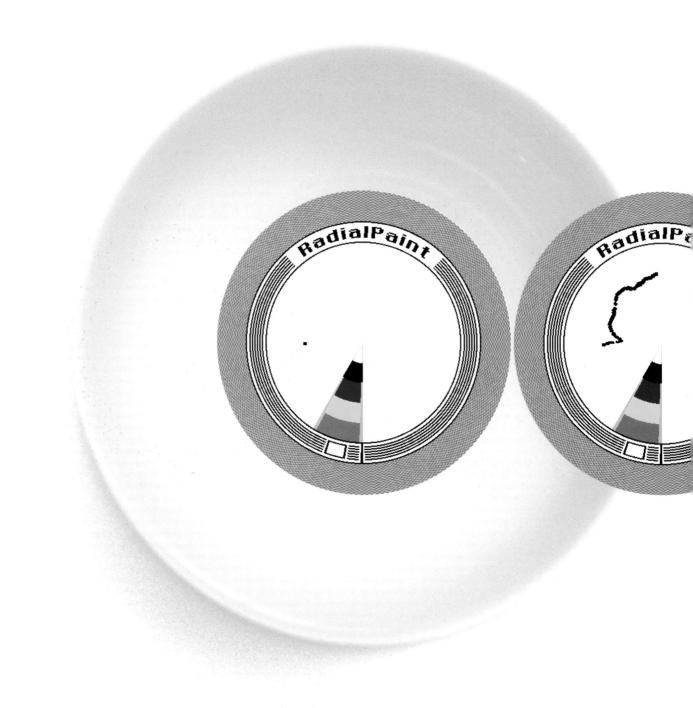

The monitor we use is rectangular, the pixels that fill its space are also rectangular, the windows that tile our interface, its buttons, sliders, and controls are all rectangular. All programs are written with this basic assumption of rectangularity. To break free from any implicit visual restraint requires the maturity to recognize, together with the training to neutralize, predisposition to synthetic conventions.

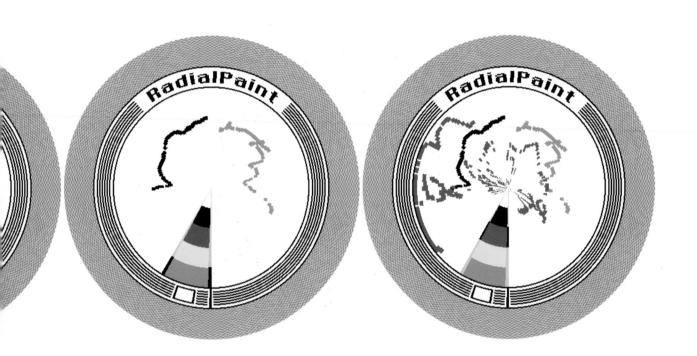

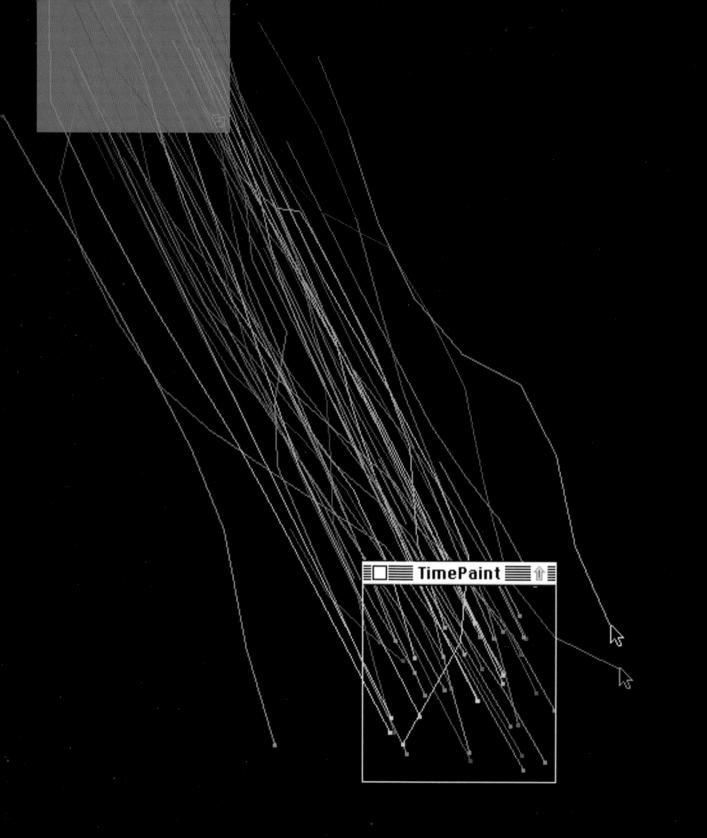

visualized in this project to paint time.

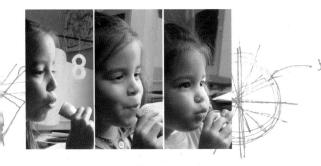

My children's growing curiosity in the computer was the impetus for a wide variety of basic constructions such as a series of digital pinwheels.

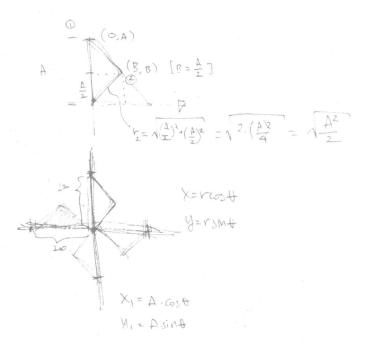

$$\chi_2 = r_2 \cos \theta = \frac{A}{N2} \cos(\theta - 45^{\circ})$$
 $\chi_3 = 0$
 $\chi_2 = r_3 \sin \theta = \frac{A}{N2} \sin(\theta - 45^{\circ})$ $\chi_3 = 0$

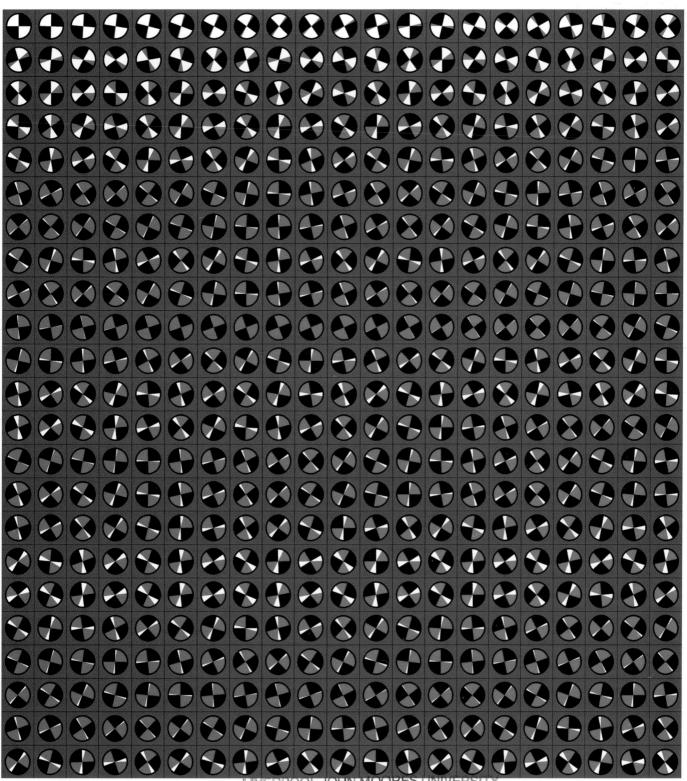

LIVERPOOL JOHN MOORES UNIVERSITY

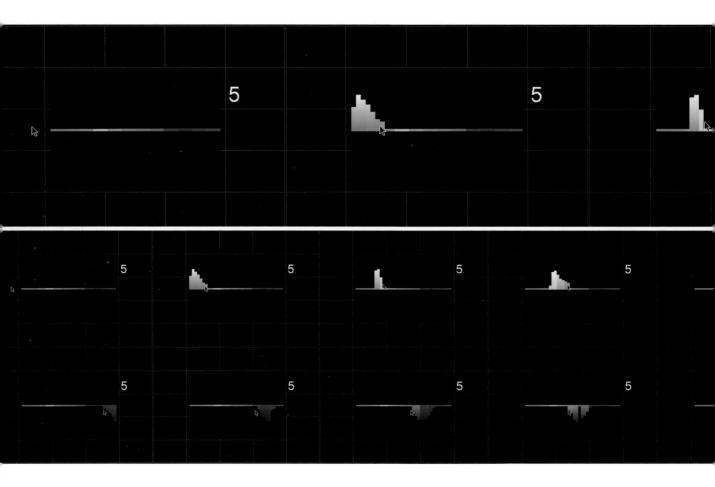

A reaction that incorporates a "tail" of some form, whether it be comet-like or a more abstract propagation of a wave, has the effect of reinforcing a false reality. You become privy to a completely synthetic world and appreciate cues from a realm you already know, even if it is faked.

A reactive color bar reaches upwards to white or downwards to black as the cursor strums its top or bottom surfaces.

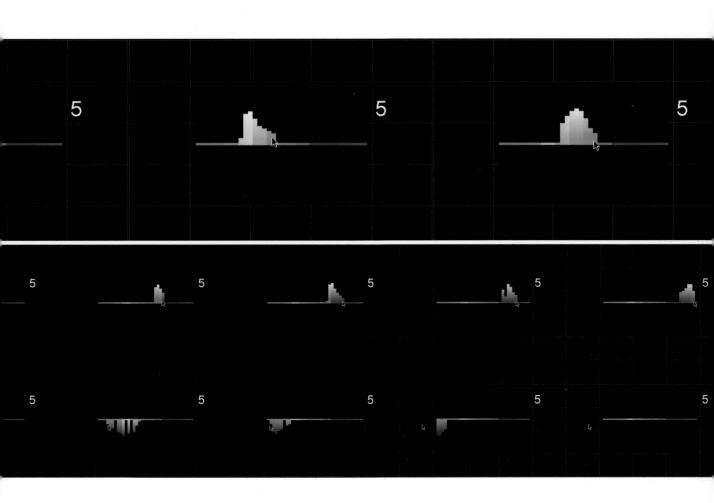

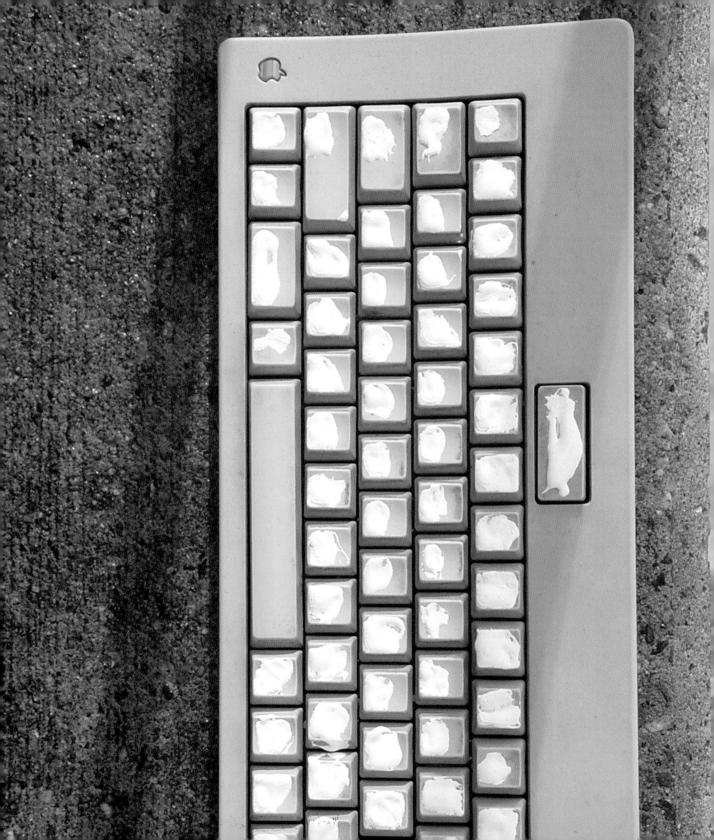

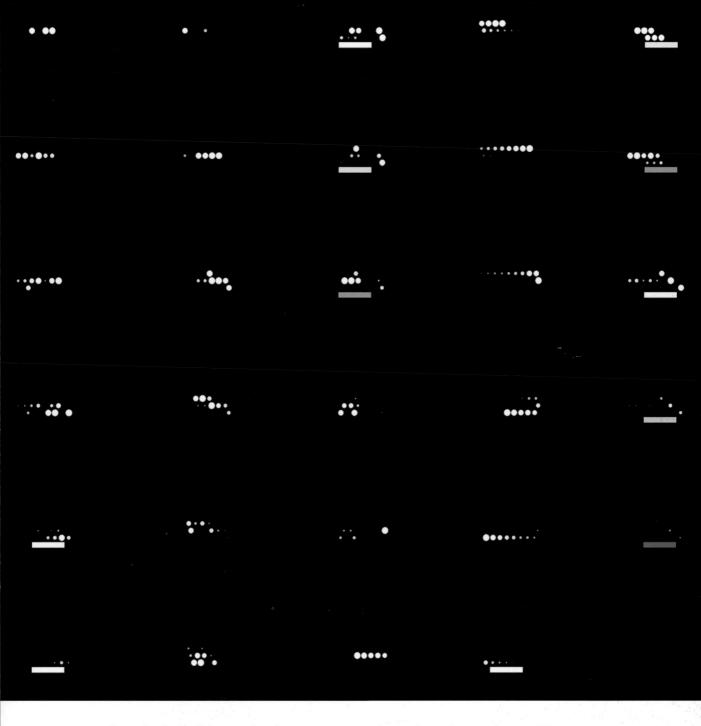

Removing the signifying meaning of symbols, letters, and numbers can reveal the keyboard array's true identity as a coarse, tactile musical instrument. In an early experiment, as the keys of the keyboard are touched, circles dot the screen in corresponding positions as a kind of rain impinging on the computer screen.

LIVERPOOL JOHN MOORES UNIVERSITY

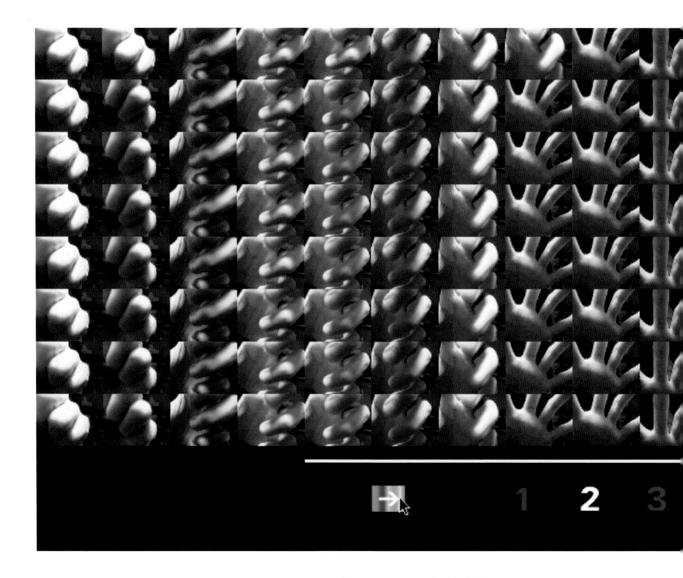

The average computer has four sensory inputs: keyboard, mouse, mike, and camera. Humans have five: touch, taste, smell, sight, and hearing. In both cases a set of human experiences and motivations guide the interpretation and processing of an output.

Reorganization of input video imagery processed in real time.

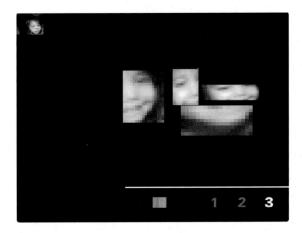

Three variations on a cross form and its interaction with the progression of time.

The common thread to all reactive graphic systems is the condition of time. Time can be perceived in one of two ways: as a natural precondition for reality or as a state measurable with respect to some specific reference.

A series of eight computers represents eight directions in dismantling common conceptions of the computer as a tool, in a 1994 exhibition held in Tokyo entitled "John Maeda: Deconstructing Cyberspace."

Reactive Books began as an idea to reconcile print media with digital media. The emphasis was to bring together high-quality printing with high-quality digital design, constructed in a single vision by a single person. The first book was *The Reactive Square* (1995). →

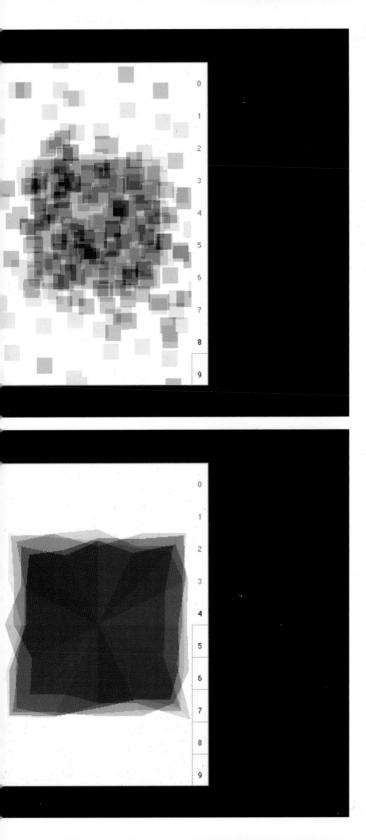

Influenced by the early Russian suprematist Kazimir Malevich, I originally wanted to title this book *Ode to Malevich*. His courage to abandon all decoration in pursuit of the simplest of forms, such as a single square, inspired my thinking about black squares that would exist only on the computer. The medium of the computer could allow tremendous potential as a starting point, but I was not sure in what manner and mode these squares should be interactive.

Not long before the conception of this project, my second child was born. I saw my children growing up in a world filled with computers and their awkward mechanics. I wanted my children to use computers, not by wrestling with the mouse and keyboard, but by simply talking or singing to elicit a reaction from the computer. The input method for *The Reactive Square* thus became the standard, oft-ignored Macintosh microphone, typically buried in a drawer with other useless cables. Viewers could talk to *The Reactive Square*, and it would react accordingly. →

The printed form of *The Reactive Square* was designed as a tactile experience, featuring ten pages with die-cut tabs and using richly textured materials. The accompanying floppy emblazoned with the Digitalogue logomark emphasized two points: the disparity between the sensual experience of paper and the manmade clunkiness of the plastic floppy disk; and that even a small data receptacle, such as a floppy disk compared to a CD-ROM, could hold a wealth of visual information. →

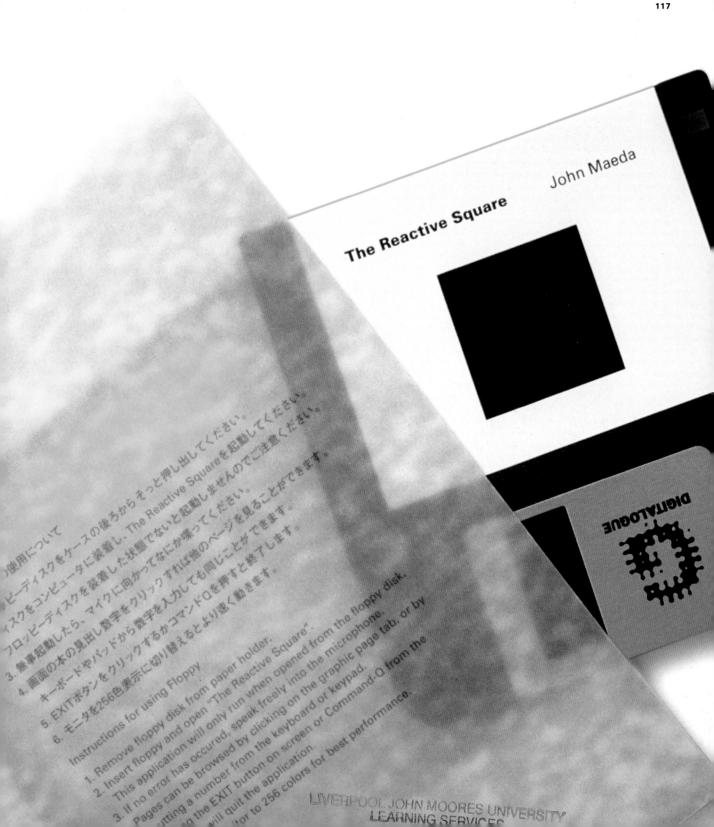

A computer program is a utilitarian typographer's dream-a functioning machine composed completely of type.

#define NPAGES 10 // number of pages int gsndtypewritergridval = 32; extern int gErr; int gNRINGS = NRINGS; void TOde2Malevich::InitOde2Malevich:(void) \ c_sndavailp = OpenSoundInput(); if (lc_sndavailp) gErr = -2; // means sound cannot be opened if $(rectW(cb) < 600) \mid gNRINOS = 14$; gsndtypewritergridval = 20; c birthtime = TickCount(l); c brandnewp = 1; c drawcalledp = 0; c unity = c rooth/(NPAGES+2); c page = c unity "NPAGES, c page = c (int)((float)c page if c page | c rooth/(NPAGES+2); SethectWH/fbc sqr.c pageorgx+dx.c pageorgy+dy, sqdim.sqdim); c sqdim = sqdim; g oderect = c sqr; InsetRect(&g oderect, sqdim/4, sqdim/4); \ SetRect(&c indexr.c pageorgx+c pageorgx+c pageorgx+c pageorgy, c pageorgx+c page c_pageorgy+c_pageh); SetRectWH(9c_pagec,c_pageorgy,c_pageorgy,c_pagew-c_indexw.c_pageh); c_pagearea = c_pager; insetRect(9c_pagearea,1,1); SetRectWH(9c_pagebounds,c_pageorgy,c_pageorgy,c_pageorgy,c_pageorgy,c_pageh); c_curpagenum = 0; c_pust_switchedp=1; c_destpage = -1; initInternalParameters(1); c_exitr = c_bounds; c_exitr.bottom--; c_exitr.infet = c_exitr.infet = c_exitr.bottom--16; \quad void TOde2Malevich:InitInternalParameters(void) \quad \quad \text{int}; c_fasttick = \quad $Tick Count(!): ||for square| circle red c|| lastmax perturb = 0; c|| lastp = 0; ||for spiral thingy c||_a = c|| sqdim|| 2; c|| sqorg h = c||_a + c|| sqr.left; c||_sqorg v = c||_a + c||_sqr.top; for ii = 0; i < 16; i + +)|| c||_b[i] = c||_a; ||for sound type writer c||_cursyridx = c||_a + c||_sqr.top; for ii = 0; i < 16; i + +)|| c||_b[i] = c||_a; ||for sound type writer c||_cursyridx = c||_a + c||_sqr.top; for ii = 0; i < 16; i + +)||| c||_a; |||_cursyridx = c||_a + c||_sqr.top; for ii = 0; i < 16; i + +)|||c||_a; |||_cursyridx = c||_a + c||_sqr.top; for ii = 0; i < 16; i + +)|||_cursyridx = c||_sqr.top; for ii = 0; i < 16; i + +)|||_cursyridx = c||_sqr.top; for ii = 0; i < 16; i + +)|||_cursyridx = c||_sqr.top; for ii = 0; i < 16; i + +)|||_cursyridx = c||_sqr.top; for ii = 0; i < 16; i < 16;$ gsndtypewritergridval; c_cursgridy = c_cursgridx;||2; c_curs.h=c_curs.v=0; c_curs.dimx = c_sqdim/c_cursgridx; c_curs.dimy=c_curs.dimx;||2; c_curs.org, h = c_sqorg, h-(c_curs.dimx'c_curs.gridx)||2; c_curs.h=c_curs.org, v-(c_curs.dimx'c_curs.org, h-1; c_curs.org, v-1; c_curs.org, c_psize_c_sorg_vc_psize_c_psize^3_c_psize^3_c_psize^3_c_ringvals[0]=0; for[i=1,i < gNRINGS; i++) \ c_ringr[i] = c_ringr[i-1]; InsetRect(8c_ringr[i], c_psize_c_psize); c_ringvals[i]=0; \ c_ringr(0].right=2; c_ringr(0].bottom=2; for[i=1,i < gNRINGS; i++) \ c_ringr[i] = c_ringr[i] $c \ ringr[i]. right=c \ ringr[i]. right=c \ ringr[i]. bottom=c \ ringr$ for lace doily c_lacedivs = 12.||3; c_lacedim = c_sqdim/c_lacedivs; c_lacedivs-t_c_lacedivs-t_setRectWH(&c_laceoutr, c_sqr.left+(c_sqdim-c_lacedivs c_lacediv) *c_lacedivs *c_ c lacedivs c lacedim); c laceinr = c laceoutr; InsetRect[&c laceinr,c lacedim; acedim; laceoutr.bottom++; ||c laceoutr.top-; ||c laceinr.bottom++; ||c laceinr.right++; c lacedeg = 0; || for vortex #ifdef powers c_vortexdivs = 9;||7: c vortexloops = 4.//3; #endif #ifndef powerc c vortexdivs =7; c vortexloops = 3; #endif c vortexdim = c sqdim/c vortexdivs; SetRectWH/&c vortex, c sqr.left+(c sqdim-c vortexdim*c vortexdivs)/2, c sqr.top+(c sqdim-c vortexdivs)/2, c sqr.top+(c sqd c_vortexdim^c_vortexdims_c_vortexdims_c_vortexdims_c_vortexdims_c_vortexdivs_c_vort TOde2Malevich::MouseDown(Point pt) \ int pagenum; if (PtInRect[pt.&c.sqr)&BcommandKeyP(f) \ RecalcMinsoundval(): return, \ if (PtInRect(pt.&c.indexr)) \ pagenum = (pt.v-c.indexr.top)/c. unity; if (pagenum < 0) pagenum = 0, if (pagenum = 0). >= NPAGES) pagenum = NPAGES-1; Switch2Page|pagenum|; | else if |PtlnRect(pt,9c_exitr)| | Rect_r = c_exitr; Boalean insidep = 1; InsetRect(9r,-1,-1); ForeColor(whiteColor); FrameRect(9r); while(Button()) | GetMouse(9pt); if |PtlnRect(pt,9c_exitr) & sinsidep | insidep | Futnaculped: extra US instancy | manage|- | reflection with a contraction | manage|- | The Comment of the Co StringWidth("p1")||2||c_indexw"3|8, c_pagertop+|c_unity|2+8|,||c_unity-c_indexw|2-2, c_indexw|4, c_indexw|4, for(j = 0; j < c_curpagenum; j++) | MoveTo(r.left,r.top); NumToString(j,mystr); | Tif (j = c_destpage) | c_destinvr = r2; ForeColor(blackColor); PaintRect(θ r2); ForeColor(whiteColor); | else | PanPat(θ qd,gray); RGBForeColor(θ gray50); PaintRect(θ r2); $Fore Color(white Color); PenPat(\&qd.black); \\ |^*DrawString(mystr); OffsetRect(\&r,0,c_unity); \\ ||RGBFore Color(\&gray75); \\ for (j=c_curpagenum+1; j < NPAGES; j++) \\ ||MoveTo(r.left.r.top); NumToString(j.mystr); \\ ||DrawString(mystr); \\ ||DrawString($ $Of setRect(\theta r.0.c.unity); \} \} \# define SPIREBEGIN poly = OpenPoly[]: MoveTo(0.0) \# define SPIREEND ClosePoly[]: PaintPoly[poly]: KillPoly[poly]: \# define L(x,y) LineTo(x,y) lineTo(x,y) lineTo(x,y) lineTo(x,y) lineTo(x,y) MoveTo(x,y) MoveTo(x + MYR(p), y + MYR(p)) # define PLINETO(x,y,p) LineTo(x + MYR(p), y + MYR(p)) # define PMOVETO(x,y,p) MoveTo(x + MYPR(p), y + MYR(p)) # define PLINETO(x,y,p) LineTo(x + MYR(p), y + MYR(p)) # define PMOVETO(x,y,p) MoveTo(x + MYPR(p), y + MYR(p)) # define PMOVETO(x,y,p) LineTo(x,y,p) LineTo($ y = MVPR[p] dedine PLINETO(2, x, p). LinaTo(x + MVPR[p]) extern Synthandic rootScaff, x void Tode2Malevich.: DrawPage0flong val) | long maxperturb = c, addim(4, PolyHandle poly; ForeColor/whiteColor); | y - MVPR[p] extern Synthandic rootScaff, x void Tode2Malevich.: DrawPage0flong val) | long maxperturb = c, addim(4, PolyHandle poly; ForeColor/whiteColor); | PaintRot(5c, pagearea), poly = DepenDoly(). ForeColor(blackColor); maxperturb = long maxperturb = (5c, pagearea), poly = DepenDoly(). ForeColor(blackColor); maxperturb); PLINETO(c, sagreight - S, carlotton-Linaxperturb); PLINETO(c, sagreight - S, carlott (c_just_switchedp) {ForeColor(whiteColor); PaintRect(@c_pageareal; \ maxperturb = maxperturb*(long)val|SNDRANGE; BlockMove(@c_ringvals[0].@c_ringvals[1].sizeof(int)*(gNRINGS-1)); c_ringvals[0] = maxperturb; ForeColor(blackColor); PanSize(c_psize, c_psize); if (rootDepth == 1) \ forti=0;i<gNRINGS:i++) \ if (c_ringvals[i] > 204) PenPat(@qd.white); else if (c_ringvals[i] < 51) PenPat(@qd.black); else if (c_ringvals[i] < 102) PenPat(@qd.dkGray); else if (c_ringvals[i] < 103) PenPat(@qd.dkGray); PenSize(c_psize,c_psize); if (ronObepth == 1) { tor(=0)/SpNRINGS;+++ { it (c_ringvals() < 5:20.4) PenPa(legd_psize); else PenPa(legd_psize); else PenPa(legd_psize); if (i) FrameRet(Dc_ringr(ii); PenPa(legd_black); lese In (c_ringvals() < 5:20.4) PenPa(legd_black); lese In (c_ringvals() < 5:20.4) PenPa(legd_black); lese In (c_ringvals() < 5:20.4) PenPa(legd_black); lese In (c_ringvals() < 6:20.4) PenPa(legd_black); lese In (c_ringvals() < 5:20.4) PenPa(legd_blac PaintRect(See pagearea): maxperturb = maxperturb * (long)val|SNDRANGE; ForeColor(blackColor); PenSize(c windsize); windsize); m1 = MYR(maxperturb); for(j = 0, y = c windorg v; j < c windsize) | for(j = 0, x = c windorg h; j < c windsize) | for(j = 0, y = c windorg v; j < c windsize) | for(j = 0, x = c windorg h; j < c windsize) | fried = 0, x = c windorg h; j < c windsize) | fried = 0, x = c windsize) | fried = 0,loops; int k=0, dim=c_vortex/lim, n=c_vortex/loops '2+1', int ox = c_vortex.rleft,oy = c_vortex.rlop; long maxperturb=dim:///2. Rect r. RGBColor col. if (c_just_switchedp) | ForeColor(whiteColor); PaintRact(9c_pagearea); ForeColor(blackColor); $PaintRect(Be_vortexr); \ | sete_c| bitt=c_vortexr, maxperturb=maxperturb' | long|val|SNDRANGE; for | loops <=c_vortex| loops <=c_vortex| loops | SetRectWH(Br.ox+|k-1]' dim.oy+k' dim. (n)' dim,oy+k' dim.oy+k' dim.oy$ $SetRectWH(\Thetar, ox+k*dim, oy+(k+n-1)*dim, (n)*dim, dim); ScrollRect(\Thetar, dim, 0, rootScrRgn1); \\ SetRectWH(\Thetar, ox+k*dim, oy+(k+1)*dim, dim, (n-1)*dim); ScrollRect(\Thetar, 0, dim, rootScrRgn1); \\ \\ |n-2|; k++; \\ ||ForeColor(blackColor); \\ |n-2|; k++; \\ ||ForeColor(blackColor); \\ |n-3|; k+1|; \\ ||ForeColor(blackColor); \\ |n-3|; \\$ col green=col.blue=col.red=(long)(val)<<8; RGBForeColar(9cal); PaintRect(9r); PenSize(maxperturb,maxperturb); ForeColar(whiteColar); MoveTo(r.left.r.top); Line(dim-maxperturb,dim-maxperturb); PenSize(1.1); \ void TOde2Malevich::DrawPage5(long val) || snd typewriter | Rect r; long maxperturb = 255L; RGBColor col; if (c. just switchedp) | Rect br; ForeColar(whiteColar); PaintRect(9c_pagearea); ForeColar(blackColar); PaintRect(9c_cursbds), \ else c_btr = c_cursbds; SetRectWH(Br,c_cursorg,h+c_curs,h'c_cursdimx, c_cursorg,v+c_curs,v'c_cursdimy, c_cursdimy-1; maxperturb = maxperturb'(long)val/SNDRANGE; if (rootDepth == 1) \ if (maxperturb > 204)

PenPat(Bqd.ktGray); else if (maxperturb < 51) PenPat(Bqd.ltGray); ForeColor(blackColor); \ else if (maxperturb < 102) PenPat(Bqd.dtGray); else if (maxperturb < 153) PenPat(Bqd.ltGray); else PenPat(Bqd.ltGray); else if (maxperturb < 104) col.green = col.blue = col.red = maxperturb<<8; RGBForeColor(Bcol); \ | else \ | col.green = col.blue = (255L-maxperturb)<8; col.red = maxperturb<<8; RGBForeColor(Bcol); \ | if (val=0) \ | // cursor stuff removed for timing reasons if $The KCount()-c. curstime>101+c. cursty as e^*OL) \mid (if (c. cursphase=0) \mid c. cursphase=1; Fore Color(white Color); \mid else \mid (c. cursphase=0; Fore Color(black Color); \mid Paint(val(8r); c. curstime=Tick Count(); \mid else \mid (iPaintRect(8r); PaintRect(8r); PaintRect$ ForeColor(whiteColor); [FrameRect(\text{iff}: paintOval(\text{iff}: paintOval(\text{iff} rootGw->CopyTo(&c_Jaceoutr,Oc.); ||InsetRect(&r,I.1); rootGw->CopyFrom(&c_Jaceoutr,Oc.); ||CopyBits(|BitMap *)&(qd.thePort)->portBits, ||BitMap *)&(qd.thePort)->portBitMap *)&(qd across top & bottom | ForeColor(blueColor); PaintRect(&c_laceoutr); ForeColor(greenColor); PaintRect(&c_laceoutr); return;* | ForeColor(whiteColor); r = c_laceoutr; r.bottom=r.top+c_lacedim; PaintRect(&r); r.bottom=c_laceoutr.bottom. r.top=t.botom-c lacedim; PaintRect(8r); r.top = c laceoutr.top; r.right=c lacedim; PaintRect(8r); r.top = c laceoutr.top; r. SetRectWH(9r2.c. laceoutr.left.c. laceoutr.bottom-c_lacedim.c_lacedim.c_lacedim); ForeColor(blackColor); InsetRect(9r1,maxperturb,0); InsetRect(9r2,maxperturb,0); for(i=0,i<c_lacedivs.i++) | PaintRect(9r1); PaintRect(9r2) Single-trimor___accounts.com___accounts.com___accounts.com___accounts.com___r = 8: int dim2 = c_sqdim/mydivs/2: int dim = dim2*2: long maxperturb=dim*5/4. Rect mybds. Rect r2: if (c_just_switchedp) | ForeColor(whiteColor). PaintRect(8c_pagearea): maxperturb = maxperturb = maxperturb | SetRectWH(@mybds.c_sqr.lop+(c_sqdim-dim*mydivs)/2.c_sqr.top+(c_sqdim-dim*mydivs)/2.dim*mydivs+1.dim*mydivs+1); ForeColor(blackColor): PaintRect(8mybds): SetRectWH(@r.dim2-maxperturb)/2.dim2-maxperturb $maxperturb/2, maxperturb, maxperturb); OffsetRect(\thetar, mybds.left, mybds.left$ ScrollRect(& topr,shiftx,0,rootScrRgn1); r=c_topr; r.right=cleft+shiftx; r.bottom=r.top+maxperturb; ForeColor(whiteColor); PaintRect(&r); r.top=r.bottom; r.bottom=c_topr.bottom; ForeColor(blackColor); PaintRect(&r); ScrollRect(8c_ightn.O.shiftx.rootScrRgn1); re_eightr.isbttom=r.top+shiftx; rlaft=r.ightr.nosperturb; ForeColor(whiteColor); PaintRect(8c_ightn.O.shiftx.rootScrRgn1); rec_bottr.heft; ForeColor(blackColor); PaintRect(8c_ibotr.shiftx, rlop=c_bottr.top; ForeColor(blackColor); PaintRect(8c_ibotr.shiftx, rlop=c_bottr.top; ForeColor(blackColor); PaintRect(8c_ibotr.shiftx, rlop=c_bottr.top); ForeColor(blackColor); PaintRect(8c_ibotr.shiftx, rlop=c_bottr.top); ForeColor(blackColor); PaintRect(8c_ibotr.shiftx, rlop=c_bottr.top); ForeColor(blackColor); PaintRect(8c_ibotr.shiftx, rlop=c_bottr.top); ForeColor(blackColor); PaintRect(8c_ibotr.shiftx, rlop=c_bottr.shiftx, rlop=c_bottr.shiftx, rlop=c_bottr.shiftx, rlop=c_bottr.shiftx; rlop=c_bottr.shi r.top=t.bottom-shiftx; r.right=x.left+maxperturb; ForeColor(whiteColor); PaintRec(19r); r.left=x.right; r.right=c_left.right; ForeColor(blackColor); PaintRec(19r); \ left= Rect r; long maxperturb=c_sqdim|2;|||2; int shiftx; RGBColor col; col.red=col.green=col.blue=(255t*(long)val|SNDRANGE)<68; maxperturb = maxperturb*(long)val|SNDRANGE; shiftx = ((c_sqdim|16)*(long)val|SNDRANGE); if (shiftx == 0) shiftx = 1; ScrollRect(9c_topr.shiftx,0.rootScr8gn1); r=c_topr. Tright=r.[a4+shiftx; r.bottom=r.top+maxperturh; ForeColor(blackColor); PaintRect(\(\frac{a}{2}\); r.top=r.bottom; r.bottom=r.top+shiftx; r.left=cright-maxperturb; ForeColor(blackColor); PaintRect(Gr); rright=cleft; r.left=c_right.left; RGBForeColor(Gcol); PaintRect(Gr); ScrollRect(Gr); ScrollRect(Gr); OrotScrRgn1); r=c_botr; t.left=c_right-shiftx; r.top=c.botr.op; RGBForeColor(Gcol); PaintRect(Gr); ScrollRect(Gr); ScrollRect(Gr); PaintRect(Gr); rections the state of the state r.left=right; r.right: r.right: r.right: RG8ForeColor(8col).PaintRect(8r); | void T0de2Malevich::DrawPage9(long val) | // jallo pyramid long newb; tong maxperturb = c_a/4; int i; short b,b.2, c, c2; PolyHandle poly; short db = c_a/32; RG8Color col, $\begin{array}{ll} (25) & \text{with} & \text{Supplemental Supplemental Sup$ ZONJ PRINTING UNITED THE PROPERTY OF THE PROPE SPIREEMD; break; case 12: SPIREBEGIN; L(-b,-b); L(-c,-c/2); SPIREEMD; break; case 13: SPIREBEGIN; L(-b,-b2); L(-c,-c); SPIREEMD; break; case 14: SPIREBEGIN; L(-b,-b); L(-c,-c/2); SPIREEMD; break; case 15: SPIREBEGIN; L(-b2,-b); L(-c,-c/2); SPIREEMD; break; case 16: SPIREBEGIN; L(-b2,-b); L(-c,-c/2); SPIREEMD; break; case 17: SPIREBEGIN; L(-b2,-b); L(-c,-c/2); SPIREEMD; break; case 18: SPIREBEGIN; L(-b2,-b2); L(-c,-c/2); SPIREBEGIN; L(-b2,-c/2); SPIREBEGIN; L(-SPIREEND: break: default: break: | | SetOrigin(0.0); | void Tode2Malevich::DrawPagefint num) | long val = GetSoundInput(): if (val < MINSOUNDVAL) | val = 0. | else | val = (val - MINSOUNDVAL) | c. bltr = c. pagearea; switch(num) | (ase 0: DrawPage0(val); break; case 2: DrawPage7(val); break; case 2: DrawPage7(val); break; case 3: DrawPage8(val); break; case 3: DrawPage8 break; case 4: DrawPage4(val); break; case 9: DrawPage9(val); break; default: break; | c_just_switchedp = 0; || yave everyone a chance | void TOde2Malevich::AnimatedDraw(void) | rootScrGw->LockFocus(); if (c_sndavallp) | DrawPage(c_curpagenum); \ rootScrGw->UnlockFocus(); \ rootScrGw->CopyFrom(6c_bltr.0c_b TextMode(srcCopy); | else | ForeColor(redColor); PaintRect(9c_exitr); ForeColor(blackColor); Helvetica(10); MoveTo(c_exitr.left+2,c_exitr.bottom-4); DrawString("\pEXIT"); | #ifdef powerc long mywaits(10] = {0.10,11,01,0.0,2}; #else long mywaits[10] = [0.0.0,0.0,0.0,0.1]; #endit void Tode2Malevich::Idle(void) | if [gErr] | StringPtr s: long now = TickCount(); switch[gErr) | case -1: s = "pError: Not enough memory. Please restart or increase memory.": break; case -2: s = "pError: Cannot open sound input. Does not support microphone."; break; case -3: s = "pError: Not opened from floppy."; break; case -4: s = "pError: Requires System 7.1 or later."; break; default: s = "pUnknown error"; break. | Helvetica(18); if (rootDepth == 1) { ForeColor(blackColor); TextMode(srcBic); |/TextMode(srcXor); MoveTo((rectW(c_bounds)-StringWidth(s))/2+c_bounds.left, rectH(c_bounds)/2+8+c_bounds.top); DrawString(s); TextMode(srcCopy); now = TickCount(); **Industrial Control of the Control 1995 John Maeda, DIGITALOGUE Co., Ltd."); AnimatedDraw(); now = TickCount(); while(TickCount()-now < 1L); | FareColor(blackColor); MoveTo(c_bounds.left+2.c_exitr.bottom-4); DrawString("pCopyright © 1995 John Maeda, DIGITALOGUE Co., Ltd."); c_brandnewp = 0; } | if {c_curpagenum != 5} \ | if {TickCount(|-c_lasttick >= mywaits[c_curpagenum])} \ | if {c_sndavailp} \ AnimatedDraw(|; c_lasttick = TickCount(|; } \ else \ | if {TickCount(|-c_lasttick > mywaits[c_curpagenum])} \ | if {c_sndavailp} \ DrawPage(5); c_lasttick = TickCount(|; } \ else \ | if {TickCount(|-c_lasttick > mywaits[c_curpagenum])} \ | if {c_sndavailp} \ DrawPage(5); c_lasttick = TickCount(|; } \ else \ | if {TickCount(|-c_lasttick > mywaits[c_curpagenum])} \ | if {c_sndavailp} \ DrawPage(5); c_lasttick = TickCount(|; } \ else \ | if {TickCount(|-c_lasttick > mywaits[c_curpagenum])} \ | if {c_sndavailp} \ DrawPage(5); c_lasttick = TickCount(|; } \ else \ | if {TickCount(|-c_lasttick > mywaits[c_curpagenum])} \ | if {c_sndavailp} \ DrawPage(5); c_lasttick = TickCount(|; } \ else \ | if {TickCount(|-c_lasttick > mywaits[c_curpagenum])} \ | if {c_sndavailp} \ DrawPage(5); c_lasttick = TickCount(|; } \ else \ | if {TickCount(|-c_lasttick > mywaits[c_curpagenum])} \ | if {c_sndavailp} \ DrawPage(5); c_lasttick = TickCount(|; } \ else \ | if {TickCount(|-c_lasttick > mywaits[c_curpagenum])} \ | if {c_sndavailp} \ DrawPage(5); c_lasttick = TickCount(|; } \ else \ | if {TickCount(|-c_lasttick > mywaits[c_curpagenum])} \ | if {c_sndavailp} \ DrawPage(5); c_lasttick = TickCount(|; } \ else \ | if {TickCount(|-c_lasttick > mywaits[c_curpagenum])} \ | if {c_sndavailp} \ DrawPage(5); c_lasttick = TickCount(|-c_lasttick > mywaits[c_curpagenum])} \ | if {c_sndavailp} \ DrawPage(5); c_lasttick = TickCount(|-c_lasttick > mywaits[c_curpagenum])} \ | if {c_sndavailp} \ DrawPage(5); c_lasttick = TickCount(|-c_lasttick > mywaits[c_curpagenum])} \ | if {c_sndavailp} \ DrawPage(5); c_lasttick = TickCount(|-c_lasttick > mywaits[c_curpagenum])} \ | if {c_sndavailp} \ DrawPage(5); c_lasttick = TickCount(|-c_lasttick > mywaits[c_curpagenum])} \ | if {c_sndavailp} \ DrawPage(5); c_lasttick = TickCount(|-c_lasttick > mywaits[c_curpagenum])} \ | if {c_sndavailp} \ DrawPage(5); c_lasttick = TickCount(|

 $(Sd2^2) = \sqrt{S \cdot d2}$ $\theta_{\text{stant}} = a \tan \frac{d}{dz} = \frac{2 dz \cdot d}{dz}$ 4.2487 th. 1.1071 Ren Herry Merrys 12.

= (d2)2+(d2)2+(d2)2+(d2)2+(d2)2

1,1071 int vals [48] iv+ i, Pack sings ingr [B] nx1 (latet. 10) 0x-byge, 02-byg byge 45 () yare) ; 2.0344 De (2-, 14+) } Mirli-D, (-pik, pike),

Vals (5) ~ cerul, Fame (pider prize)) fr(1=0;1<12;1+1){ 2552 61. - 11 , 5-11. L. (10) [1] (1) - 1 hoursel) -1.1071 Ender (colocia) (fleet to Fun pur less The product ~ >) 1071 0 = Oshu+ pravs X= r. costs y= r-12t.

> tall

Gutters (AKT), -poils, -poils); y = (2.2361 · (fund do). sm+

X=(2.2361. (flour) d2). cos to

I later began an abstract series of typographic marionettes, where cursor motion is linked to a chain of letters, in this case the "Tokyo Type Director's Club."			F_Q
	PB6 95	∂ ₽ 6 95	Īv
		B	J
		Þ	^
		w yyy	
		TOKK KYYY O	D
		-0 -0 -0	С
	333	333	333
0 1	°C %	b 9	
500	e f _{Dii}	tt .	
Ar C'I'M		9 ₅₋	
s F	B &	£ 355€	© ™
s s	go uuu	ss 55 g	0
S _S SSSSSSC	gD & "uu	c s	
9999°C	b b		is y
IRK-DA A	FOREQ 5	POKYO	PBKY
u P	\$33 9	r	
333	333 ⁹ 999	333	333
	7 9 3	<u> </u>	

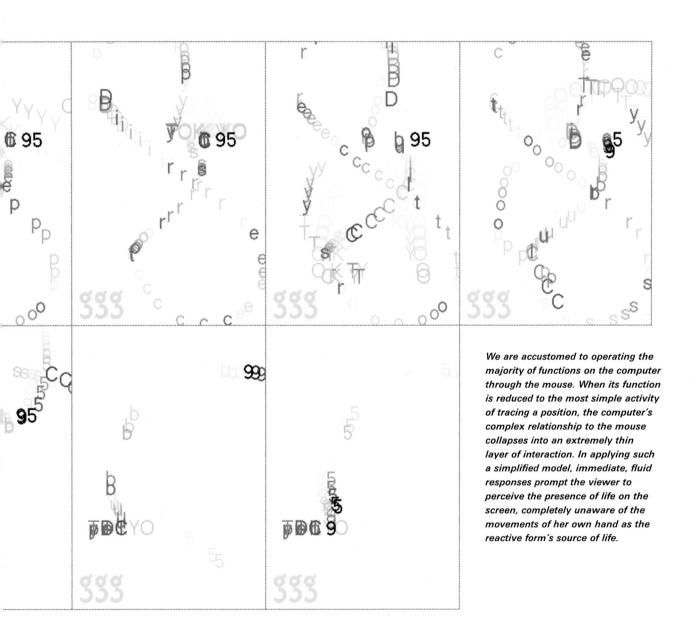

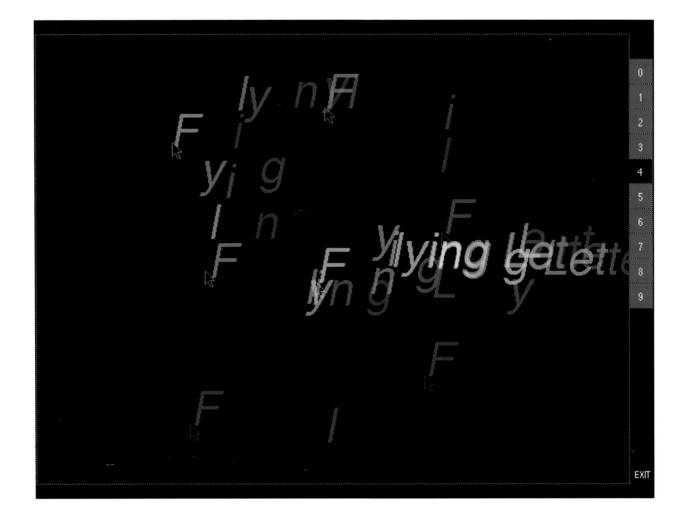

The completely abstract nature of *The Reactive Square* puzzled many viewers. As a break from the stoicism of geometric space, I chose to play with kinetic type. The result is *Flying Letters*, a collection of ten typographically motivated reactive graphics rendered in monochrome with an accompanying short story about my childhood experience with letters that fly. →

close to you.

Typographic themes are always immediately endearing because, when draped over even the most abstract of ideas, they appear to make sense from nothing. We are trained from a young age to read and write letterforms and thus feel a deep intellectual attachment to text. The composition of a work involving kinetic typography is best measured by mentally replacing all traces of text with similarly sized moving blobs. Usually the resulting animation, devoid of all of its semantic camouflage, can be of the most offensive quality.

same as , insert here > Creat PString (C-pholettstr "p.") for (1=0, 1< c-peoleth is luthun-1, i H) concert 15 mind ((_plearblut thr, "/p province the 0×014/1 ox labo Coneculations (C-produlation, "(p."); amber of the second (CURSORKEYS. y for (i=o', i<8* PKOMYK-EVELS; (++) { C-pkoler CLRTOP (y) {(y)=(y)tox7F; Stattoply 1 RIGHTSHIFT 3 (y)= (y)) DX3C //Cheek The shift by is 1/ Cheek FIRST CHROPLY (4) &OX7F)
LEPISHUPT 0X38 // (NI while for appliciting Il covers both shift keys. e (ctype. W) (owlrak text. WW: Do SHIFTKEY (wid) wighed ther km [16]; Parlitur Pathiko Proline asigned short k' pedrulin orden leftpm=0, nightp=0, palida politice etkys (llong +) km)'
His many int / level, i', peline, pechally +((KM[RIGHTSHIPT >>3]>>(RIGHTSHIPT 67))&1)& 13/4p=1 c-pholettunity = (-payearent/c-pholett 18:11 ((km [LEFTIHAT >>3)>) (LEFTINE &7/161) (-phovish+unity = c-paycorask) (-phovish+ SetPax Font (SHIFTKEY); //pertypo der 18Ap= 1' C-pkow = String Width ("(ppachinho") drw left side C-pkofhiju+ = 32, llupdate if meessa ndex = 1, 1=0 Mare to (c-phodettpt (i) h, C-phodett (i].v) y=c-pkolettunity; for (i=0, i<c-pkolettnum; i++) { f(lettp) Drawthi Gran Cher (" p!) , C. pko (index) C-pholettpt [i]. h= MYPR (Cpayo elle Drus Cher (pt) index +1 C-pholety+[i].v=y; Naite (C-pko (index) != !!) } } The Ci=O, i< C-provided man, i+1) { ive (=-1, i=1,) Block Mare (cpkslefibit), cpkolefibit+1 sizef(M)* 1 8+c_pholeHnum my (c-pkdeftstr [i] (=!!) { (_plengl+pst [i] h= MYPR(cpase) C-pkolaffits[0]=1etapi if ((-pkolettsfr [i) == 'p') { level++', Nove to (c-pkolettpt [level)-h, ... + C-pagerenw/: ym+=Aypr (cokonshtungif (Cpkole+16toCi-13) C-picolettpt(leve(]v); 3 + C-plofheighti Draw Charl townson (al solve [:])

I designed *Flying Letters* as a long foldout book that doubled as a container for the accompanying disk. → When letters are handwritten they are directly in contact with the pen and person that renders them. When letters are read we rarely reach out to touch them unless they are printed in a manner that invites touch, such as letter-press or spot lamination. The responsive "ink" of the computer screen is uniquely qualified to realize endless variations of relationships to touch, but it is seldom exploited beyond the token roll-over or highlight. As a result, interactive texts are usually no better than the average pop-up book for children.

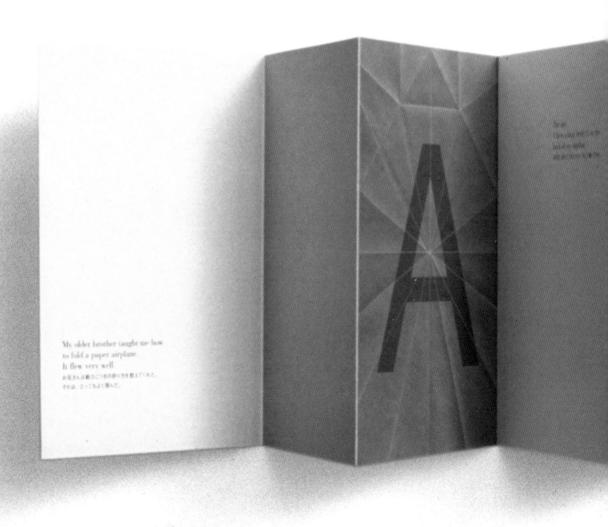

LIVERPOOL JOHN MOORES UNIVERSITY
LEARNING SERVICES

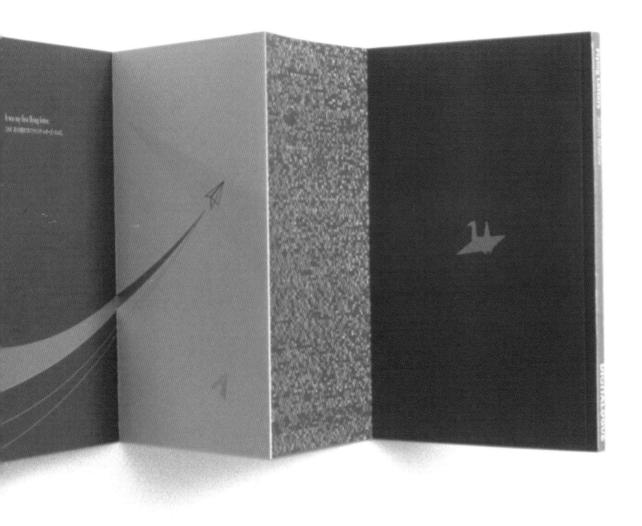

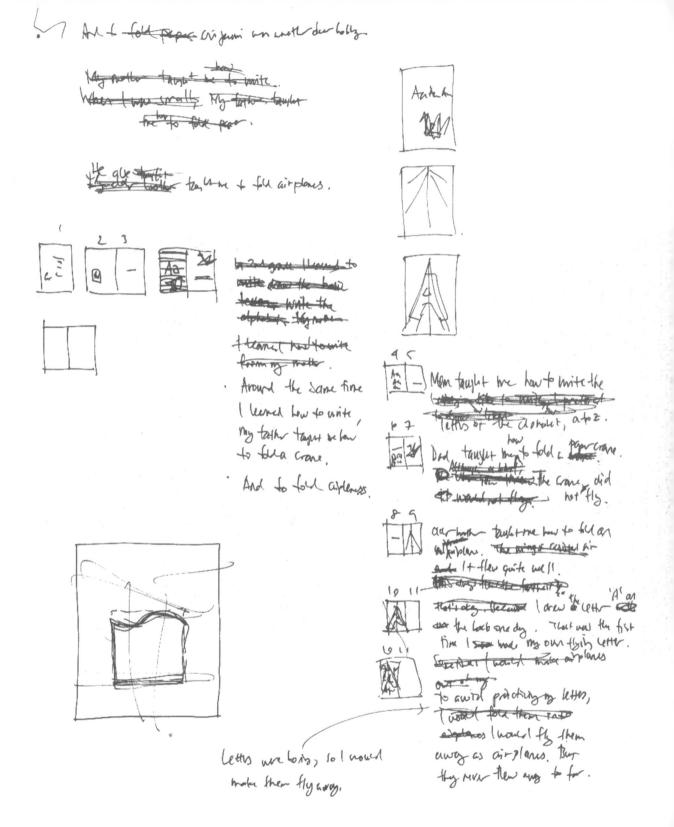

I became tired of cries for more antialiased type to correct the jaggedness of digital type. While one side of me cried to see Garamond butchered on the pixel grid, another side thought, "Who cares?" I decided to create a series of twelve clocks based upon the decidedly untrendy (at the time) original typeface of the computer—a simple face set on a basic 5 by 7 grid. →

Issues of screen resolution will be irrelevant in the future because computer screens will be as sharp as printed paper. In fact, experts believe that they will eventually be one and the same. The most important areas of visual exploration are therefore not in the mimicry of screen space and the printed page, but in the deconstruction of our spatial senses to stimulate the higher dimensions of expression made possible by the computer.

5×2

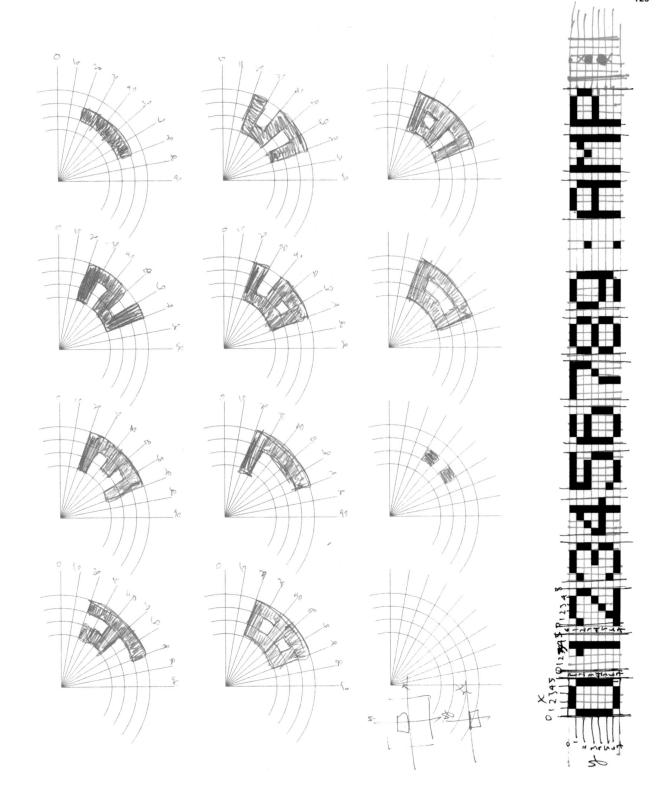

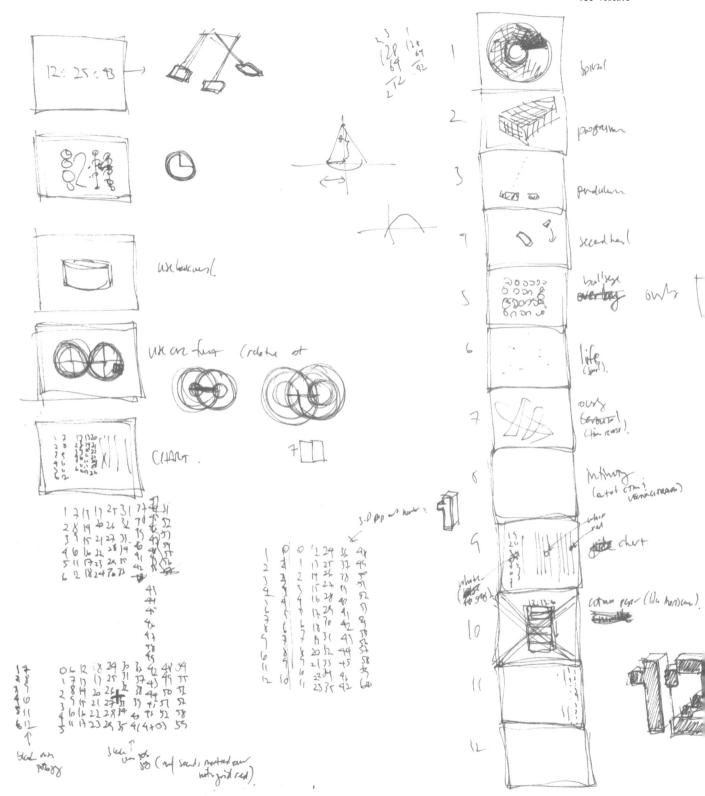

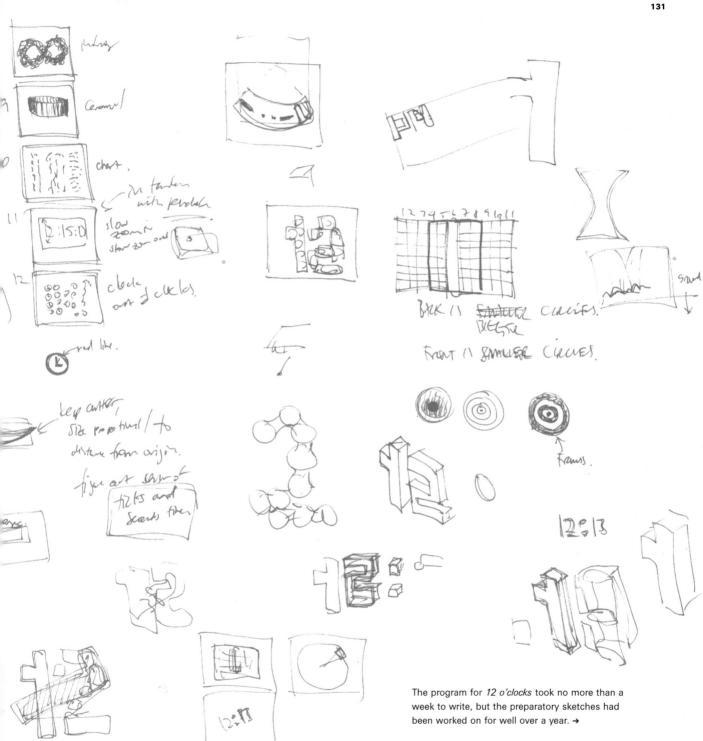

LIVERPOOL JOHN MOORES UNIVERSITY LEARNING SERVICES

As I transcribed the pencil sketches to algorithms, I felt the vast difference between the expressive contexts. Often, switching from pencil sketching to computation lifted impediments to innovation. For instance, I had difficulty developing the concept for one of the clocks, a tricolor clock composed of concentric circles (the second image in the first row), but it became perfectly clear when I sketched it as computation on the screen. Then again, some of the unresolved pencil sketches refused to improve in the computational phase. Eventually, I'd give up and rework them again on paper.

The pages of the printed book were created by the same software that runs the clocks themselves. I rewrote the codes to output in the PostScript language and rearranged some of the themes to maximize the effect of output to print media. In fact, all of the images were created computationally, except for the book's opening illustration, which was rendered not by a computer but by my children. →

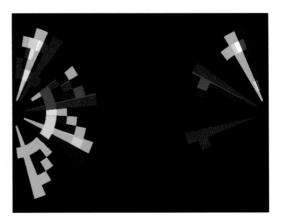

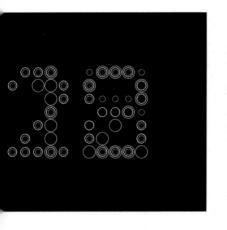

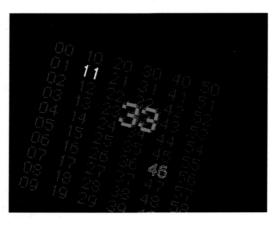

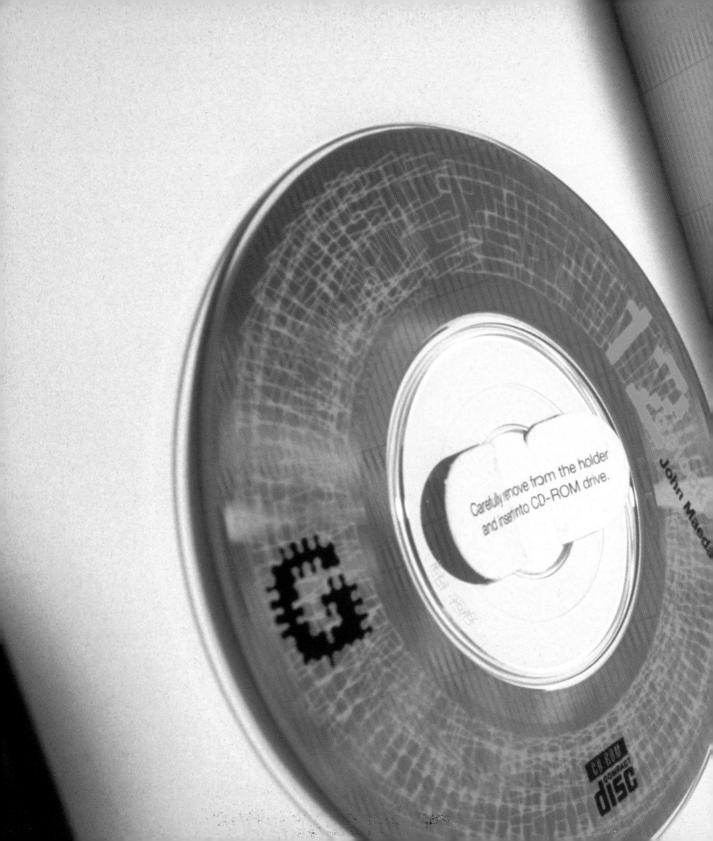

For a series of print pieces using the colored marker caps for the arts-supply manufacturer .Too Corporation, I wanted to demonstrate the real-time conversion of any video imagery into .Too marker caps. This concept was used for .Too's Graphic Arts Message '96 event.

.Too

.Too

This project was conceived for Sony Tokyo Design Center as realized with Yumie Sonoda. Each physical object used Sony's product semantics to communicate a non-standard usage of the object.

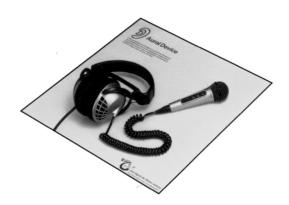

A microphone attached to headphones—speak into the microphone, and your voice is converted into music.

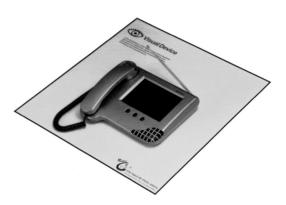

A video-camera that can be picked up and strapped onto the hand, with a viewfinder that can be spoken into to generate a set of gentle pulses on your palm depending to your voice.

_

ball f A-2 The Dec 10

Successive variations on a grid of spinning forms illustrate the absence of a single default scale on the computer.

There are few creative luxuries in life greater than non-commercial projects. The freedom to experiment responsibly within a completely irresponsible envelope of expression is by no means easy. The intellectual challenges of solving a client's problems are indeed formidable and should not be belittled. But when the world's greatest problem-solver runs out of other people's problems to solve, she realizes that her own problems are not only the most difficult to articulate.

Black and white poles are upset with a brush of the cursor to reveal a hidden color that appears momentarily. The spatially discrete train of dots contrasts lightly with the smooth shifts of color.

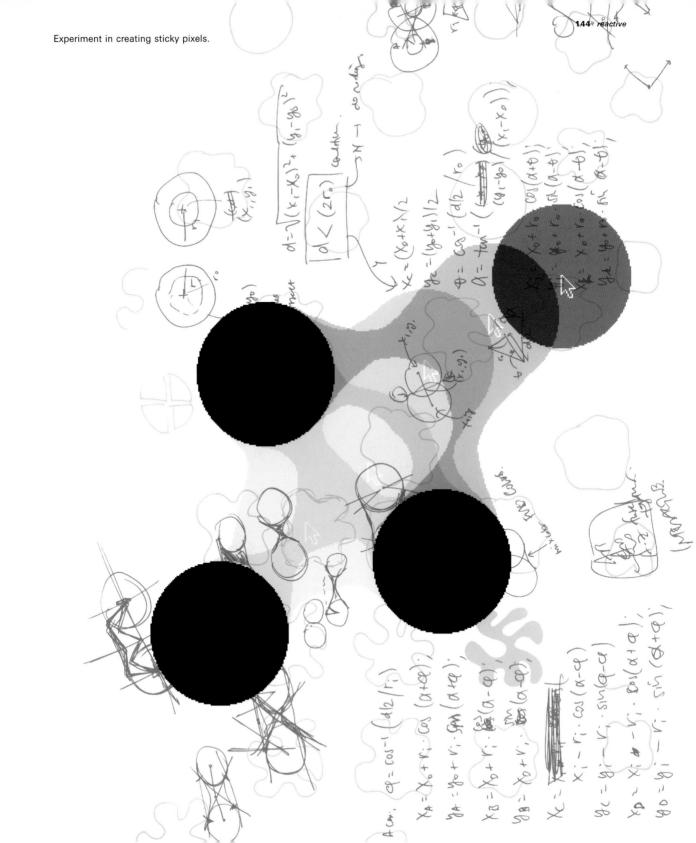

5 paper I would like to say that I never leave the house in the morning without a pen, but sometimes I do make this disastrous mistake. Once I realize my error, the feeling I get is not unlike what a drug addiction must be like. "Must have pen!" is all that runs through my mind as I check my pockets over and over, hoping it might appear by sheer will. The second I satisfy my fix with pen in hand, another fundamental need wells up with equal force, "Must have paper!" However, I find that the paper addiction is much easier to satisfy than the pen addiction because in the worst case I can write on a scrap piece of paper from my wallet or the interior of my car, on a napkin or placemat, or, as a last resort, my hands (although recently I have discovered that, depending upon the season, the abdomen can be a flatter surface). To most of us, paper is more a state of mind than an object—it is a place outside our minds to think and reflect. It is unfortunate that the display technology of the computer we use has been designed around the flat, rectangular metaphor of machine-cut paper, instead of the unflat, unrectangular, and infinitely multidimensional space of pure computation.

A sheet of paper stimulates a visual dialogue between your hand and mind. The subject can be absolutely anything, which can make a lifeless sheet of paper the most intimidating of companions. Eventually the two of you hit it off and conversation flows freely. From childhood memories to management theory to shopping habits, there is no end to what thoughts you might share. And just when a mutual understanding starts to form, you find that there is no more room to carry it even further.

The miracle of adhesives provides a reliable method of escape from any physical confine.

Out of room? Simply tack on another to keep on going. Need more room?

Tack on another, and so on.

The make-up of a book relies heavily upon liberal amounts of adhesive. There is the glue that holds the crevice in the middle together, and the conceptual glue that connects each page to the next.

When we become dissatisfied with the amount of space our computer screen provides, the natural reaction is simply to extend the size of the screen with more screens.

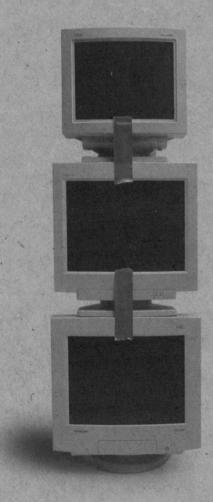

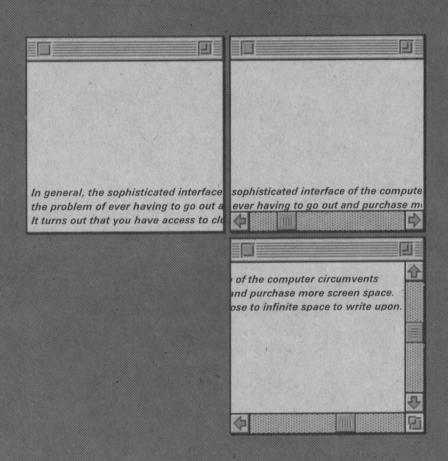

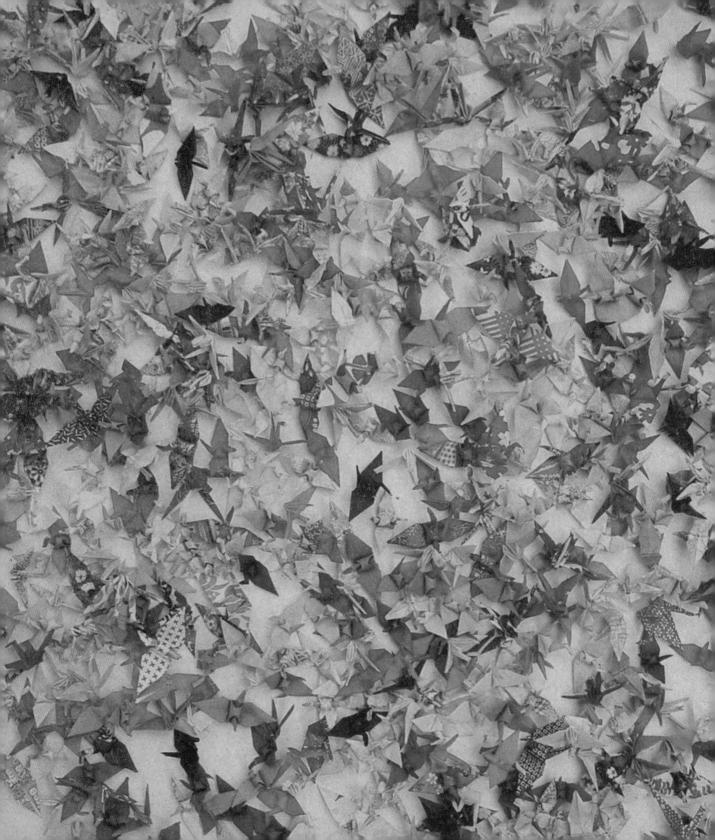

In Japanese the words paper and god (more accurately, "spirit") are phonetically equivalent. It is an unsurprising coincidence that origami, the art of folding paper, bonds an animate spirit, such as a crane, to the physical form of paper without any extraneous synthetic additions or interruptions.

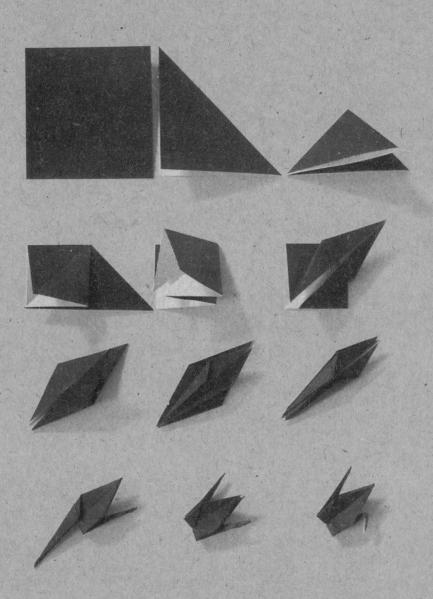

We can respond to this one-upmanship of paper by trying to similarly fold a computer screen with old-fashioned brute force.

This would be an unfortunate mistake, preventing us from sensing the real material inside the computer—the program—that is continually folding, collapsing, growing, and evolving at unimaginable speeds.

(retui -DAYON-· 101024 100 - = 0; public inde · = new - - last obj String nasi-- =null; int groupc = 0.mth. "olor.whit ~ 0, overpc = 0; double Dock. The so, int graye of uperfuull, tlateg 'root Game :0= dontitycumgem; Communication of the state of t "group=null. The state of the s Al=null | int n 190this I'M element Sold Charles Homenth Winter to double dx zaving O RES OJ JUNOUUE OUT OF THE THINDS Appropriate was double hell And Projection CATITY: IF (10.5elp) | willement | void clearl) (syst.tonnum XXX: A THE THE WAY CHEM IS HE 1:1++1 (lobi lo = (lobi) elem sgroup(); my = null; bile voich new lategithm, "

1

LEVILLING GERVICES

Today the computer is used for little more than as a digitally powered brush for painting numbers instead of real pigment.

No matter how many technologies might be developed to augment the operation of our bodies and mind, it is hard to imagine a better starting point for thought than a blank sheet of paper. Its honesty and reliability naturally provoke excitement for the next encounter.

6 *static* At the moment printed images do not have the privilege of changing at rapid speeds. On the other hand, on-screen digital imagery cannot currently be realized at very high resolutions. In the future we can imagine that digital will be sharp and print will be in motion. While we await the day when paper will literally run away from us, we can examine the unique properties of each material in their natural form. Printed images look most natural on paper; digitally motivated images look best on the computer. It seems odd when people describe a printed piece as being a "digital print." By nature of their construction, digitally originated images cannot be so trivially realized in print; an analogy would be to call a photograph or illustration of a building an "architectural print." Naturally the print has representational and sometimes artistic value, but we usually assign superior value to the building being depicted, unless there is something to hide, such as a poor facade or perspective. In print such inadequacies can conveniently be placed or cropped out of view. A digital print by comparison should be thought of as illusory—a mere sliver or minor facet of what really exists in the digital realm.

I was given my first print commission by Michio Iwaki to celebrate thirty years of Shiseido advertising films. I chose an abstract method of visualization in which the image would represent those thirty years of commercials in the visual domain in a non-intuitive way. Three data sources were used: Visuals, audio, and the film titles were to be mixed into the image. So began my experiments in print.

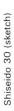

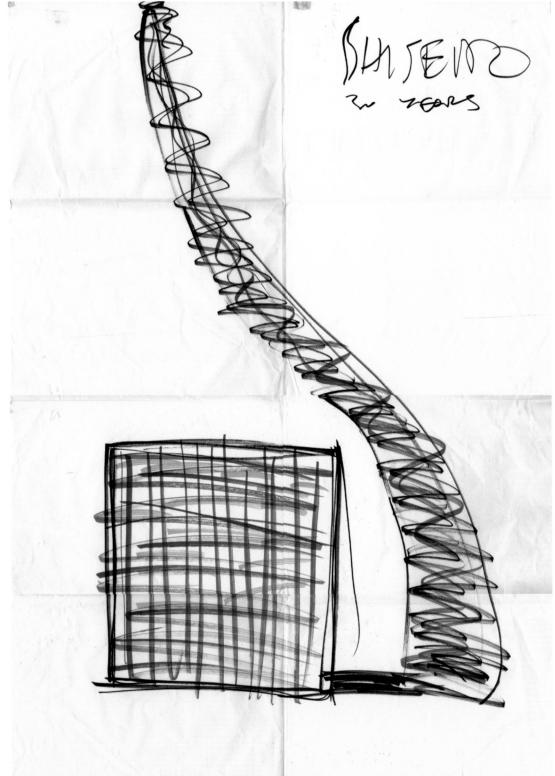

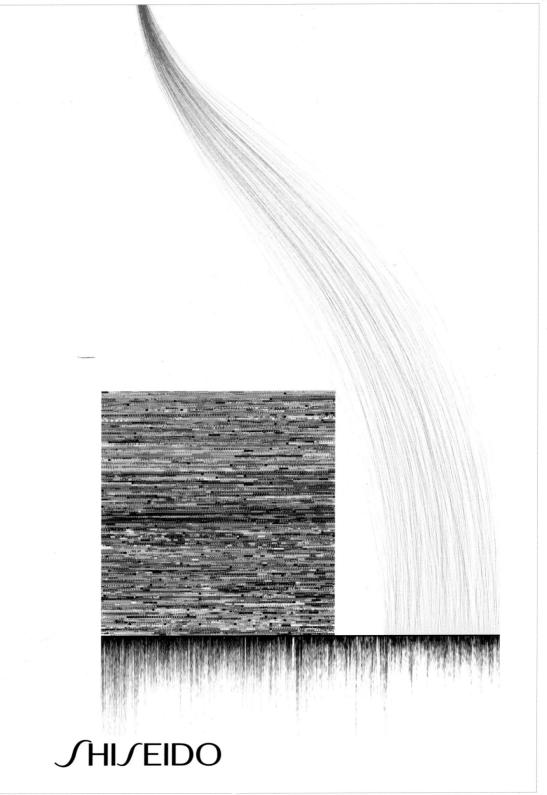

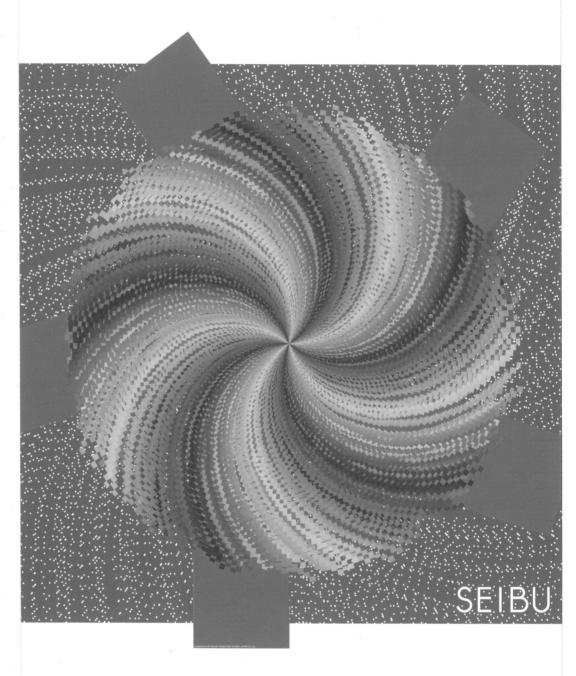

LIVERPOOL JOP" MOORES UNIVERSITY
LEARNING SERVICES

Flags, 1 Color

Arrangement of flags based upon a simple flag grammar.

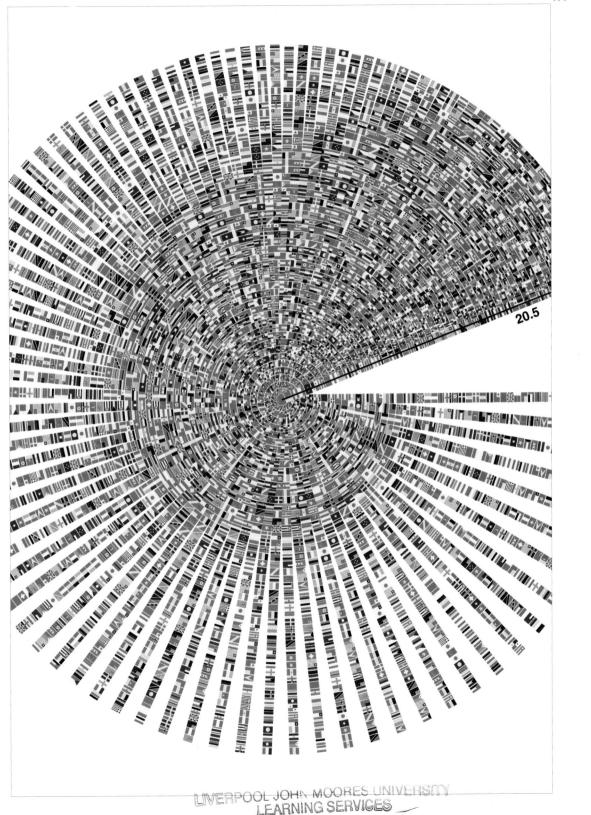

																											_		
		_						H			H			Ì														-	
V				-																						,		•	
						100																							
•	•	10		•	•	•																							
-		0			•		8				0						•	0	•	•	•	•		•	•				
•	•	•	•	•		•	•	0	•	•		•	8	0	•	•	•	•	•	•		•	•	•	•	•	•	•	•
			8	В				8			0	0	0		0				•		=	8			16		•		•
*	No.	*	*		Ž.	*	*	*	猴	W.	*	*	*			後	*	*	*	*	×	*	Q.	14	養	×	***	No.	被
THE STATE OF	禁	Ů.	蹇	N.	逍	***	*	藥	继	鄉	龒	S.	*	*	徽	S.	*	鉄	W	林	鬱	*	· en	\$	*		雅	*	·
*	熊	Ç.	M	袋		糖	藥	SQ.	*	s.		*	*		*	彩	10		, the		戀	100	*	100	15.	W.	豫	ile.	*
		·		*	6000 (1) (1)	40.)/E		30100 3000 30	AMATO STATES	#80.00 20 K 1 20 K 1 200.00	dhatar - ara - ara - ara	20.74	×	920 920 930	Marie and American		*	981 1867	38.			STATES THE STATES	450000 010000 010000 010000	2000 1811 1811	3.		8134 8136 8136 8136 8136 8136 8136 8136 8136	1000 104 104 104 104 104 104 104 104 104	2000K 2000K 2000K 2000K 2000K
		110000	900001 110001 5-11001	響響	64 × 64 × 64 × 64 × 64 × 64 × 64 × 64 ×		劉	35 - 100 30 - 100 30 - 100	* 5	×	-				4					-			2000 C	*	*			****	1000 1000 1000
	180	艦		M	N	M				E		7100	ino:	38	594.5 574.5 576.5	1000	101000 201000 201000 201000	3. S.	188	S					MI	6			
•	•	•	•			•																•	•	•		•			
											8				•		•	•	•	•									
							•	=	•	•	•	•	•	-	•	=		=											=
						•			臟	×		No. of Street,	×	5005 5205	38			NAME NAME						*	10.00		21		
									-			鼷										100				X			See See
						Sense Sense		10000 10000 10000 10000				See		SSEC SEC			200	200E	2000							1000		Dist	
			1000 H					200				1242												5555					
	1112			1012						1022	200	2002	1215					2201			100E			ene		191010	2000		
	1000	3334		1000	•	•	2000			5351								**************************************	•		****					*		***	
	\bigcirc				_	0	_	_	_	○	_	0			_	_			•	_	-				_	_	0		0
0			Ø		_	_	\phi	_		_		_	_	_	_	_		_	-	_	_		•		_		0		
					_			_																	_				
								_			_				_	_		_	_										

Syncolor Left

Promotion for Grapac's color-proofing technology.

Syncolor Right

A pattern of lines derived from the structure of the Sony symbol for SonyDrive.

Sony Xmas

Arrangement of Sony products in a fan structure for SonyDrive.

Sony Fan

SONY

Sony Mountain

Six hundred Sony products arranged in a landscape for SIGGRAPH 95 in Los Angeles.

グラフィックアーツメッセージ '96 大阪 5月23日(木) 10:00~19:00 (受付終了18:00) 24日(金) 10:00~17:00 (受付終了16:00) 会場/マイドームおおさか3F Too 総合展示会 Graphic Arts Message '96 8888888

drawinkeire (x,y,r, maxlw, mm lw) hia

EYES: one type (do+)

EYETROWN. (S)

house that

Mourros (x)

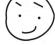

15版

An activity with my children that grew into a challenge. \rightarrow

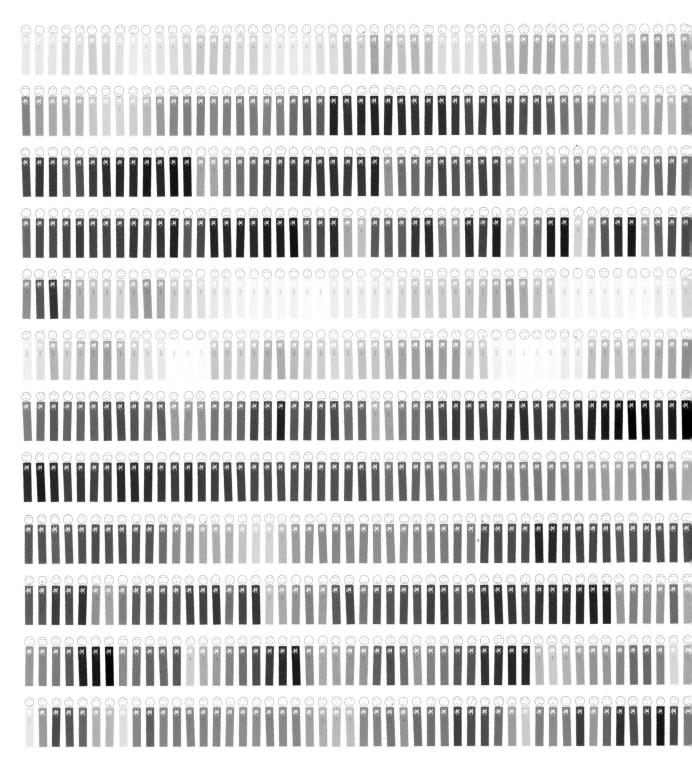

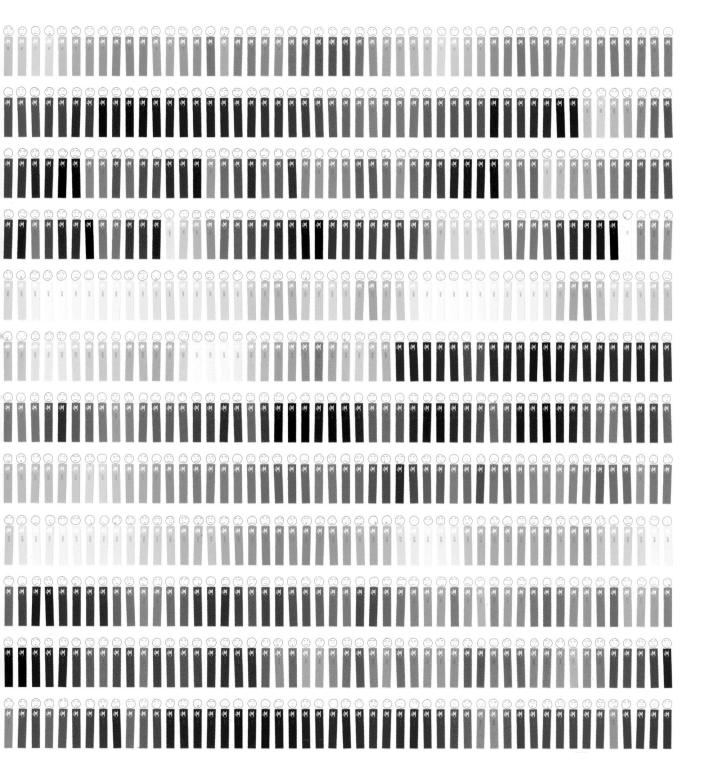

Japanese color chips arranged as a group photo.

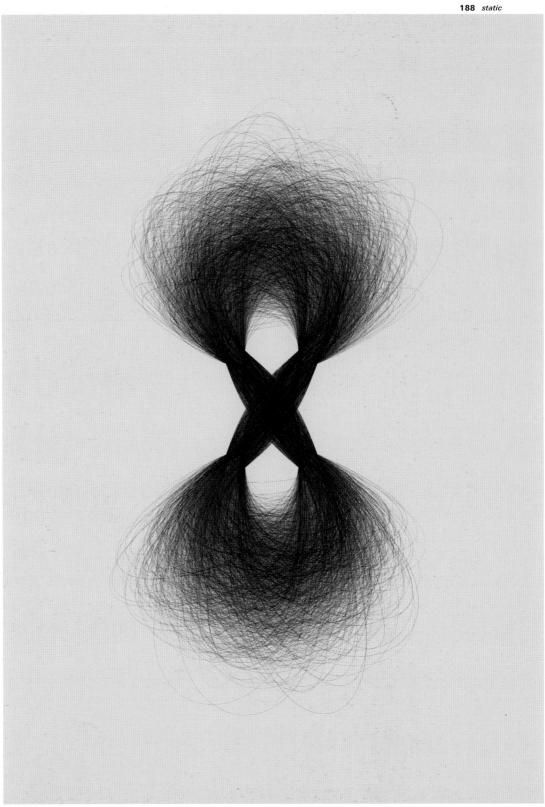

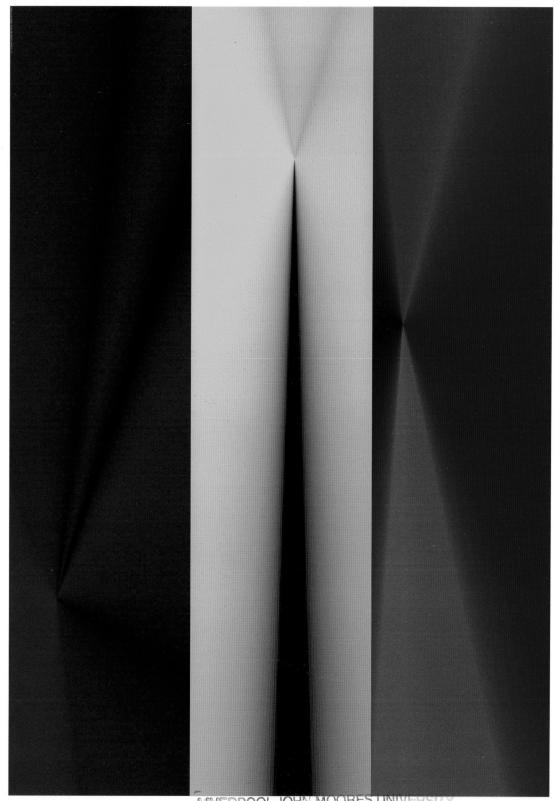

LIVERPOOL JOHN MOORES UNIVERSITY

Density diagram of a cross.

Shape Study 1

Density diagram of a diamond.

Density diagram of a rectangle.

Shape Study 3

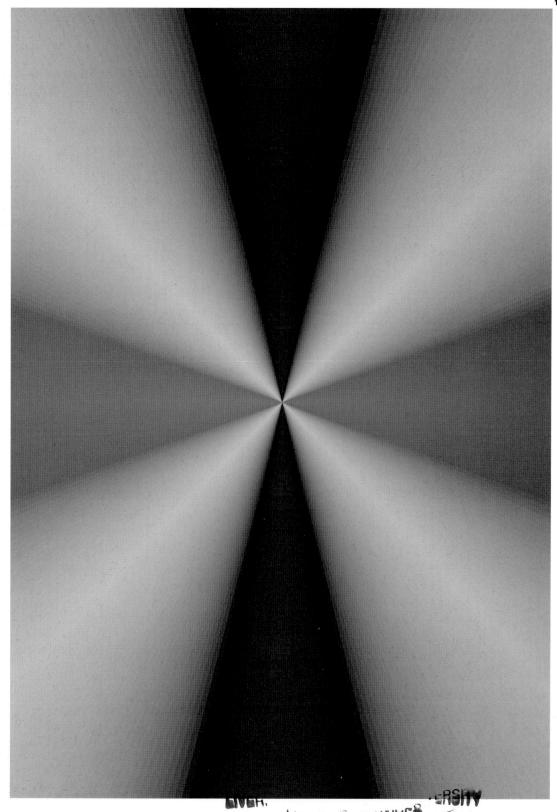

Density diagram of a parallelogram.

Shape Study 5

Density diagram of an ellipse.

Relationship in shape and color as one node.

Tomoe 1

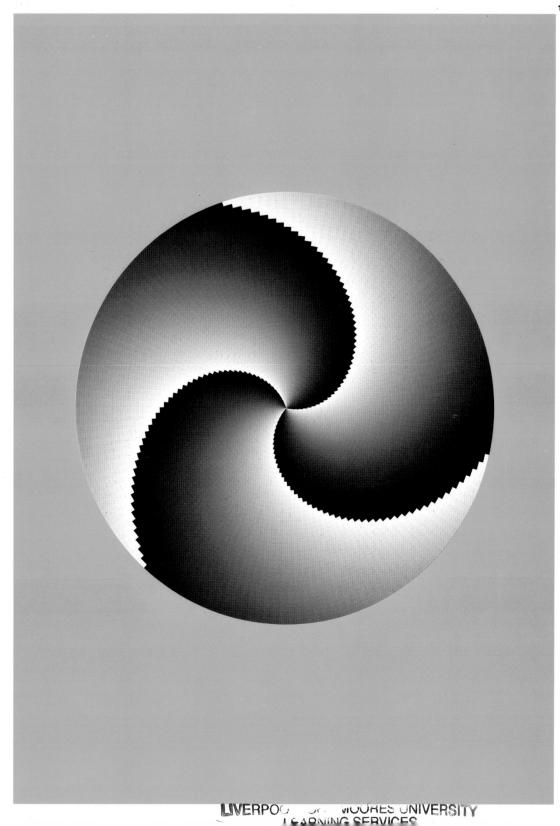

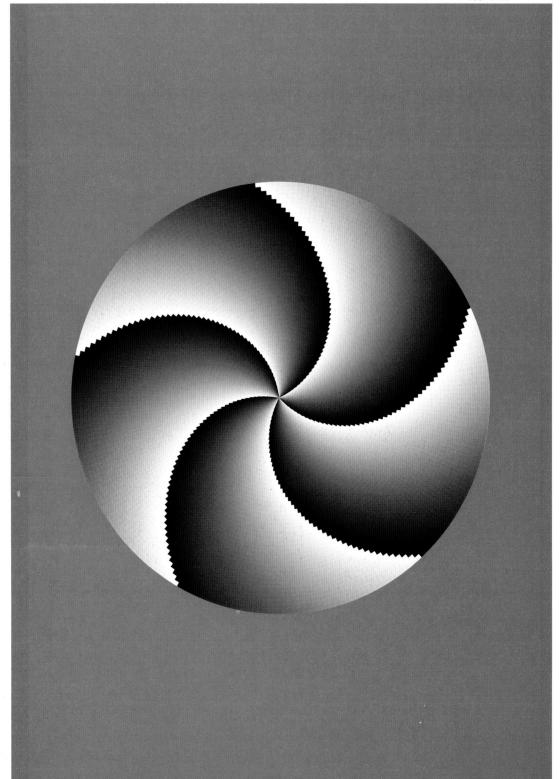

Relationship in shape and color as five nodes.

Tomoe 3

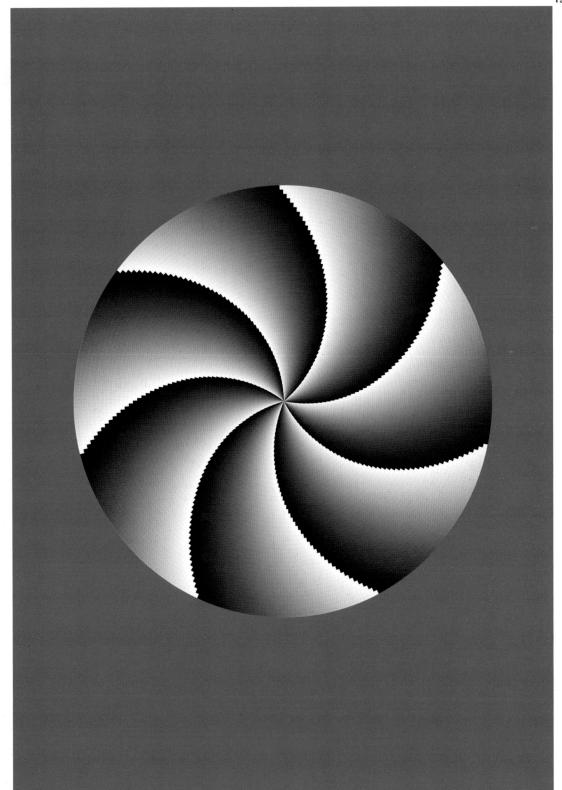

Relationship in shape and color as seven nodes.

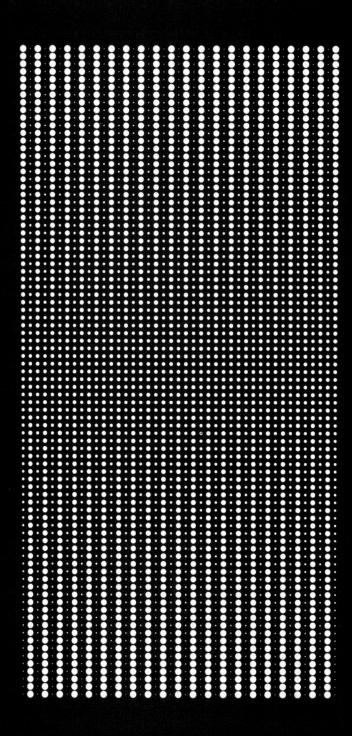

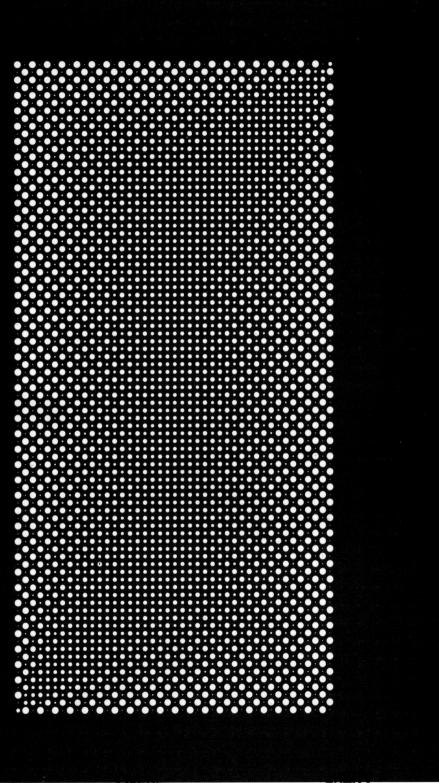

ELAINING DENVILES

Chase toward center.

Dots 3

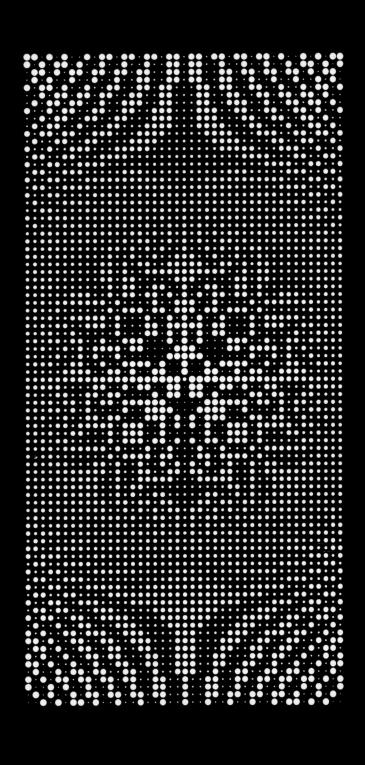

LEARNING SERVICES

The second secon neretrantitien die erderetranteretranteretranteretranteretranteretranteretranteretranteretranteretranteretra nten populinge, alge lagicia aggregativa (na taga aggregativa) de la particular de la company de la granda de

206 static sevently willow sevently, can zero magents eightly vellow eightly, can zero magents einetly vellow eightly, can zero magents einetly vellow eightly, can zero magents einetly vellow eightly, can zero magents evently vellow eightly, can zero magents evently vellow eightly, can zero magents evently vellow eightly vellow eightly, can zero magents evently vellow eightly vellow eightly vellow eightly, can zero magents evently vellow eightly vellow cyan fifty magents one hundred yellow one hundred, cyan fifty magents one hundred yellow one hundred yellow one hundred yellow one hundred yellow one hundred. Cyan niety magents one hundred yellow one hundred yellow one hundred yellow one hundred. Cyan niety magents one hundred yellow one hundred yellow one hundred. Cyan niety magents one hundred yellow one hundred. ro magenta forty realow frity, wan zero magenta buty-eight yellow sixty, cyan zero magenta fifty-six yellow seventy, cyan zero magent idred, cyan ten magenta eighty-two yellow one hundred, cyan ten magenta seventy-four yellow ninety, cyan ten magenta sixty-six ye thirty wight the property of t there there is no fifty aspects for seight yellow sixty, you thirty magents asked with the seight, you thirty magents asked with the seight, you thirty magents asked with the seight, you fifty magents asked with the seight yellow on bundred, you asked magent asked with the seight yellow on bundred, you asked with yellow on bundred, you asked yellow sighty, you seventy magents asked yellow eighty, you seventy magents asked yellow on bundred, you asked yellow on bundred, you make yellow on bundred, you thirty magent state, are thirty magent fifty was a lighty, you thirty magent fifty edget, one bundred, cyan fifty magents seventy solice one bundred, cyan fifty magents sixty four yellow seventy, you sixty magents sixty four yellow seventy, you seventy magents sixty four yellow seventy, cyan seventy magents sixty four yellow seventy, cyan seventy magents seventy magents sixty four yellow seventy, cyan seventy magents sixty four yellow seventy, cyan seventy magents seventy magents sixty four yellow seventy magents a sixty four yellow seventy, cyan seventy magents a sixty four yellow one hundred, yellow seventy magents a sixty four yellow seventy magents a sixty four yellow seventy magents a sixty four yellow one hundred. e fifty magants sixty yellow one hundred, cyan fifty magant fifty six yellow eight; year fifty magants sixty year sixty, you sixty magants sixty who yellow seventy, cyan eventy-six yellow one hundred, cyan eighty magants eighty-four yellow one hundred, cyan fifty-six yellow eighty-four yell hirty which sixty, was thirty magnife thirty willow eightly, was thirty magnife thirty willow one hundred, cyan fifty magnife fifty willow eightly, cyan seventy willow seventy, cyan eightly magnife eightly willow one hundred, cyan ninety magnife seventy willow one hundred, cyan eightly willow one hundred, cyan ninety magnife n one hundred, can sixty magents fifty yellow one hundred, cyan fifty-six magents seventy-six magents seventywho are hundred, can severty magnets fifty vilon one hundred, can sixty two magnets there is a starty can say that the severty magnets there is a starty can say that magnets severty vilon one hundred, can severty vilo thirty sales which seems to the second of the the secon magents zero yellow ninety, cyan eighty magents zero yellow one hundred, cyan eighty-two magents no yellow one hundred, cyan eighty-two magents no yellow one hundred, cyan seventy-four magy yellow seventy, yell fifty magents ten yellow seventy. seventy, of thy night ten seventy that the seventy that t magents zero yellow one hundred, cyan one bundred magents ten yellow one hundred, cyan ninety magents ten yellow ninety, cyan eighty ty modes the new fifty.

The state of the st seventy are a lifty six, we nighty agrees are with skey four, you hinkly regards zero which skey four the seventy two, you one hundred major are not seventy two, you one hundred major are not seventy two, you one hundred major are not seventy two, you may not seventy two, you one hundred major are not seventy two, you may not seventy two you may not seventy two. You may not seventy two you may not seventy the yo magents thirty vellow seventy, cyan one hundred magents thirty yellow eight, cyan sets the magent thirty yellow seventy. Cyan one hundred magents thirty yellow seventy-four, cyan eighty magents seventy-four, cyan is ast y magents thirty yellow seventy-eight, cyan eighty willow seventy-eight, cyan eighty magents seventy-eight, cyan eighty willow seventy-eight, cyan eighty magents seventy-eight, cyan eighty willow seventy-eight, cyan eighty magents seventy-eight, cyan eighty willow seventy-eight, cyan eighty will evently as a recommendation of the second se thirty yellow seventy-two, cyan one hundred magents fifty yellow eighty, cyan eighty magents fifty wellow sixty eighty selections sixty eight yellow sixty magents fifty yellow.

wwnty-six, cyan one hundred magents seventy yellow eighty-eight, cyan one hundred magents eighty yellow ninety-two, cyan one hundred magents ai ty supress zero velosi thirty-two, cun ninety velosi zero velosi thirty-siz, cyan one hundred magenta zero velosi thirty-two, cun ninety velosi zero velosi thirty-siz, cyan one hundred magenta zero velosi tori, cyan ninety magenta zero velosi tori, cyan one hundred magenta zero velosi tori, cyan ninety magenta zero velo whose thrity-eight, can sevently regions ten video thirty four, as natty spaces ten video thirty.

If the space of the spa zero pellow eighteen, cyan one hundred majorniz zero gellow twenty, cyan one hundred majorniz zero gellow twenty sight, cyan one hundred majorniz zero gellow twenty four, cyan seventy majordiz ten gellow twenty-sight, cyan one hundred majorniz zero gellow twenty thirty two year sixty eighty magents fifty yellow fifty-six, year sixty magents fifty yellow fifty-five, year one hundred magents eighty yellow eighty-four, year one hundred mag to, cyn eighty magent zero villow zero, cyn ninety magent zero villon zero, cyn one hundred magent zero villon zero, cyn one seventy magent ben villon ten, and the ton the contract of the co hundred magenta ten yellow ten, cyan ninety magenta ten yellow ten, cyan eighty m hundred magenta thirty vellow thirty, cyan one hundred magenta fifty yellow fifty, cyan eighty magenta fifty yellow fifty, cyan one hundred magenta fifty yellow fifty, cyan one hundred magenta fifty yellow fifty, cyan one hundred magenta eighty yellow fifty. veloc zero, cyan one hundred magenta twenty velox zero, cyan one hundred magenta twenty valox zero, cyan eighty magenta sixteen yellox zero, cyan eighty magenta zixteen yellox zero, cyan eighty magenta itty, cyan eighty magenta forty vellow thirty, cyan one hundred magenta forty-four vellow thirty, cyan one hundred magenta sixty yellow fifty, cyan eighty magenta seventy, cyan one hundred magenta seventy. recognition twenty yellow zero, cyan sixty respons twenty-four yellow zero, cyan seventy magenta to yellow zero, cyan one hundred magenta forty-six yellow ten, cyan pinety magenta forty-two vegents twenty-six yellow. twenty-eight yellow zero, cyan eighty magenta thirty-two yellow zero, cyan ninety magenta thirty-six yellow zero, cyan one hundred flow ten, cyan eighty magenta thirty-eight vellow ten. cyan seventy magenta thirty-four yellow ten, cyan sixty magenta thirty wellow ten. it. therety from a control of the co cycle one maladree majorité insigert sour ventor maney.

The proposition of the propositi seventy-two yellow thirty, cyan one hundred magenta eighty yellow fifty, cyan eighty magenta sixty-eight yellow fifty, cyan sixty magenta fifty-six yellow fifty, cyan one hundred magenta eighty-eight yellow seventy, cyan one hundred magenta eighty-eight yellow seventy, cyan one hundred magenta eighty-eight yellow seventy. venty majors. (Hyvais venty majors a stry four pilot sero, you selly majors a stry four pilot sero, you sharp majors a stry majors of the service of the ser special seventy-four velow tea, cyan eighty magenta sixty-six yellow ten, cyan seventy magenta fifty velow ten, cyan sixty magenta fifty velow ten, cyan fifty magenta fifty welow ten, cyan fifty magenta fifty velow ten, cyan fifty velow ten, cyan fifty magenta fifty velow ten, cyan fifty magenta fifty velow ten, cyan fifty magenta fifty velow ten, cyan fifty velow t zero, cyan eighty magenta eighty yellow zero, cyan ninety magenta ninety yellow zero, cyan one hundred magenta one hundred yellow zero, cyan one hundred magenta one hundred yellow zero, cyan one hundred magenta one hundred wellow zero, cyan one hundred magenta one hundred magenta one hundred magenta one hundred wellow zero, cyan seventy yellow ten, cyan seventy magenta seventy yellow ten, cyan sev nta one hundred yellow fifty, yan eighty magenta eighty vellon fifty, yan eist yan eighty magenta one hundred yellow fifty, yan one hundred magenta one hundred yellow eighty, cyan one hundred magenta one hundred yellow eighty, cyan one hundred magenta one hundred yellow eighty, cyan one hundred magenta one hundred yellow eighty. eighty magenta eighty yellow thirty, cyan one hundred magenta one hundred yellow thirty, cyan one hundred seventy yellow sixty, cyan eighty magenta eighty yellow seventy, cyan one hundred magenta one hundred the state of the s therefore the control of the control the type of ty yellow ten, cyan thirty-four majorits fifty veliciou ten, cyan twenty a majorita histy which with the property of the same and the same with the same and the sam to,

thirty, cyan sixty magenta eighty yellow shirty, cyan seventy-two magenta one hundred yellow thirty, cyan eighty magenta one hundred yellow fifty, cyan sixtysix magenta seventy yellow sixty, cyan seventy-six magenta eighty yellow seventy, cyan eighty-eight magenta one hundred yellow seventy, cyan ninety-two magenta fifty yellow zero, chan twenty-four magents sixty yellow zero, cyan twenty-eight magent cyan forty-six magenta one hundred yellow ten, cyan forty-two magenta ninety yellow ten, enty vollow zero, cyan thirty-two magenta eighty yellow zero, cyan thirty-six magenta ninety yellow zero, cyan forty magenta one hundred yellow zero, thirty-sight magenta eighty yellow ten, cyan thirty-four magenta seventy yellow ten, cyan thirty-four magenta yellow ten, cyan thirt , you fifty magnes eighty writes theirty, your fifty-eight magness one hundred vallow thirty, you asked two inagness eighty value fifty and the property value in the property value value in the property value in the prop w mentry who zero, can alakteen magenta eighty yellow zero, can eighteen magenta ninety vellow zero, can twenty magenta one hundred yellow zero, can alakteen magenta eighty yellow zero, can twenty magenta eighty vellow zero, can twenty eighty rty, cyan forty-feur magents one hundred yellow thirty, cyan sixty magents one hundred yellow fifty, year fifty-six magents eighty yellow fifty, year fifty-six magents eighty yellow fifty, year fifty-two magents sixty yellow fifty, cyan fifty-two magents sixty yellow fifty yellow fifty, cyan fifty-two magents sixty yellow fifty yellow fifty year sixty-two magents seventy yellow sixty, cyan fifty-two magents sixty yellow fifty year fifty-two magents sixty fifty-two magents as yellow fifty yellow fifty yellow fifty yellow fifty yellow fifty yellow fifty year fifty-two magents as yellow fifty yellow fifty year fifty-two magents as yellow fifty yellow fifty year fifty-two magents as yellow fifty year fifty-two mage eighty yellow zero, cyan zero magenta ninety yellow zero, cyan zero magenta one hundred yellow zero, cyan ten mage and a sighty yellow thirty, can thirty magenta one hundred yellow thirty, cyan fifty magenta one hundred yellow fifty, cyan fifty magenta eighty yellow and the second of number yellow mercy as a remaining a remai thirty magents one hundred vallow forty-four, cyan fifty magents one hundred vallow sixty, cyan fifty magents eighty vallow fifty-six, cyan fifty magents sixty sixth seventy magents sixty yates seventy vallow sixty-two, cyan seventy magents seventy vallow sixty-two, cyan seventy magents one hundred vallow seventy-two, cyan seventy magents one hundred vallow seventy-two, cyan seventy magents one hundred vallow seventy-two, cyan seventy magents one hundred vallow seventy-six, cyan seventy magents one hundred vallow seventy-two, cyan seventy magents one hundred vallow seventy-six, cyan seven zero magenta eighty yellow thirty-two, cyan zero magenta ninety vollow thirty-sight, cyan zero magenta one hundred ye yellow thirty-sight, cyan zero magenta ninety vollow thirty-sight, cyan ten magenta seventy pellow thirty-four, cyan ten magenta sixty yellow thirty-four ten magenta sixty yellow thirty-four cyan ten magenta yellow thirty-four cya eight, you fifty magents one hundred yellow elgeby two, you fifty magents eighty yellow sixty-two, you fifty magents eighty yellow sixty who will be a seventy on the seventy yellow sixty who will be a seventy magent a sighty yellow sixty who will be a seventy magent a sighty yellow sixty yellow sixty who will be a seventy magent a sighty yellow sixty yellow sixty who will be a seventy magent a sighty yellow sixty yell cycle zero magnital ninety yellow fifty-four, cycle zero magnita n seventy sellow tory-sis, yet ten majoris sixty yees to the seventy sellow tory-eight, bundred yellow eighty, year fifty majoris yet sellow fifty-eight, year eighty eight years sixty sellow fifty-eis, year s thirty twenty fluir yellow fifty-six, cyan zero magenta eighty yellow sixty-four, cyan zero magenta ninety yellow xty-four, cyan ten magenta eighty yellow sixty-six, cyan ten magenta seventy yellow fifty-eight, seventy-two, cyan zero magenta one hundred yellow eighty, cyan zero magenta sixty yellow forty-eight, cyan zero magenta seventy-two, cyan zero magenta one hundred yellow eighty, cyan zero magenta one hundred yellow eighty-two cyan ten magenta ninety yellow severon ten magenta sixty yellow fifty, yen ten magent fifty worden brow two. and the majorits skelly veloc lifty, yet he majorits skelly veloc lifty, yet he majorits skelly veloc lifty, yet he majorits skelly veloc lifty four, cyan thirty majorits skelly veloc seventy, cyan thirty majorits one hundred velow eighty-sks, cyan fifty majorits one hundred velow minety-four, cyan fifty majorits skelly veloc seventy four, cyan fifty majorits skelly veloc seventy majorits one hundred velow minety-skyll. Even seventy majorits one hundred veloc minety-skyll. Even seventy majorits one hundred veloc minety-skyll. Even seventy majorits one hundred veloc minety-skyll. Even minety majorits one hundred veloc minety-skyll. Even minety majorits one hundred veloc minety-skyll. Even minety majorits skyll veloc seventy majorits one hundred veloc minety-skyll. Even minety majorits one hundred veloc minety-skyll. Even minety majorits skyll veloc seventy majorits one hundred veloc minety-skyll veloc seventy majorits skyll vel

Lithing to grant where the second	
	and that are all the continue to the factor of the factor

#include "ailib h" #include "Mountain.h" void invjustmori(void); void justmori(void); void justmoriS(void); void moriE(void); void moriE(v 2.3 Th\n0 Tq\n3 Tg\n0 0 T\n0 Tc\n0 T nsc. cubedim. gg. gg2.sc2: int iiw = 176/4. iih = 211/4; double iw = iiw, ih = iih. dy; double nsc2; gg=95; gg2=9; mt[0]=0; mt[1]=mc[0]+mc[1]; mt[2]=mt[1]+mc[2]; mt[3]=mt[2]+mc[3]; aiopen("mori9.ai"); aiopen("mori9mw.0); justmori(); aigrestore(); aigrestore(); aigrestore(); aigrestore(); aisetgrayF(0); aisetg nsc. cubed im. gg. gg2.sc2: int. iiw = 176. iih = 217. double iw = iiw, ih = iih. dy; double dd=0; gg=.95; gg2=.9; mt[0]=0; mt[1]=mc[0]+mc[1]; mt[2]=mt[1]+mc[2]; mt[3]=mt[2]+mc[3]; aiopen("mori9.ai"); aigsave(); aitransfer for the substitution of the substitutionj++1 | aigsave(); aitranslate(0, nsc*mw*[double)(j+1)|4.]; aiscale(nsc,nsc); $for(i=0.i\le|w;i++1|$ | double (x,ty, int kk = i%4; aigsave(); aitranslate(mw*(ii4),0); aitranslate(tx=mt[kk]+mc[(kk]>=1?(kk]+1:(kk)]/2.ty=mh(2); airranslate(nsc); | #include \(\left\) static void main \(\text{7}() \) | double bd r = 10; double w = 728-bdr*2, h = 1030-bdr*2; double mw=1000, h = 222.645; double sc=w/mw; double mw2=sc*mw, h = 10; double sc=s(1000], h = 10; hfread(buf,iiw*lih,sizeof(char),fp); fclose(fp); gg=95; gg2=9; mt[0]=0; mt[1]=mc[0]+mc[1]; mt[2]=mt[1]+mc[2]; mt[3]=mt[2]+mc[3]; aiopen("mori7.ai"); aigsave(); aitranslate(bdr,bdr); cubedim=wiiw; printf("max rows"); aiopen("mori7.ai"); aiopen("mor [c = buf[(j)-liw+i]; aigsave(); aitranslate(mw*(i/4),0); if (!c) moric(i%4,0); aigrestore(); aigrestore(); aigrestore(); aitranslate(0,h-mh2); aisetgrayF(0); aiscale(sc.sc); justmori(); aigrestore(); aitranslate(0,h-mh2); aigrestore(); aitranslat segs[1000],poss[1000]; int npts=250.i; double mt[4]; double nsc.gg.gg2.sc2; gg=95; yg2=9; mt[0]=0; mt[1]=mc[0]+mc[1]; mt[2]=mt[1]+mc[2]; mt[3]=mt[2]+mc[3]; aiopenf mon7.ai]; aigsave(j; aitranslate(bdr.bdr), airotate(i); nsc = (1-(i)/360.+1/mxsc)*mxsc; aiscale(nsc,nsc); aitranslate((-mt[0]-mc[0]/2),(-mh/2)); moric(0,fl); moric(0,fl); aigrestore(); \ ///// aitranslate(0,h-mh/2); aiscale(sc,sc); aisetgrayF(0); moric(1,0); moric(2,0); moric($bdr'2;\ double\ mw=1000,\ mh=222.645;\ double\ sc=w/mw,newsc;\ double\ mw2=sc'mw,mh2=sc'mh;\ int\ npts=100,ij;\ double\ nseg,x1,y1,x2,y2;\ int\ ff=1;\ double\ mt[4];\ doubl$ double x.y; aigsave(); aisetgrayF((double)i/(nseg-1)); aisetgrayS(0+((double)i/(nseg-1)*yg2+(1-gy))); x=i*(x2-x1)/(nseg-1)+x1; y=h-mh2+i*(y2-y1)/(nseg-1); aitranslate(x.y); aiscale(sc.sc); |/|/ ssc=(f-(double)i/(nseg-1)*f(-(double)i/(nseg-1))*f(-(doubl $double \ x,y,tx,ty,\ aigsave();\ aisetgrayF((double)i/(nseg-1)),\ aisetgrayF((double)i/(nseg-1)),\ aisetgrayF((double)i/(nseg-1)),\ x=x1:/ii^*(x2\cdotx1)/(nseg-1)+x1;\ y=h-mh2+i^*(y2\cdoty1)/(nseg-1);\ x=0;\ aitranslate(0,y);\ aisetgrayF((double)i/(nseg-1)),\ aisetgrayF((double)i/(nseg-1)),\ x=x1:/ii^*(x2\cdotx1)/(nseg-1)+x1;\ y=h-mh2+i^*(y2\cdoty1)/(nseg-1);\ x=x1:/ii^*(x2\cdotx1)/(nseg-1)+x1;\ y=h-mh2+i^*(y2\cdoty1)/(nseg-1)+x1;\ y=h-mh2+i^*(y2\cdoty1)/(ns$ moric(2,ff), $aigrestore(i,:] \times 1=mt[3]$ 'sc.y1=h-mh2, x2=x1, y2=0-(mh2-mh2-minsc)/2; for(i=nseg-1;i>0;i-) [double x,y, aigsave(i); aisetgrayF((double)i/(nseg-1)), aisetgrayF((double)i/(nseg-1))mh/2)]; /// moric(3,ff); aigrestore(); } aigsave(); aitranslate(0,h-mh2); aiscale(sc,sc); aisetgrayF(0); justmori(); aigrestore(); aisetgrayF(0); aigrestore(); aisetgrayF(0); nisetgrayF(0); morisign(); aiclose(); } static v double mt[4]; double nsc.gg.gg2; gg=95; gg2=9; mt[0]=0; mt[1]=mc[0]+mc[1]; mt[2]=mt[1]+mc[2]; mt[3]=mt[2]+mc[3]; aiopen("mori6.ai"); aisetlinewidth(.4); aigsave(); aitranslate(bdr,bdr); nseg = 180;//180; x1=0; $aiscale(sc,sc); |||| \ aitranslate(mt[0]+mc[0]/2,mh(2); \ airotate(i); \ aitranslate(-mt[0]+mc(0)/2,l-mh(2)); \ ||| \ moric(0,ff); \ aigrestore(); \ || \ x1=mt[1]*sc, y1=h-mh2, \ x2=w-(mt[2])*sc; \ y2=0; \ for(i=nseg-1,i>0;i=2) \ || \ double \ x,y; \ aigrave(i); \ aitranslate(-mt[1]-(mc[2]+mc[1])/2), \ || \ moric(1,ff); \ aigrestore(i); \ aitranslate(-mt[1]-(mc[2]+mc[1])/2), \ || \ moric(1,ff); \ aitranslate(-mt[1]-(mc[1]$ airotate(i); aitranslate([-mt[2]-mc[3]/2),[-mh/2]); ||| moric(2,ff); aigrestore(); | x1=mt[3]*sc_v1=h-mh2; x2 = 0; y2=0; for(i=nseg-1;>0;i=2) | double x,y; aigsave(); aisetgrayF((double)i/(nseg-1)); aisetgrayF((double)i/(n aigrestore(); \aigsave(); aitranslate(0,h-mh2); aiscale(sc,sc); aisetgrayF(0); justmori(); aigrestore(); aisetgrayS(0); aigrestore(); aitrombo(0.0,728,1030); aisetgrayF(0); morisign(); aiclose(); \\ [/void main() static void main() mt(1)=mc(0)+mc(1):mt(2)=mt(1)+mc(2):mt(3)=mt(2)+mc(3); aiopen("mori5.ai"); aiopen("mori5.ai"); aigsave(); aitranslate(bdr,bdr); aisetlinewidth(.2); sp=(h-mh2.4)/3; for(i=0.i<360.i++) $\{|for(i=360.i>=0.i--)|$ $\{double nsc=i+1; int\ ff(i=0.i<360.i+-)\}$ mt[3]-mc[4](2),(-mh/2); moric(3,ff); aigrestore(); aigrestore(); aigrestore(); aigrestore(); aiscale(sc,sc); airranslate(0,h-mh2); aiscale(sc,sc); airranslate(0,h-mh2); airrans $aigrestore(); \ aigsave(); \ airtanslate(0,h-mh2); \ aiscale(sc,sc); \ airtanslate(mt[0]+mc[0]/2,mh/2); \ airotate(i); \ nsc = (1-(i)/360.+1./mxsc)*mxsc; \ aiscale(nsc,nsc); \ airtanslate((-mt[0]-mc[0]/2),(-mh/2)); \ moris(0,tf); \ aigrestore(); \ airtanslate(0,h-mh2); \ airtanslate(0,h-mh2)$ mw(2,0); aisetlinewidth(.2+dsin(i)'3); //aisetgrayF((double)//90); justmoriS(); aigrestore(); \ aigrestore(); $double\ w = 728 \cdot bdr'2. h = 1030 \cdot bdr'2;\ double\ mw = 1000,\ mh = 222.645;\ double\ sc = w/mw.newsc;\ double\ mw = 28 \cdot mw.mh2 = sc \cdot mw.mh2 = sc \cdot mw.mh,\ double\ sc = sc \cdot mw.mh2 = sc \cdot mw.mh,\ double\ sc = sc \cdot mw.mh2 = sc \cdot mw.mh,\ double\ sc = sc \cdot mw.mh2 =$ aisetgrayF(0); for(j=0,j<i+2,j++) { justmori(); aitranslate(mw.0); } aigrestore(); off+=mh*newsc; if (ABS(h-off)<1) break; if (h-off<0) break; i++; printf("cycle %d [h=%fg]\n"; newsc*mh); } aisetgrayS(0); aigrestore(); aitranslate(mw.0); } for(i=0;i<npts:i++) { aigsave(); aitranslate(|w-mw*segs[i]|mh)|2,h-mh2-poss[i]-segs[i]); //aitranslate(oh-mh2-poss[i]-segs[i]); aiscale(segs[i]|mh,segs[i]|mh); //aitranslate(mw/2,0); //aiscale(dcos((double)i*5),1); //aitranslate(mu/2,0); //aitranslate($mh=222.645; double\ sc=w/mw;\ double\ mw2=sc*mw,mh2=sc*mh;\ double\ segs[1000], poss[1000];\ int\ npts=100.i;\ aiopen("mori1.ai");\ aigsave();\ aitranslate(bdr,bdr);\ for(i=0,i<npts+2;i++)\ |\ double\ n=i+1;\ segs[i]=mh2*npts=100.i;\ aiopen("mori1.ai");\ aigsave();\ aitranslate(bdr,bdr);\ ait$ mh2); aiscale(sc,sc); aisetgrayF(0); justmori(); aigrestore(); for(i=0,i<npts:i++) [aigrave(); aitranslate(0,h-mh2-poss[i]-segs[i]); aiscale(sc,segs[i]/mh); if (1962) justmori(); aigrestore(); laisetgrayF(0); aisetgrayF(0); aisetg allineto(245.2,132.6), ailineto(245.2,80.1); ailineto(133.7,80.1), ailineto(133.7,52.48); ailineto(245.2,52.48); ailineto(245.2,0); ailineto(0,0); ailineto(0,52.48); ailineto(6,54.52,48); ailineto(6 ailineto(324,132.6); ailineto(324,0.02551); ailineto(258.2,0.02551); ailineto(724.1,0.02551); ailineto(724.1,0.02551); ailineto(768.6,40.99); ailineto(768.7,0.02551); ailineto(1000,0.02551); ailinet ailineto(768.6,132.6); ailineto(768.6,93.47); ailineto(724.1,93.47); ailineto(724.1,158.5); aicurveto(724.1,193.9,695.3,222.6,659.9,222.6); ailineto(585.2,222.6); ailineto(585.2,164.9); ailineto(640.6,164.9); aicurveto(646.9,164.9); ailineto(324,222.6); ailineto(324,164.9); ailineto(391.3.164.9); aicurveto(397.6.164.9.402.7.159.9.402.7.153.6); ailineto(402.7.0.02551); ailineto(474.8.0.02551); ailineto(474.8.40.99); ailineto(519.4.40.99); ailineto(519.4.40.99 aicurveta(138.8,577,133.7,62.79,133.7,69.07); ailineta(133.7,90.07); ailineta(245.2,90.07); ailineta(245.2,90.07); ailineta(245.2,142.5); ailineta(133.7,142.5); ailineta(133.7,170.2); ailineta(245.2,170.2); ailineta(245.2,222.6); aifill(); aimoveto(258.2,222.6); ailineto(258.2,90.07); ailineto(324,90.07); ailineto(324,222.6); ailineto(258.2,222.6); ailineto(724.1,222.6); ailineto(724.1,181.7); ailineto(768.6,181.7); ailineto(768.6,1 ailineto(834.5.90.04); ailineto(768.6.90.04); ailineto(768.6.129.2); ailineto(724.1,129.2); ailineto(724.1,64.14); aicurveto(724.1,28.72.695.3.0,659.9.0); ailineto(585.2.0,02857); ailineto(585.2.577); ailineto(640.6.577); aicurveto(724.1,28.72.695.3.0,659.9.0); ailineto(585.2.0,02857); ailineto(585.2.577); ailineto(585.2.577); aicurveto(724.1,28.72.695.3.0,659.9.0); ailineto(585.2.0,02857); ailineto(585.2.577); ailineto(585.2.577); aicurveto(724.1,28.72.695.3.0,659.9.0); ailineto(585.2.577); aicurveto(585.2.0,02857); aicurveto(585.2.577); aicurveto(585.2.0,02857); aicurveto(585.2.0,0 ailineto(324,0.02857); ailineto(324,577), ailineto(391,3,577); aicurveto(397,6,577,402.7,62.79,402.7,69.07); ailineto(402,7,222.6); ailineto(474,8,122.6); ailineto(474,8,181,7); ailineto(519,4,181,7); ailin ailineto(133.7.90.07); ailineto(245.2.90.07); ailineto(245.2.142.5); ailineto(133.7.142.5); ailineto(133.7.170.2); ailineto(245.2.170.2); ailineto(245.2.22.6); ailineto(0.222.6); ailineto(0.7.0.2); ailin allineto(258.2.90.07); allineto(324,90.07); allineto(324,222.6); allineto(324,222.6); allineto(258.2.222.6); allineto(724.1.222.6); allineto(724.1.181.7); allineto(768.6.181.7); allineto(768.7.222.6); allineto(1000.222.6); allineto(1000.222.6 ailineto(768.6.90.04); ailineto(768.6.129.2); ailineto(724.1.129.2); allineto(324,577); allineto(391.3,577); aicurveto(397.6,577,402.7,62.79,402.7,69.07); allineto(402.7,222.6); allineto(474.8,222.6); allineto(474.8,181.7); allineto(519.4,181.7); allineto(519.4,222.6); allineto(585.2,222.6); allin ailineto(990.2,33.25); ailineto(914.6,146.3); ailineto(947.6,146.3); ailineto(971.9,33.25); ailineto(972.2,33.25); ailineto(972.2,146.3); ailineto(1000.146.3); ailineto(1000.3.912); ailineto(956.6,3.912); ailineto(930.8,116.1); a aicurveto(7979,150,8474,141,9,8474,75.08); aicurveto(8474,8,272,7979,0.1447,779,0.1447); aifiil(); aisetgrayF(1); aimoveto(779,124,8); aicurveto(763,124,8,740,4,114,9,740,4,75.08); aicurveto(740,4,35,23,763,25,32,779,2) aicurveto/589.9.59.67.597.8.73.15.611.9.77.91); aicurveto(600.2.83.06.593.8.87.42.593.8.114); aicurveto/593.8.129.8.592.8.139.6.590.146.1); ailineto(590.146.1); ailineto(520.4.146.1); aicurveto(602.2.4.139.4.623.5,132.623.5,1 aicurveto(619.6.39.45,623,28.35,640.4,28.35); ailineto(667.8,28.35); aicurveto(496.5.80.29.518.7.75.14.518.7.43.81); aicurveto(518.7.27.95.510.2,0.464,0); aicurveto(420.4,0.408.7.28.55,408.5,45.99); ailineto(437.1,45.99); aicurveto(437.9,39.65,440.2,24.58,466.2,24.58); aicurveto(477.5,24.58); aicurveto(477.5,24.58 ailineto(492.4.102.3); aifill(); aimoveto(295.9.3.766); ailineto(263.2.3.766); aicurveto(244.4.81.68.242.6.91.59.239.9.107.8); ailineto(239.5.107.8); aicurveto(236.9.92.98.234.6,78.5.219.1,3.766); aicurveto(246.9.3.766); a aicurveto(2077.62 45,210.1,72.76,225.8,146.1); ailineto(254.4,146.1); ailineto(295.9,3.766); ailineto(326.1,3.766); ailineto(326.1,3.766) aimoveto(92.61,146.1); ailineto(123,146.1); ailineto(80.33,3.766); ailineto(47.02,3.766); ailineto(0,146.1); ailineto(31.38,146.1); ailineto(39.55,116.8); ailineto(44.49,116.8); ailineto(92.61,146.1); ailineto(47.02,3.766); ailin aicurveto(138.8.577,133.7,62.79,133.7,69.07); ailineto(133.7,90.07); ailineto(245.2,90.07); ailineto(245.2,142.5); ailineto(133.7,142.5); ailineto(133.7,170.2); ailineto(245.2,170.2); (s) aistroke(); else aifill(); break; case 1: aimoveto(258.2,222.6); ailineto(258.2,90.07); ailineto(324.90.07); ailineto(324.222.6); ailineto(258.2,222.6); if (s) aistroke(); else aifill(); aimoveto(474.8,222.6); ailineto(474.8,222.6); ailineto(474.8, aimoveto(768.6.129.2); ailineto(724.1.129.2); ailineto(724.1.64.14); aicurveto(724.1.28.72.695.3.0.659.9.0); ailineto(585.2.0.02857); ailineto(585.2.577); ailineto(640.6.577); aicurveto(646.9.577.652.62.79.652.69.07); ailineto(585.2.69.07); allineto(651.9.181.7); ailineto(651.9.222.6); ailineto(724.1,222.6); ailineto(724.1,222.6); ailineto(724.1,181.7); ailineto(768.6.181.7); ailineto(768.6.129.2); if (s) aistroke(); else aifill(); break; case 3: aimoveto(768.7,222.6); ailineto(1000,222.6); ailineto(

Morisawa 10 (program source)

Reaching the limits of a typography affliction, I created ten variants on the logotype of Japanese type foundry Morisawa Company. →

ign = "0 To\n1 0 0 1 1164.9689 -1042.5546 0 Tp\n0 Tv\nTP\n0 Tr\n/_Helvetica 5 4.6997 -1.0998 Tl\n0 Ts\n100 100 Tz\n0 Tc\n0 Tt\n0 Tt\n0 Tr\n0 Tr\n1 TV\n0 0 5 Tc\n100 100 200 Tl\n0 5 Tc\n100 100 0 0 Ti\n0 Ta\n0 0 2 $\label{eq:double_bdr} \left\{ \textit{double} \ \textit{bdr} = 10; \textit{double} \ \textit{w} = 728 \cdot \textit{bdr}^2 2, \textit{h} = 1030 \cdot \textit{bdr}^2 2; \textit{double} \ \textit{mw} = 1000, \textit{mh} = 222.645; \textit{double} \ \textit{sc=w/mw}; \textit{double} \ \textit{mw} = 225 \cdot \textit{mw.mh} = 225 \cdot \textit{l.i.j.}; \textit{double} \ \textit{mt} = 1030 \cdot \textit{mt} = 1030$ [i=0,i<90.i++) { aigsave(); aitranslate(mw2,h-mh2); aisetgrayF(1-(double)i/90.); aiscale(sc.sc); airotate(90.·i); nsc2 = (double)i/90.; nsc2 = dsin(i); nsc2=1+(f1-(double)i/90.)*(h-w)/mw2); aiscale(nsc2.nsc2); airtranslate(mw2,h-mh2); airtranslate(mw2,h-mh eini/| {double bdr = 10; double w = 728-bdr*2,h=1030-bdr*2; double mw=1000, mh=222.845; double sc=w/mw; double mw2=sc*mw,mh2=sc*mh; double segs(1000),poss(1000); int npts=250.ij; double mt[4]; double m=w/w; printf("max rows displayable %d\n", (int)((h-mh2)/cubedim)); nsc=cubedim'4./mw; aigsave(); //aitranslate(0.h-mh2+cubedim-nsc'mh); aitranslate(0.h-mh2+cubedim-nsc'mh); at aitranslate(0.h-mh2+cubedim-nsc'mh); ay = nsc'mw/4.; fortj=0.j<jh. translate(-tx,-ty); moric(kk,0); aigrestore(); | aigrestore(); | aigrestore(); | aigrestore(); | aigrestore(); | aisetgrayF(0); aiscele(sc,sc); | aisetgrayF(0); aiscele(sc,sc); | aisetgrayF(0); aisetgr 0.i.j. double mt[4]: double nsc,cubedim,gg.gg2,sc2; int liw = 176, lih = 211; double iw = liw, lh = lih,dy; FILE 'fp=fopen('mona176by211",'r'); char 'buf.c; buf=malloc(sizeof(char)'liw'lih). "inti((h-mh2)|cubedim)]; nsc=cubedim*4./mw; aigsave(); aitranslate(0,h-mh2+cubedim-nsc*mh); dy = nsc*mw/4; for(j=0.j<ih; j++) { aigsave(); aitranslate(0,-nsc*mw*(double)(j+1)/4.); aiscale(nsc.nsc); for(i=0.i<iw;i++) { aigsave(); aitranslate(0,-nsc); for(i=0.i<iw;i++) { aigsave(); aitranslate(0,-nsc); for(i=0.i<iw;i++) { aigsave(); ait /F(0); morisign(); aiclose(); } static void mainunused() { double bdr = 10; double w = 728-bdr*2; double mw=1000, mh=222.645; double sc=w/mw; double mw2=sc*mw,mh2=sc*mh; double $\{ ||f(sr(i=360:i)=0:i-)| \{ ||f(sr(i=360:i)=0:i-)| \} \}$ aisatgrayF(1); //moric(0,0); aisatgrayF(0); aisatgrayF(0); aisatgrayF(0); aisatgrayF(0); aisatgrayF(0); aisatgrayF(0); morisign(); aiclose();] static void main8() //void main() { double bdr = 10; double w = 728-bdr '2,h=1030 nc[0]+mc[1]; mt[2]=mt[1]+mc[2]; mt[3]=mt[2]+mc[3]; alopen("mori8.ai"); aisetlinewidth(.5); algsave(); aitranslate(bdr.bdr); nseg = 360°3; x1=0;y1=h-mh2; x2 = 0; y2=0-(mh2-mh2"minsc)/2; for(i=nseg-1;>>0;i--) (i=nseg-1;>>0;i--) (i=nseg-1;>>0ranslate(mt[0]+mc[0]/2,mh/2); aiscale(dcos(i)*ssc,ssc); aitranslate(-mt[0]-mc[0]/2,(-mh/2)); /// moric(0,ff); aigrestore(); | x1=mt[1]*sc;y1=h-mh2; x2 = (mt[1])*sc;y2=0-(mh2-mh2*minsc)/2; for(i=nseg-1;>0;--)[||(nseg-1)||'|(1-minsc)+minsc)|| ||(nseg-1)||(nseg-1)|| ||(nseg-1)||(nseg-1)|| ||(nseg-1)||(nseg-1)|| ||(nseg-1)||(nseg-1)|| ||(nseg-1)||(nseg-1)|| ||(nseg-1)||(nseg-1)|| ||(nseg-1)|| ||(nseg-1)||(nseg-1)|| ||(nseg-1)||(nseg-1)|| ||(nseg-1)||(nseg-1)|| ||(nseg-1)||(nseg-1)|| ||(nseg-1)||(nseg-1)|| ||(nseg-1)||(nseg-1)|| ||(nseg-1)||(nseg-1)|| ||(nseg-1)||(nseg-1)|| ||(nseg-1)||(nseg-1)|| ||(nseg-1)||(nseg-1)||(nseg-1)|| ||(nseg-1)||(n-th-mh2+i*(y2-y1)/(nseg-1); aitranslate(x,y); aiscale(sc,sc); aitranslate(-mt[2],0); |||| ssc=([1-(double)ii(nseg-1))*(1-minsc)+minsc); aitranslate(tx=mt[2]+mc[3]/2,ty=mh/2); aiscale(dcos(i)*ssc.ssc); aitranslate(-tx,-ty); || $12+i^*(y_2-y_1)/(nseg^{-1});$ aitranslate(x,y); aiscale(sc,sc); aitranslate(-mt[3],0); |||| ssc=(1-{double})i/(nseg-1))^*(1-minsc)+minsc); aitranslate(mt[3]+mc[4]/2,mh/2); aiscale(dcos(i)*ssc,ssc); aitranslate(-mt[3]-mc[4]/2). pain() | double bdr = 10; double w = 728-bdr 2.h=1030-bdr 2; double mw=1000, mh=222.645; double sc=w/mw.newsc; double mw2=sc*mw.mh2=sc*mw.mh2=sc*mh; int npts=100; double i.j; double nseg.x1,y1.x2,y2; int ff = 1; $mc[0]^*sc; \gamma 2=0; for(i=nseg-1;i>0;i==2) \ \{double\ x,y; aigsave(); aisstgrayF((double)i/(nseg-1)); aistgrayS((double)i/(nseg-1)^*gg2+(1-gg)); x=i^*(x2-x1)/(nseg-1)+x1; y=h-mh2+i^*(y2-y1)/(nseg-1); aistgrayF((double)i/(nseg-1)); aistgrayF((double$ $double)!/(nseg-1)]; aisetgrayS((double)!/(nseg-1)^* gg2+(1-gg)); x=i^*(x2-x1)!/(nseg-1)+x1; y=h-mh2+i^*(y2-y1)!/(nseg-1); aitranslate(x,y); aiscale(sc.sc); aitranslate(-mi(1),0); //// aitranslate(mi(1)+(mc(2)+mc(1))!/(nseg-1); aitranslate(-mi(1),0); //// aitranslate(-mi(1),0); /// aitranslate(-mi(1),0); // aitransla$ g-1)*gg2+[1-gg]); ||a|iset[grayS(0); ||a|iset[frayS(0)]; ||a|is ='(x2-x1)/(nseg-1)+x1: y=h-mh2+i'(y2-y1)/(nseg-1); aitranslate(x,y); aiscale(sc.sc); aitranslate(-mt[3],0); |||| aitranslate(mt[3]+mc[4]/2,mh(2); airotate(i); aitranslate(i-mt[3]-mc[4]/2), -mh(2); ||| moric(3,ff) double w= 728-bdr 2, touble mw=1000, mh=222.645; double sc=w/mw,newsc; double mw2=sc*mw,mh2=sc*mh; double segs[1000].poss[1000].off.sp; int npts=100.i,j; double mt[4]; mt[0]=0; 10.5; aisetgrayS(i/360.); f(i): aigrastore(i): aigrasve(i): aigrasve(i): aigrave(i): aiscale(sc,sc): aitranslate(mt[1]+mc(2)/2,mh(2)): airotate(i): nsc=(i-(i)/360+1/mxsc)* mxsc: aiscale(nsc,nsc): aitranslate(-mt[1]-mc(2)/2). (-mh(2)): mrotic(1,ff): late(0,h-mh2); aiscale(sc.sc); aisetgrayF(0); justmori(); aigrestore(); aigrestore(); aisetgrayF(1); aimaskoutrect(-3.-3.728+6,1030+6); aisetgrayS(0); aitombo(0,0,728,1030); aisetgrayF(0); morisign(); aiclose(); atatic save(||; aitranslate(||dt,bdr|); for(||-o|,||200))+=1| {abuble dist = ||h|,2 missing ||, aitranslate(||dt,bdr|); for(||-o|,||200))+=1| {abuble dist = ||h|,2 missing ||, aitranslate(||dt,bdr|); ai save(); aitranslate(0,h-mh2); aiscale(sc,sc); aisetgrayF(0); justmori(); aigrestore(); off=mh2; i=0, while(1) { aigsave(); newsc=sc*(double)(i+2); aitranslate(0,h-off-mh*newsc); aiscale(newsc,newsc). isstgrayF(0); morisign(); aiclose(); \[//static void main3() void main1() double bdr = 10; double w = 728-bdr²2, h=1030-bdr²2; double mw=1000, mh=222.6;//45; double sc=w/mw; double mw2=sc*mw.mh2=sc*mb. Move(segs,poss,sizeof(double)"npts): CollapseSegments2(npts,poss); i=npts-1; printf("last; %lg/n",h-mh2-poss[i]-segs[i]); aigsave(); aitranslate(0,h-mh2); aiscale(sc,sc); aisetgrayF(0); justmori(); aigrestore(); ri(); algrestore(); \ aisetgrayF(0); aisetgrayF(0); aisetgrayF(0); aisetgrayF(0); aisetgrayF(0); morisign(); aiclose(); \ static void mori1() \ \ double bdr = 10; double w = 728-bdr*2,h=1030-bdr*2; double mw=1000, tore(); altombo(0.0,728,1030); aisatgrayF(0); morisign(); aiclose(); \ void invjustmori(void) \ \ \ ' w=1000, h=222.645 '\ aimoveto(145.1,164.9); aicurveto(138.8,164.9,133.7,159.9,133.7,159.9,133.7,153.6); ailineto(133.3,132.6); 61.54.132.6); allineto(61.57,158.5); aicurveto(61.57,153.9.90.28.222.6.125.7.222.6); allineto(245.2.222.6); allineto(245.2.164.9); allineto(145.1,164.9); alline 222.6.935.8.222.6]: ailineto(852.4.222.6); ailineto(852.4.164.9); ailineto(916.5.164.9); aicurveto(922.7.164.9.9278.159.9.9278.153.6); ailineto(9278.52.53); ailineto(834.5.52.53); ailineto(834.5.132.6); \$3.6|; ailineto(651,9,93,47); ailineto(585,2,93,47); ailineto(585,2, _0,02551); ailineto(585.2,40.99); ailineto(651.9,40.99); ailineto(651.9,0.02551); ailineto(724.1,0.02551); aifill(); \ void justmori(void) \ /* w=1000, h=222.645 */ aimoveto(145.1,577); 61.54.170.2); ailineto(61.54,142.5); ailineto(0.142.5); ailineto(0.90.07); ailineto(61.54,90.07); ailineto(61.57,64.14); aicurveto(61.57,28.72,90.28,0,125.70); ailineto(245.2.0.02857); ailineto(245.2.57.7); ailineto(145.1.57.7); of (1000, 64.14); alcurveto (1000, 28.72, 971. 2, 0, 935.8, 0); allineto (852.4, 0.02857), allineto (852.4, 57.7); allineto (916.5, 57.7); alcurveto (902.7, 57.7, 927.8, 62.79, 927.8, 69.07); allineto (927.8, 170.1); allineto (834.5, 170.1); 6.279.65.2,69.07); ailineto(651.91.29.2); ailineto(651.91.29.2); ailineto(782.6.9.02.7), ailineto(658.2,90.04); ailineto(658.2,90.04); ailineto(658.2,90.04); ailineto(658.2,90.04); ailineto(658.2,90.04); ailineto(658.2,90.04); ailineto(788.2,91.04); ai neto(651.9,181.7); ailineto(651.9,222.6); ailineto(724.1,222.6); aistroke(); void moriE(void) | /* w=1000, h=150.016 */ aisetgrayF(0); aisetgrayF(0); aimoveto(862,146.3); ailineto(889.8,146.3); ailineto(889 lineto(905,3.912); ailineto(862,3.912); ailineto(862,146.3); ailill(); aimoveto(779.0.1447); aicurveto(760.2,0.1447,710.7.8.272,710.7.75.08); aicurveto(710.7,141.9,760.2,150.779,150); .1.25.32.817.7.35.23.817.7.75.08); aicurveto(817.7.114.9.795.1.124.8,779.124.8); aifill(); aisetgrayF(0); aimoveto(696.9.3.766); ailineto(634.73.766); aicurveto(596.8.3.766,589.9.31.72.589.9.44.01). 5.9793.624.790.4,646.790.4); allineto(6678.90.4); allineto(6678.146.1); allineto(6678.146.1); allineto(696.9.146.1); allineto(696.9.3.766); allill(1); aimoveto(492.4.102.3); aicurveto(492.2.110.2.488.2.125.3.462.2.125.3); aicurveto(448.2.125.3.432.5.121.9.432.5.106.9); aicurveto(432.5.95.75.443.2.92.78.458.3.89.21); ailineto(473.5.85.64); 1): ajcurveto/491.52.73.481.9.55.11.475.9.56.51: allineto/441.2.65.03): alcurveto/421.8.69.78.403.9.7771.403.9.103.31; alcurveto/403.9.146.1.4476.149.9.460.1.149.9): alcurveto/512.149.9.520.9.119.9.520.9.119.9.520.9.102.31 39.41,164.7,107.8); allineto(164.3,107.8); alcurveto(161.9,94.36,159.4,82.07,140.43.766); allineto(109.4,3.766); allineto(150.6,146.1); allineto(180.1,146.1); alcurveto(195.2,76.33,197.8,62.45,202.8,35.09); allineto(203.2,35.09); 116.8); ailineto(363.6,116.8); ailineto(371.7,146.1); aifill(); aisetgrayF(1); aimoveto(357.2,92.19); ailineto(326.2,92.19); ailineto(342.35.88); ailineto(342.4,35.88); ailineto(357.2,92.19); aifill(); aisetgrayF(0); o(47.06,92.19); ailineto(62.87,35.88); ailineto(63.26,35.88); ailineto(78.06,92.19); aifill(); | void moric(int n,int s) | /* w=1000, h=222.645 */ switch(n) | case 0: aimoveto(145.1,577); 61.54.170.2): ailineto(61.54.142.5); ailineto(0.142.5); ailineto(0.90.07); ailineto(61.54.90.07); ailineto(61.57.64.14); aicurveto(61.57.28.72.90.28.0.125.70); ailineto(245.2.0.02857); ailineto(245.2.577); ailineto(324.0.02857); ailineto(324.57.7); aicurveto(397.6.577.402.7.62.79.402.7.69.07); ailineto(402.7.222.6); ailineto(474.8.222.6); if (s) aistroke(); else aifill(); break; case 2: neto(585.2,129.2); ailineto(585.2,90.04); ailineto(519.4,90.04); ailineto(519.4,129.2); ailineto(474.8,129.2); ailineto(474.8,181.7); ailineto(519.4,181.7); ailineto(519.4,222.6); ailineto(585.2,222.6); ail curveto(1000,28.72,971.2,0,935.8,0); ailineto(852.4,0.02857); ailineto(852.4,57.7); ailineto(916.5,57.7);

LIVERPOO MOORES UNIVERSITY

s) aistroke(); else aifill(); break; default:break; })

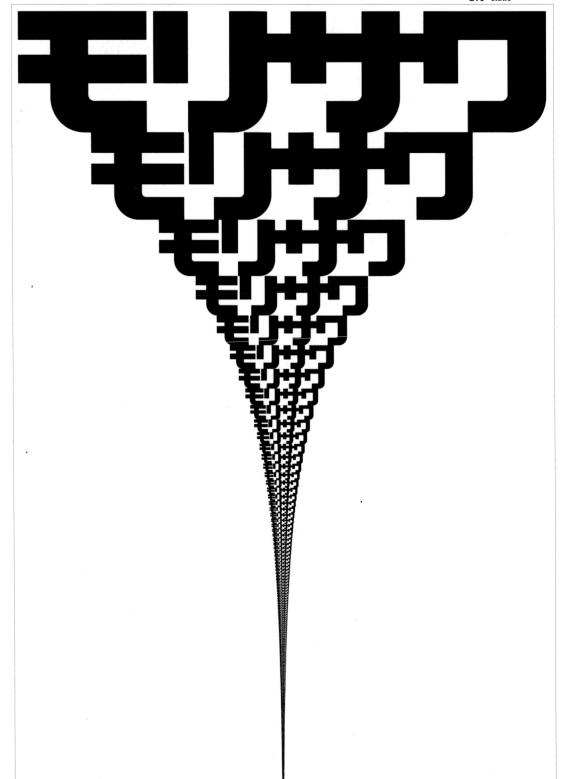

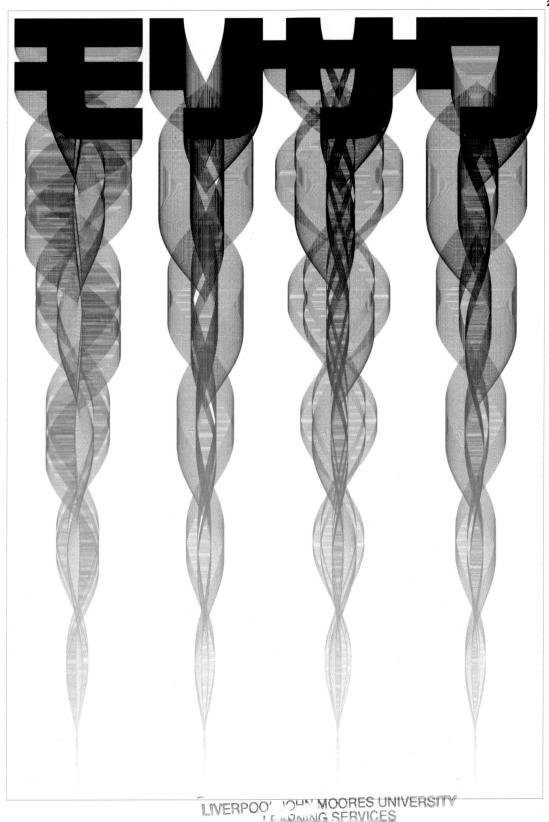

Morisawa 4

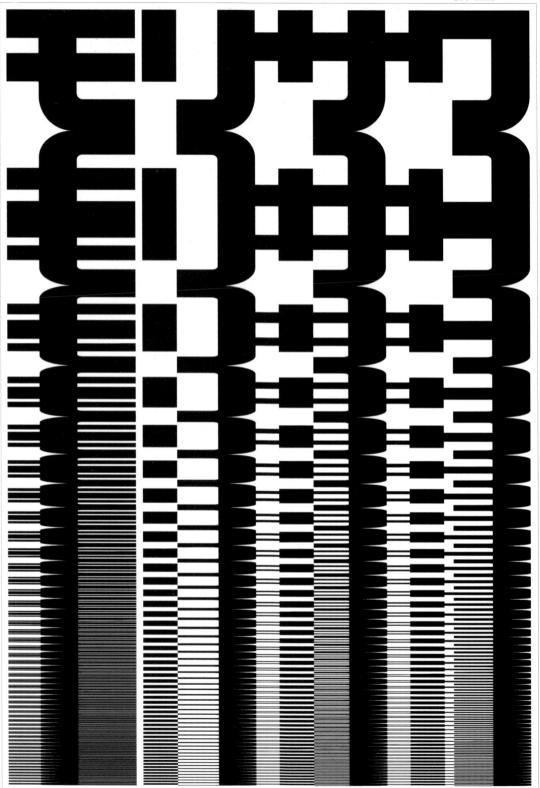

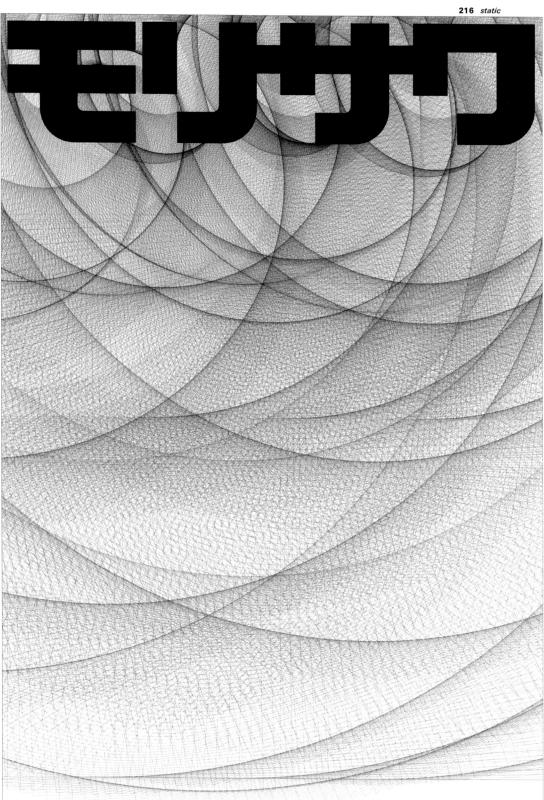

Morisawa 7

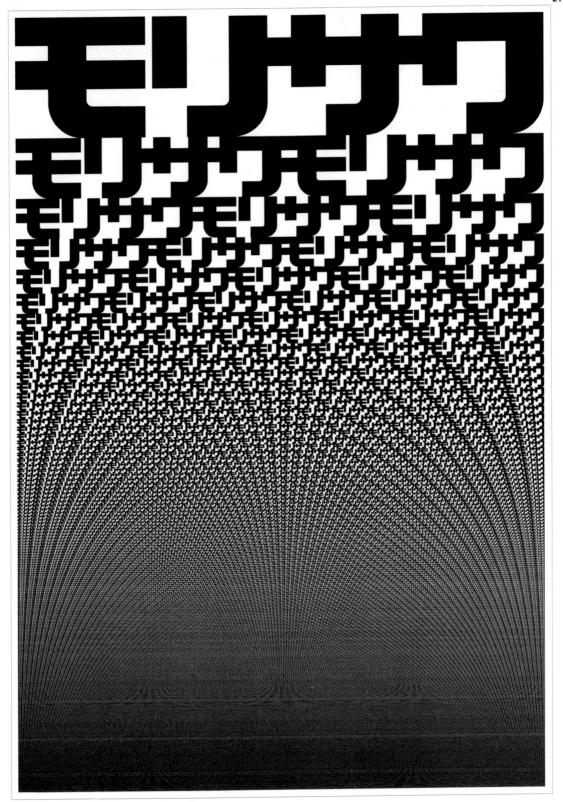

Morisawa 10

123rd Ginza Graphic Gallery (GGG) Exhibition, "John Maeda: Paper and Computer" (1996), in Tokyo.

Fifty lithographs and twenty powerbooks on display. →

of seventy-one, one throused eight to the control of the control o

前田ジョン「かみとコンピュータ」展 ギンザ・グラフィック・ギャラリー第123回企画展 1996年8月2日(金) - 8月27日(火) Exhibit traveling from Tokyo to Osaka, shown as each kilometer explicitly spelled out.

7 four colors Bradbury Thompson's landmark work in reformulating the printing press as a custom illustration tool captured a spirit that has evaded contemporary digital design. Most of today's digital composition tools are fundamentally incapable of being reduced to smaller parts that might be reconstituted in new ways. Considering that software is generally designed in a modular, layered fashion and is mutable to more than one single interface, this seems strange. Software must become truly soft, capable of being molded and recast into new tools by the will of the artist. We see aspects of this attitude in the scriptability of most of the new releases of applications, mainly to enable increased automation and greater productivity. But the truly creative mind will prefer to wander rather than repeat her greatest hits over and over again—and we also know that greater productivity often translates into poorer quality. There needs to be a concrete set of core advancements in the tools we use, not just incremental updates. To realize such a future, more artists must be unafraid to peer deep inside the machine and directly affect a deconstruction of the software systems that imprison all digital expressions.

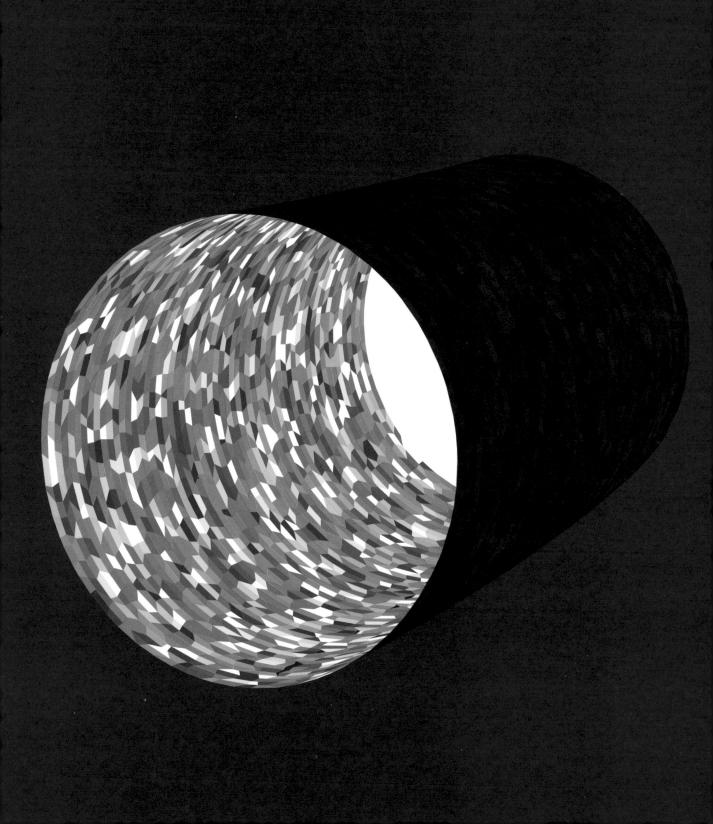

++++++++++++++++++++++++++

ナナナナナナナ

+++++++++++++++++++++++++++++++++

××××××××××××××××

×××××××××××××××××××××

++++4

LLLLI

XXXX

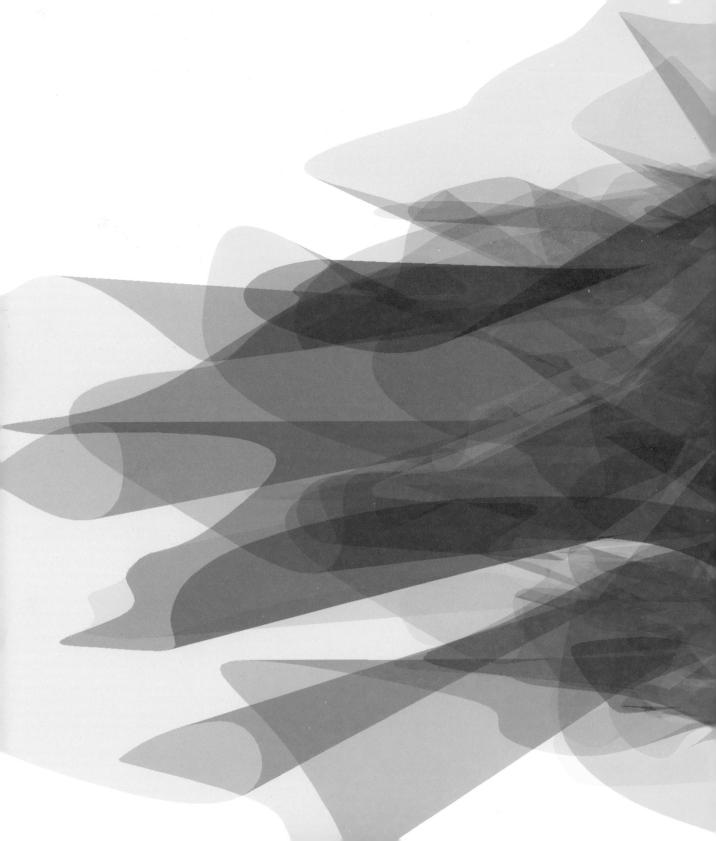

LIVERPOOL JOHN MOORES UNIVERSITY

8 *online* For a long period, work on the computer was limited to transmission by slides, video, or in printed form. When it first appeared, cd-rom was hailed as the only medium capable of delivering large quantities of digital content to the masses. Although inexpensive to physically produce in large quantities, cd-rom technology unfortunately had difficulty in finding a proper distribution channel. The emergence of the world wide web finally made it possible to broadcast digitally originated content en masse, and overnight made digital creative activities as legitimate as those in print. Initially, most work centered around the basic hypertext metaphor intrinsic to the web's html format; my favorite capability of html was to make text blink, which was everyone's least favorite feature. Unfortunately, it has since been removed, which is quite a pity considering that, as a kinetically motivated typeface styling, it was a big step beyond bold and italic. Around this time Paul Rand asked me a surprising question, "So, this work you do on the computer is interesting, but how are you going to make any money doing it?" The java programming language made it possible to create distinguishing content, at least for a while.

When the web first took hold, Kaoru Matsuzaki of Sony had the vision to commission designers to create unique front pages for the now-extinct SonyDrive. All pages had to be static in nature and within a specific size. →

Ms. Matsuzaki was called off to a remote area in Japan and was unable to manage the project. A replacement was assigned, and I quickly became reminded of Paul Rand's insistence that a good design requires a good client. →

For the remaining term of the commission, I reluctantly received changing demands of smaller, less, smaller, less, and so on. A printing analogy would be to demand less color, less ink, and, most critically, less paper area.

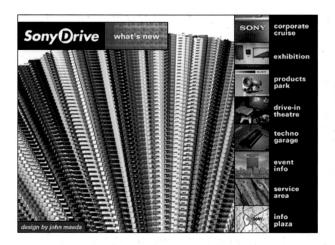

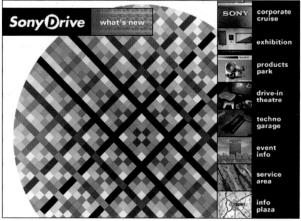

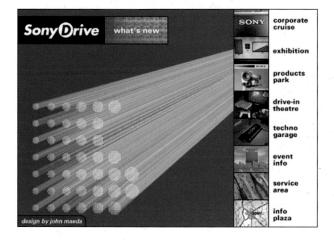

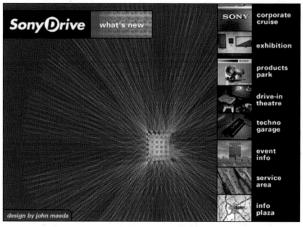

As the web has evolved from conventional static expressions to realtime dynamic expressions through a variety of advanced technologies, it is clear that the greatest challenge is not just to realize the content but to ensure that it will run for at least a week after it is launched. The term "standard" when discussed in relationship to the web takes on a new meaning when version numbers seem to append and increase faster than anyone can keep up, jeopardizing the integrity of content created for older versions of the web.

A series of online works from Shiseido commissioned by creative director Michio lwaki resulted in the bulk of my experiments for the web. With projects ranging from e-cards to games to calendars, I experimented in the java language with complete freedom.

In conjunction with the launch of Shiseido's online orchid-ordering system, Mr. Iwaki asked me to design an orchid-theme card-making system for Shiseido's website. To echo the great variety of orchids, the card system would be equally varied and built in the then-emerging java standard. →

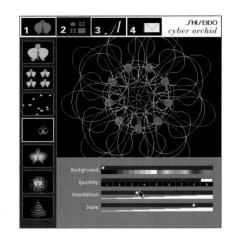

Designing a temporal form versus a static form can appear to be more difficult because there are proportionately more images to imagine and create. It turns out that the effort required to execute either situation is essentially equivalent when constructed from the programmatic standpoint. A properly constructed programmatic form is by definition of a variable nature, but if the core visual idea is without any real worth, its variations will prove no better.

With an increase in java's reliability and the continual acceleration of consumer personal computers, I redesigned the basic card system around a more ambitious, time-enhanced simulation of morning glories that open gracefully. →

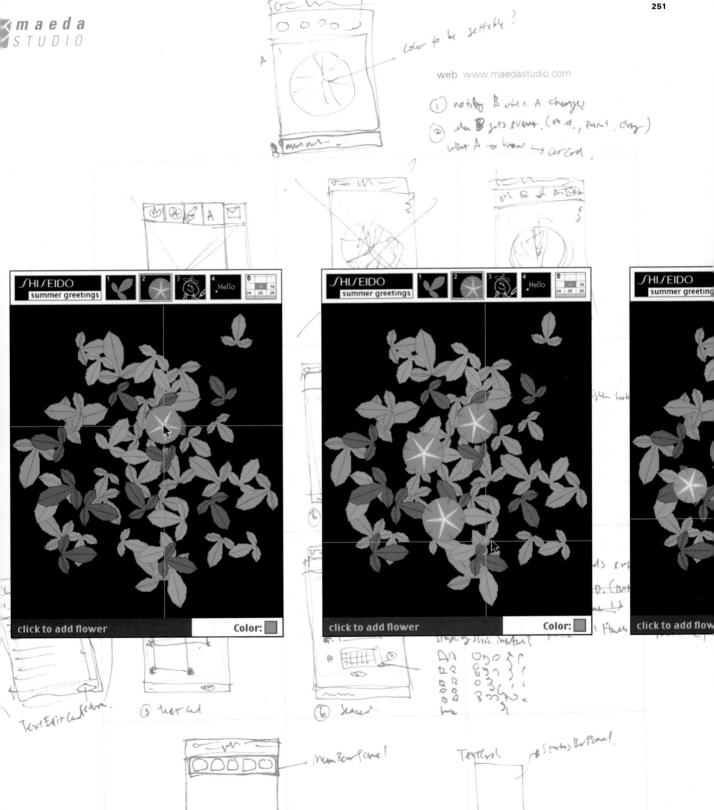

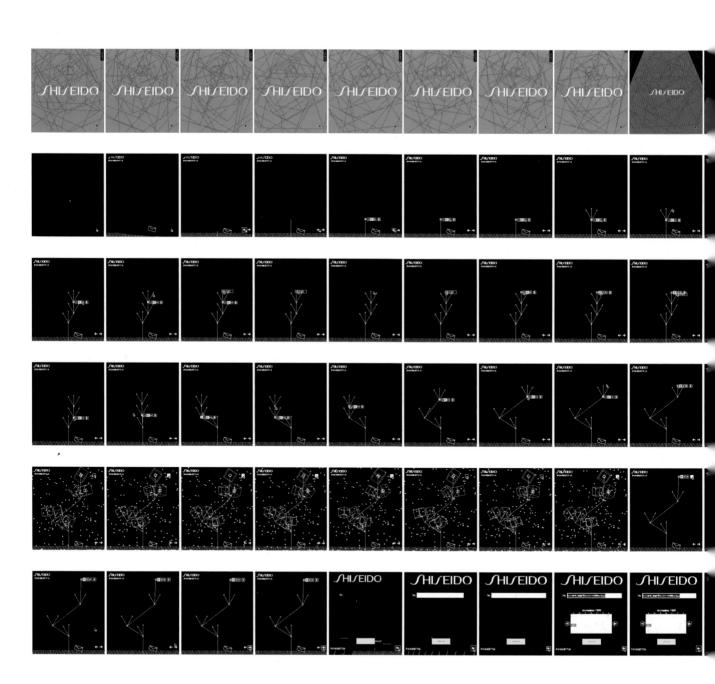

Experiment in a seamless experience of animation and interaction with a Cubistinspired poinsettia-theme card service. →

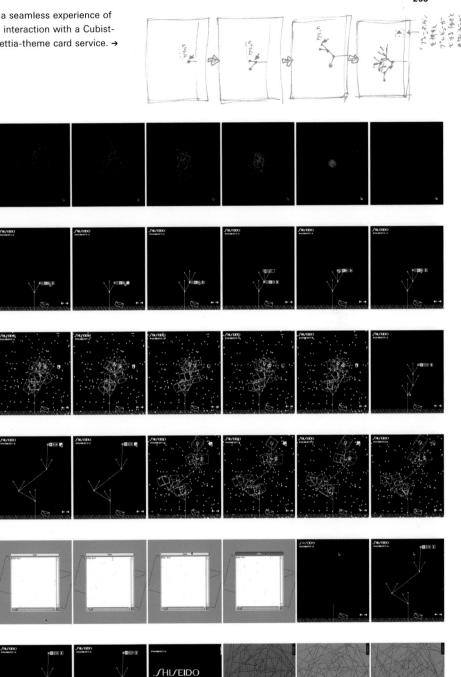

THIZEIDO

THITEIDO

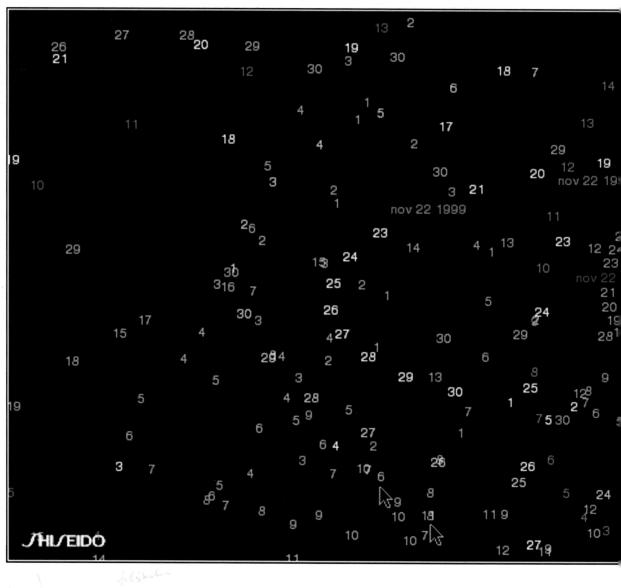

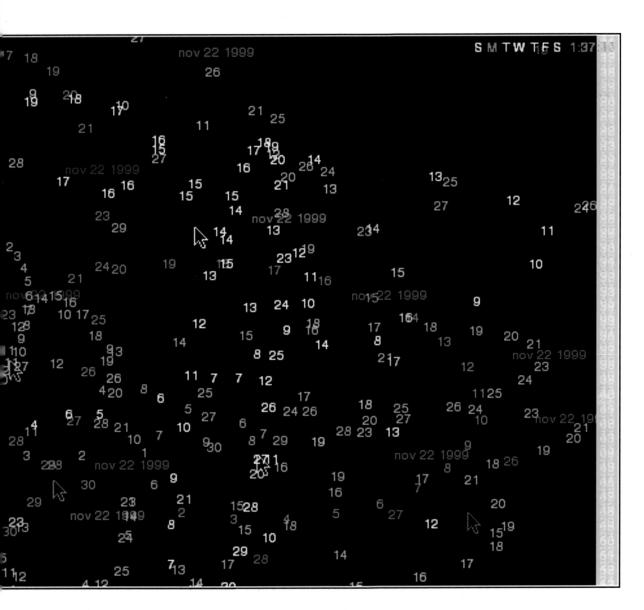

A calendar to celebrate the beginning of 1997 as a series of dynamic orbital rings. As the mouse is dragged, a new orbit is revealed and left as a trace. →

The design of a calendar is a useful exercise for developing skills in the perception of time. With each new season comes a significant change in the environmental surroundings that affects your lifestyle, dress, and body condition. To consciously map a numerical form to the natural rhythm of the earth requires a careful synthesis of math and spirit.

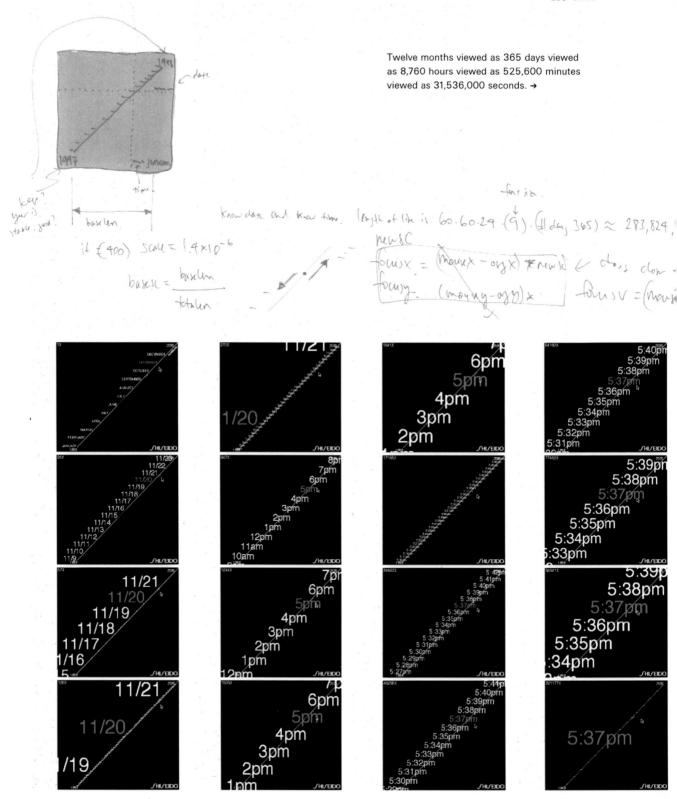

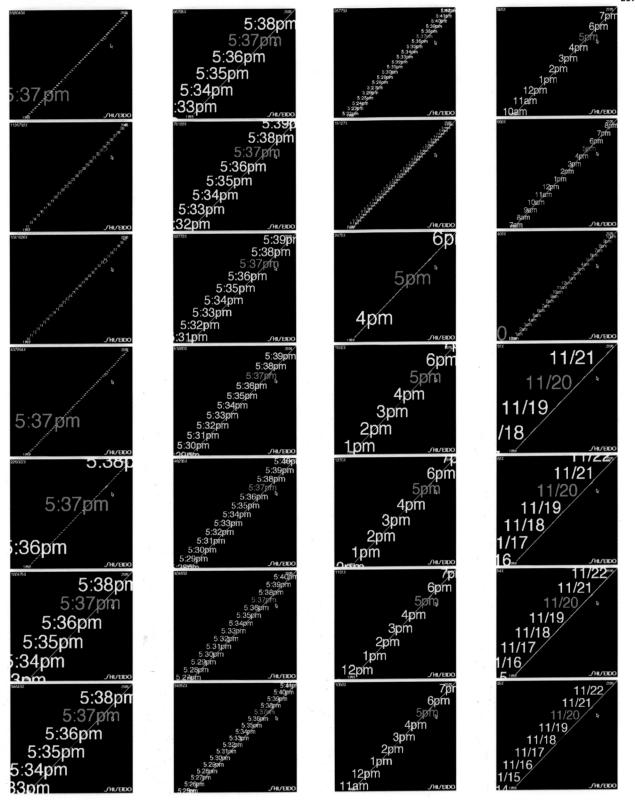

, AL/EBO	Ангево	AN/EDO .	ALIZEDO L	/H/EDO 6	Лилево	ALEDO
11/20 ./4/ebo	/H//EDO	./H./EBDO	/14/EDO	AN/EBO	ЛИЛЕВО	JAVEDO 1
ЛИЛЕВО	Нилево	AH/EBO	, AL/EDO	AN/EDO	/ht/EDO	.AVEDO
ALEBO	ЛАЛЕВОО	Лигеро	1130 1130 113	11/20 L	11 20 	JH/EDO
ЛИЛЕВО	ЛИЛЕВО		,AH/EDO	/h/ebo	AN/EDO	,Al/EDO
MANERO	ALAEDO	Лигеро	, PAZEDO	, PAL/EDO	° 11/20	11 20 11 20 JH/EDO
11/20 20 20 20 20 20 20 20 20 20 20 20 20 2	11 20 11 20 0	Льгево	11/20 b	, PH/EBO	AL/EBO	ALVEDO I
ALIEBO ALIEBO	, ALABOO	JAL/BBO	, PHAREDO	Лилево	11/20	11 22 JAVEDO

Calendar designed to celebrate spring 1997 as a series of floral petal transformations. A click reveals a new petal; a drag amplifies or reduces the visual area of the spinning flower. →

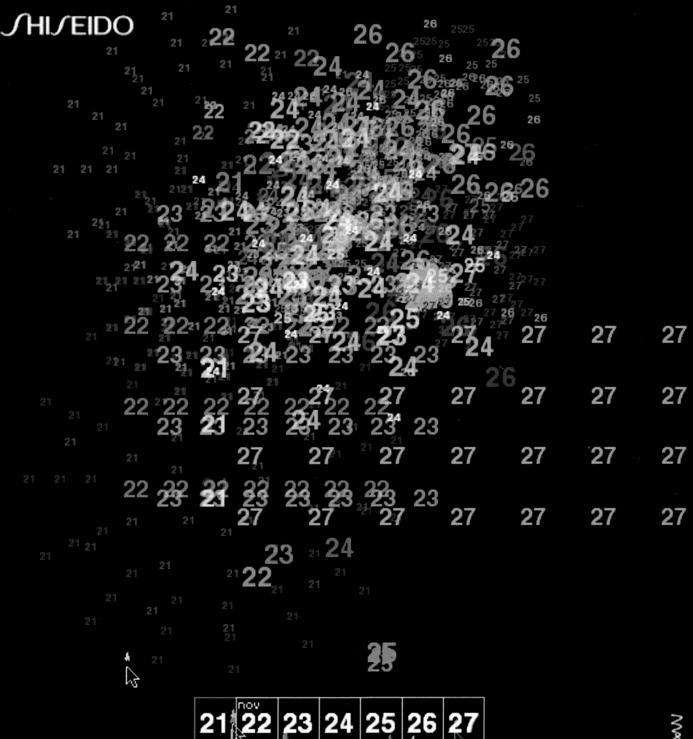

MAEDO

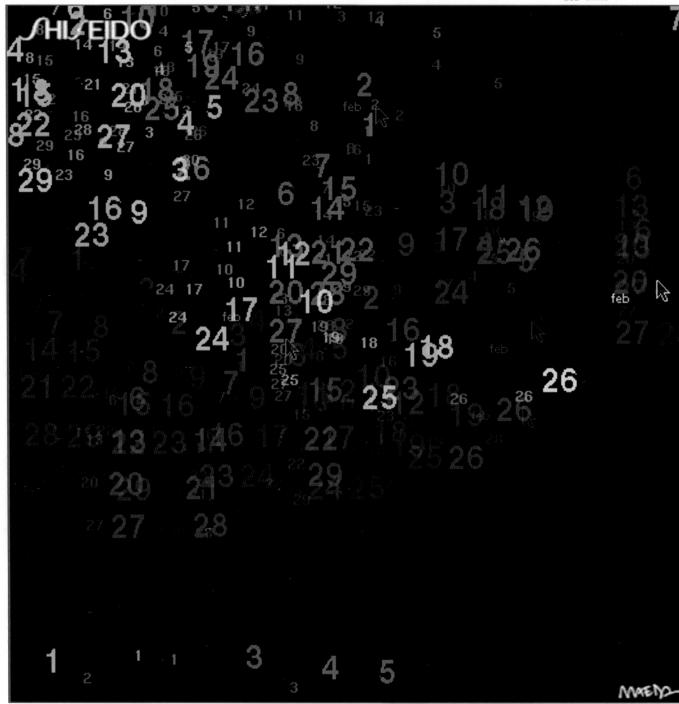

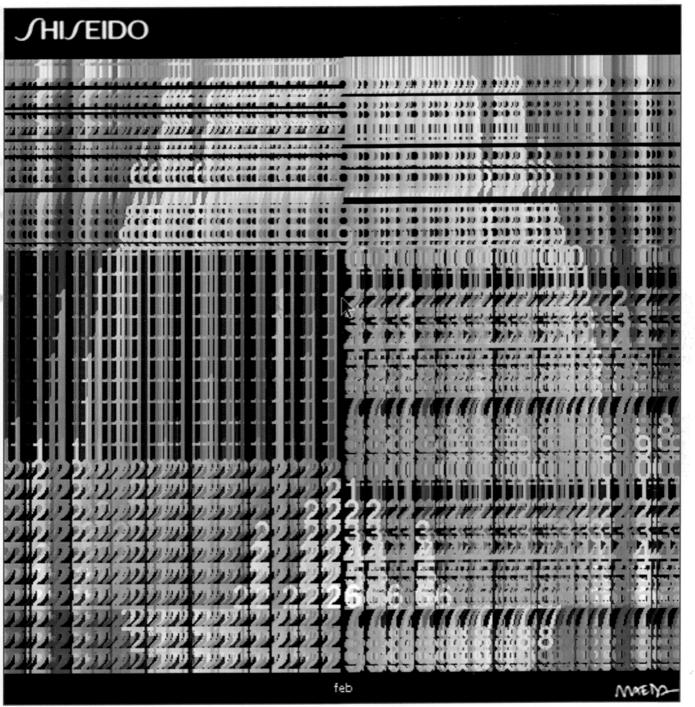

Winter remembered as an origami-like snowflake. Depending on the direction in which the mouse is spun around the center, the crystal increases or decreases in complexity. →

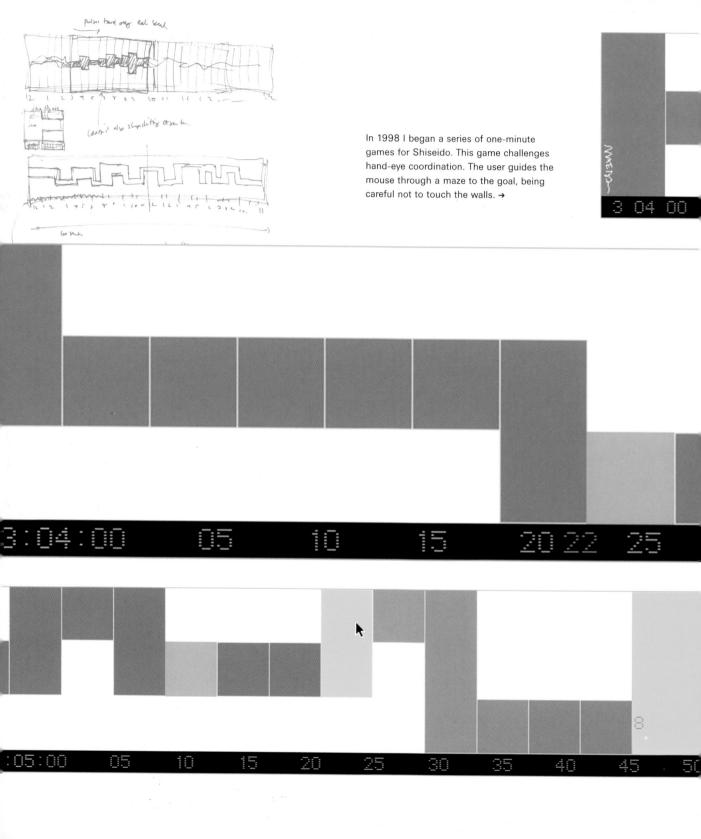

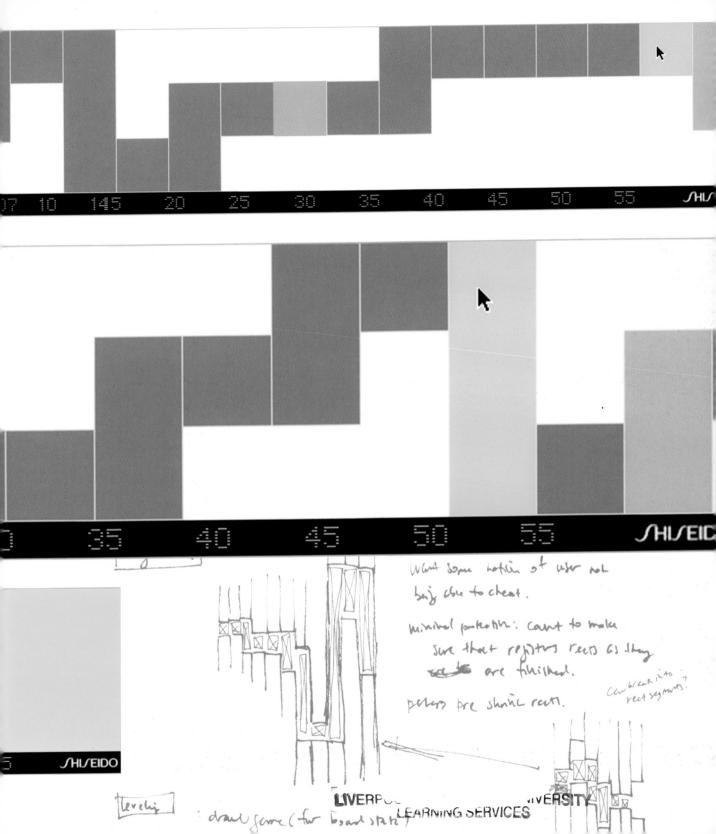

The computer is useful for managing a large set of similarly behaving elements. It is when the elements are dissimilar in size, shape, attitude, and behavior that most methods of programming fail. A completely new paradigm and kind of mind will be required to navigate the construction of future systems that scale infinitely.

brokgent chang i

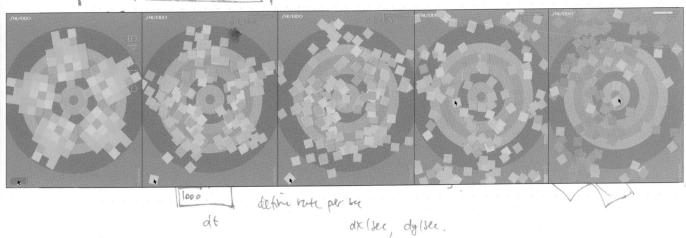

build Cache of recets. Or poly).

Catch as many cherry blossom petals as you can in one minute. →

Racing through a winding maze of twists and turns in one minute. \Rightarrow

In a game of strategy and vertigo, the player starts from the spinning center and attempts to navigate a path to the outermost layer in a variably rotating set of circles.

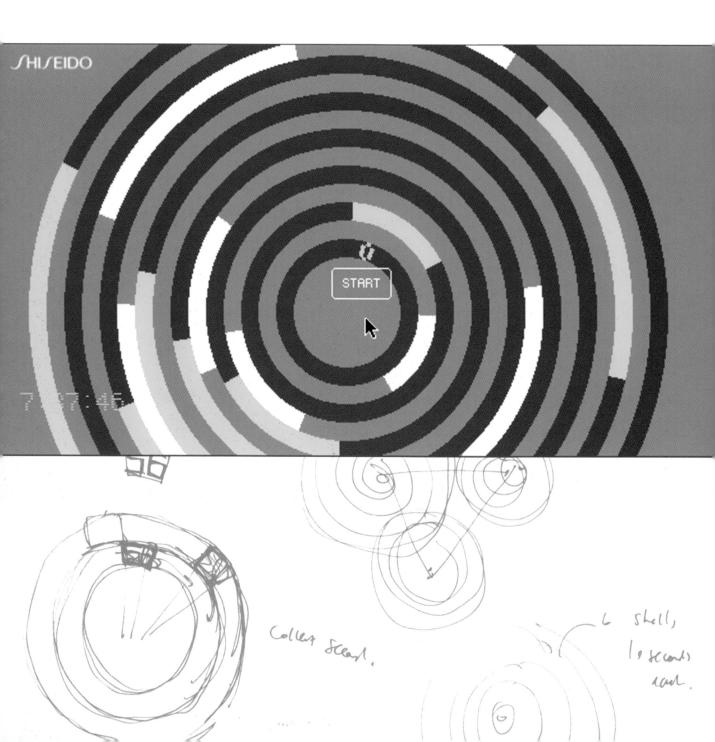

When a path traveled through interactive space is not in a planned horizontal or vertical motion, there can be a sense of thrill similar to riding a rollercoaster. For some it is an unwanted ride, in which case they should just get off; for others, it is a welcome moment of dizziness in an otherwise routine day.

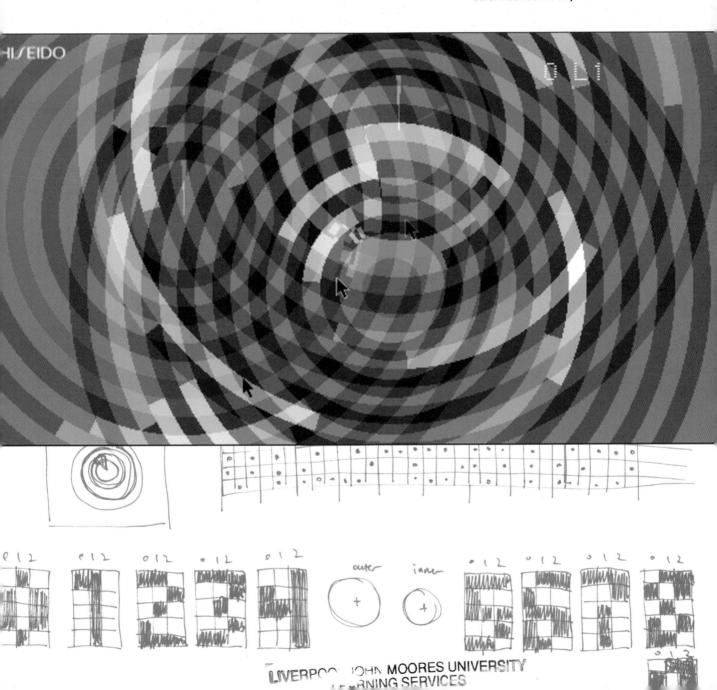

Unsolicited proposal for a denim pattern simulator for a jeans manufacturer.

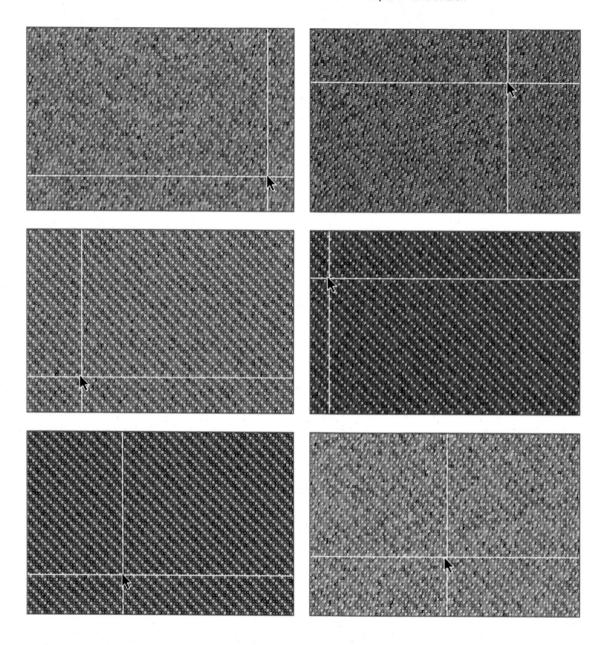

If a business proposal does not make immediate sense to a potential client, do not bother to desperately express the originality of your ideas. Exit gracefully, and trust that fate will guide you to a believer.

ABEDEFGHIJKLMNOPGRSTUUUXYZ abcdefghijklmnopgrstuuuxyz

Tangram typeface designed in 1993, dynamically reinterpreted in 1998 to celebrate the launch of the InterMedia Design Association in Japan. All seven geometric parts of a tangram are continually conserved across all letters, thus each letter freely morphs into another as subpart transformations.

The reinterpretation of a static piece as a dynamic form is usually a bad idea unless the original static form has either been developed with some degree of variability or is an unfinished work. An unfinished work represents a non-terminating point, which is precisely the rationale for any purely motivated dynamic form.

Nª İNter nedia design associatio 不容易的如何也 使用者 神经氏 布里电 经不可不能 单电电话或 的复数等 · 您是由你不以你看到外母生的各种的是如此我的历史是严重有严疑 · 型的母母的 · 佛会五多 · 好全 多是 身后 · 有我面面 · 多多角色 母参属和参考和面面系织织质量面全路或各类海鱼的三名母中似态。 аффАКСЗавылын Кане Кызы жыр бызы жарик с ■ 1 mter = media = design = association ■ inter media design association

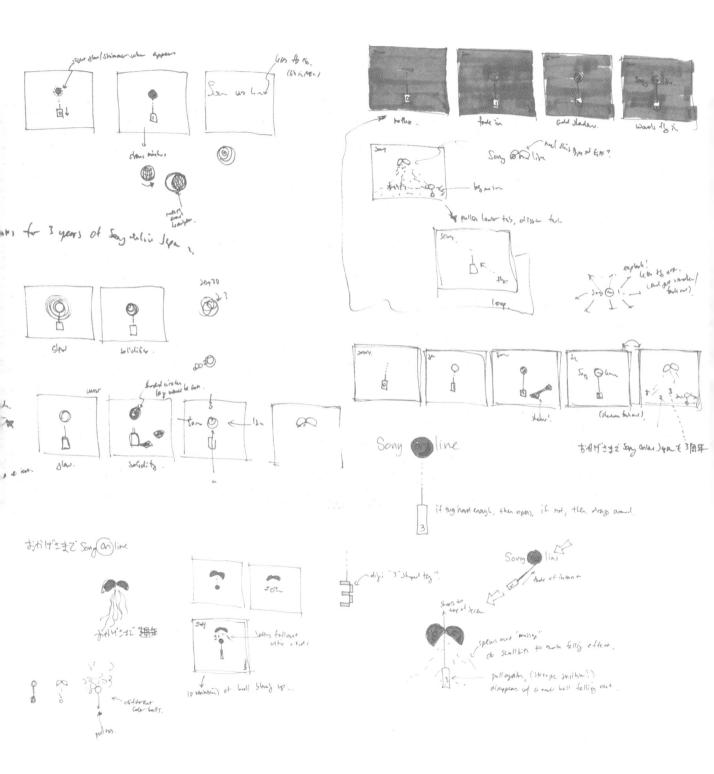

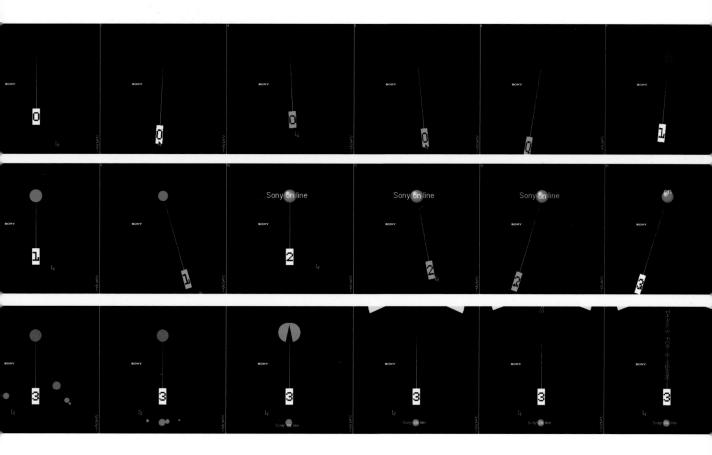

The majority of kinetic constructions I make today are limited to no more than three hours of total construction time. My reasons for doing so are a mixture of damaged hands, enforcing a small program footprint, and a desire to keep the program as simple as possible.

Ginza Graphic Gallery (GGG)

333

999

303

300

Because of their implicit use of mathematical structures, geometrically derived forms are perfect candidates for kinetic reinterpretation in the computational domain.

3 3

Center for Contemporary Graphic Art (CCGA)

Dai-Nippon Duo Dojima Gallery (DDD)

LIVERPOOL JOHN MOORES UNIVERSITY LEARNING SERVICES

It is doubtful that there will be great web designers in the manner that there were great print designers, such as Paul Rand, Saul Bass, Josef Müller-Brockman, and Yusaku Kamekura, for the simple reason that designing for the web exacts a curse with each project. Once printed, a print piece is finished; only in the rarest cases does it come back. A web piece is never finished, even after it is officially delivered and launched. Making sure that it works with every new browser release and operating system is alone a full-time job, which despite perhaps being a profitable support business, is another set of creative shackles that prevents your mind from running free.

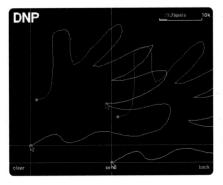

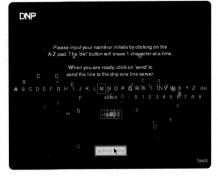

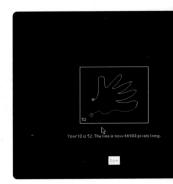

The One Line Project was conceived for Dai-Nippon Printing as a long-term web-based art project with the goal of spanning the circumference of the earth with a single connected digital line. Participants from around the world enter a stroke that is connected endpoint to endpoint with all the other strokes collected by the server.

An online digital Japanese typeface composed in four hours by eighty workshop participants in March 1997.

一七丁下三上丈万与丑不丘且世丙丞両中巨丸之丹主乃久及乏乘乙九也乱乳乾予 事二五互井来亘亜亡亦亥交亨享京亭亮人化介今仁仏以什仙他代付合伊仮会企伎 体仰件伍全仲伝任伐伏位何伽佐作伺似住伸体但低伯伴佑余伶依価佳侃供使侍舎 侮 併 侑 例 係 侯 俊 信 侵 促 俗 便 保 倹 個 候 倖 借 修 倉 値 倒 俳 倍 俵 倣 俸 倫 倭 偽 偶 健 偲 側 停 偵偏偉傘備傍傾傑債催傷僧働條僕僚億儀舗儲價優允元兄光充先兆克児免入八公 六 共 兵 具 典 円 内 冊 再 冗 军 冠 冬 冴 治 冷 准 凍 凌 凛 凝 凡 処 風 凱 國 凶 凹 出 凸 画 刀 刃 刈 切 分刊刑列初判別利券刻刷刺制到削前則剣剛剂剖剰副割創劇力加功劣助努励労劾 効動刺勇勉勘動務勤勝募勧勢勲勺匁包北旨区匹匡匠医匿十千午升半協尭卒卓南 卑博占卵印危却即卵卸厄厚厘原去参又収双反友取受叔叙叡了争口右可叶句古号 司史只召台各吉吸叫向后合吐同名吏否含吟君呉吾告吹呈呂呼周味命和哀哀哉咲 品員唆唇啄哲唐唄喝啓商唱問唯喚喜喫喬善喪嗣嘆嘉器嘱噴嚇四囚因回団囲困図 固国圈圖土圧圭在地均坑坂坊垂坪垣型城埋域基堀執堂培堪堅場堕塚堤塔塀報塁 塩塊塑塗驀境墊增墨墜墳壞墊壞壇壁士牡壱声壳変夏夕外多夜夢大太天夫央失奇 奈奉奔契奎奏奥奨奪奮女奴好如妄妃妥妊妨妙委妻始姉姓妹戚姻姿姫娯娘娠婚婆 婦媛婿媒嫁嫌嫡嬉宜実宗由定宝客室宣宥宴家害宮宰宵容寅寄寂宿密寒富寬寝寡 察寧審察寸寺寿対專封射将尉尋尊導小少就尺尼尽局尿尾届居屈屋展属層履屯山 岐岳岸岩 岬峡 峠 峻島 峰 崎 崇 崩 嵐 嵯 嵩 嶺 巌 川 州 工 巧 左 差 己 巳 巴 巻 巽 市 布 帆 希 帥 帝 帰 師 席 帯 常 帳 幅 帽 幕 幣 干 平 年 幸 幹 幻 幼 幽 幾 広 庁 庄 序 床 底 店 府 度 庫 座 庭 康 庶 庸 廃 廊廉廷延建弁弊式弐弓引弔弘弟弦弥弧弱強張彈肅彗形彦彩彫彪彬彰影役往径征 彼後待律從徐徒得御循復微微德徹並兼当尚單党巣営厳心必忙応忌志忍忘快忠念 怪性怖怜急思怠怒悔恒恨恩恐恭恵恕息恥恋悦悟悌悩悪患悠惟惨情惜悼悼惣悲惑 慌 惰 愉 愛 意 感 思 慈 愁 想 慨 慎 態 慕 慣 憎 慢 慰 慶 慧 憂 慮 憧 憤 憩 憲 憶 懐 憾 懇 懲 懸 成 我 戒 職 戱 戸 展 所 房 扇 扉 才 手 打 払 扱 技 抗 抄 折 択 投 把 抜 批 扶 抑 承 押 拐 拡 拒 拠 拘 招 拙 柘 担 抽抵拝拍披抱抹括挟拷指持拾挑拳拳振搜挿捕掛据掘揭控採捨授捷推接措掃探捺 排描掌握撥換揮提搭楊播携擠摄播機擴繫摩撮撒撲機擴擬擦支改攻放故政敏救教 敗敢敬散敦数敵嗷整文斐斗料斜斤斥断新方於施床族旗既日旧旦旭旬早易旺昂昆 早 昌 昔 明 映 昨 春 昭 是 星 星 昴 晏 晃 時 晋 晟 晨 暁 景 暑 品 晴 智 晚 普 暗 暇 暖 暢 暮 曆 暫 暴 曇 曙 曜 曲 更 書 曹 最 替 月 肌 有 肝 肖 育 肩 肯 肢 肥 服 朋 肪 胃 胤 胡 胎 胆 背 肺 胞 胸 脅 朔 脂 朕 胴 能脈朗腳脩脱脳望期朝脹腕腸腹腰膜膚膨臟木札本末未机朽朱朴杏材杉条束村杜 李果枝松枢析東杯板枚林枠栄架枯查柊柔染柱柄某柚柳柾案桜格核栞桂校根栽栈 株栓桑桐桃梅栗械梧梓梢梨棺棋極検植森椎棟棚棒椋楽棄業椿楠楓椰楊楼概構榛 槙 模 様 機 棍 槽 標 機 橘 橋 樹 檀 欄 欠 次 欧 欣 欲 款 欺 欽 歌 歓 止 正 武 步 歳 歴 死 残 殊 殉 殖 殴段教费殿毅母每毒比毛毬氏民気水永永汁汀求污汗江汐池汽決沙汰沢沖沈没泳 沿河边况治沼注泥波泊逐沸法泡油泉泰海活洪洗洲洵净津浅洗洞派洋浩消浸浜浮 浦浴流淚浪液涯渴溪混済渋淑淳渚渉深清淡添涼渥温渦滅湖港滋湿測渡湯滿湧湾 滑漢源溝準流滯漢滅溶滴漁漬漆漸激滴漂漫漏潔潤為潜滑淵激濁邊落濯濫瀬火灰 灯災炎炊炉為炭点鳥烈煮燒焦然無煙照煩熊熙熟熟燃燎燦燥燿爆爵父爽爾片版牛 物牧牲特镁大犯状狂狭狩独猪猫猛猟猪献猿烈歌獲玄率王玉玖珍玲珠班球現琢理 瑛琴琳瑚瑞瑶瑳瑠璃環爾瓶甘甚生産用甫甲申田由男町界畑畜畔畝留異略畳番疎 疑疫疾症疲病痛痘痢痴療癖癥発登白百的皆皇阜皓皮皿盆益盛盗盟監盤目直盲看 県盾省相眉冒真眠眼眺眸睡昏睦瞳瞭瞬矛矢知矩短矯石研砂砕破砲硬硝硫基磁碑 確磨磯礁礎示礼社祈祉祝神祖祐祥祭票禄禁禍禅禎福私秀科秋秒称秦租秩秘移稀 税程雜稔稜穀種稲稼稿穂穏積穫穣穴究空突窃窓窒窮窯立章竣童端競竹笑笙第笛 符 笹 筋 策 等 答 筒 筆 節 箇 管 算 箱 範 築 篤 簡 簿 籍 米 粋 粉 粗 粘 粒 粧 精 糖 糧 糸 系 紀 級 糾 紅 約紘索紙紗純素納紛紡紋経絃鉗錋紫終紹紳組紬累絵給結絢絞絶統絡辮組続維綺 網絡総綜耕綿網綾緑綸練緑綴緊縄締編緯縦縛繁縫縮績繊繭織繕繰伍罪署置罰罷 羅羊美着義群羽翁習翌翔翠翼翻耀老考者耐耕耗耳耶聖聡聞聴職肇肉腐自臭至致 興 舌 舜 舞 舟 航 般 船 舶 艇 艦 良 色 艷 芋 芝 花 芹 芸 芙 芳 英 茄 芽 苦 茎 若 苗 茅 菜 茂 荒 茜 草 荘 茶荷華崇莉菓菊菌菫菜菖著萌葵萩雞葉落蒔蒸擠蕎蓉蓮萬蕉藏薰薪邁薄裝蕗藤藤 藍藻蘭虎虛虛虞虜虫虹蚕蚁蛍蛇蛮蝶融血衆行術街衡衛衣表衿衷衰被袈袋裁装 裂補裕裝裹褐裸製複褒襟襲西要覆覇臣臨見規覚親寬観角解触言計訂記訓託討許 訟設訳詠菲詞証詔診訴評該請誇詩試詳誠營話訪語誤誌誓説読認誘渴課誼諄諸請 諾誕談調諒論諮謀論謡蓮謙講謝騰警識譜議護讓谷豆豐豚象豪貝貞負貢財貸貫責 販食質貴貸貯買費質資賊賃賄費賜賃賞賠賓賦賢購贈赤赦走赴起越超趣足距跡践 跳路踊路躍身車軌軍軒転軟軽輔較裁輔輝 輩輪輪轉辛辞辰辱農辺込巡迅近迎返述 迪 迭 迫 逆 送 退 追 逃 迷 逝 造 速 逐 通 避 途 透 連 逸 週 進 逮 運 過 遇 遂 達 遅 道 逼 遊 遠 遠 遺 遮 遭 適 遺 遵 選 遷 遼 還 避 邑 那 邦 邪 邸 郁 郊 郎 郡 郭 郷 都 部 郵 酉 酌 酒 配 醉 酢 酬 酪 酵 酷 酸 醇 醜 釀 采 积 里 重 野 量 金 針 约 鈍 鉛 鉄 鉢 鈴 銀 銃 銭 銑 鋼 銘 鋭 鋳 錦 鋼 錯 錠 錘 錬 録 鍛 鎖 鎮鐵鏡鐘艦長門閉開間閑閣閱閱閱閱防阿阻附限院陷降除陣陸陰險陳陶陪陸降陵 階 隅 随 隊 陽 隔 隱 際 障 隣 隷 隼 隻 雇 集 雄 雅 雌 雜 難 難 雨 雪 雲 雰 電 雷 零 需 農 霊 霞 霜 霧 露青靖静非面革靴鞠音韻響頂項順須頑頌頒預領頭賴頻額顯顕題類顧顧風颯飛食 飢飲飯飼飾飽養餓館首香馨馬駅駆駄駒駐駿騎験騷騰驚骨髓高髮鬼魁魂魅魔魚鮎 鮮鯉鯨鯛鳥鳩鳴鶏鶴鷹鹿麗麟麦麻磨黄黎黒黙黛鼓鼻斉斎歯齢竜亀あいうえおか きくけこさしすせそたちつてとなにぬねのはひふへほまみむめもやゆよらりる れろわをんがぎぐげござじずぜぞだぢづでどばびぶべぼばぴぷぺぽぁぃぅぇぉ っやゅょゎアイウエオカキクケコサシスセソタチツテトナニヌヌノハヒフヘホ マミムメモヤユヨラリルレロワヲンヴガギグゲゴザジズゼゾダヂヅデドバビブ ベボパピプペポァィゥエオッヤュョワカケ 0 1 2 3 4 5 6 7 8 9 A B C D E F G H I J K L M N O P Q R S T U V W X Y Z a b c d e f g h i j k l m n o pqrstuvwxyz.,!@#\$%^&*:;?!()[] [] /\.

一七丁下三上丈万子丑不丘且世内还两中巨九之丹主乃久及乏乗之九也紅紅紅子 事二五互并来直垂亡办玄交 亨亨 京李思人 化介含仁仏以什仙他代日》 9 级公会经 体仰件伍全伸任任代伏位何伽佐 年月12日(中山里低伯伴佑余伶依纽任服供此井会 **悔併侑例係候復信侵促俗便保倹/回农住信修分订倒俳倍债僬俸偷仔妈妈健鄉內仔** 值偏傳傘偏傍傾傑信催傷僧働像達徑信儀請慮於優允元兄光充先表見光色入八公 六共兵具典円內獨無完軍冠冬河治冷准凍沒沒沒凡犯風的風的閱過面面到到到的 分刊刑列初判別利舉劉刑劉制劉則前則則四則刮到副創創別力加助劣師努前 効動動動動動動務動勝幕翻發的勺切包比 8 巴匹耳丘医医十千午升半衛奉奉奉命 平得白卵印危却即卵瓣照厚厘厘基去参又収Ⅱ B 反取受赦叙数了手分合可吃旬苦冒到史只因台各吉喂岬向后会吃回名表西含のお与吾告吹呈吕呼用味命和其良裁蹊 品員咬唇啄哲唐明喝咨商福問唯喚喜喚喬善喪嗣噯嘉器嘱嗒嵊田④⑥⑥④●⑧⑧ 廊廉廷基建并常式式弓引电兄弟虽然最高思导介南驾车产店肥龄也的职权业证 在 使後特律從徐徒得都獨復微復遊撒並兼当问三菜果宮藏心必怕応忌志尽及快之之 行任持伶支之免禁悔框框思語基意思息取悉悅格係惱思惠怒惟徐情情怜悼怨忠遠 【代价伶支之冬克慈悲悲ņ枝枝竪蓄悚惺悚鹙濩鐾憂慮憧憤憩鬼憶懷<mark>憾懇怒怒成我戒</mark> 我就了美所务扇扇才手打拉报技抗护折択投把技批扶彻承押拐拡**桅楔杓稻柑杨桓** 抽批抖拍仄冗抓摆摆摆转持给排拳拳振搜掉捕掛据掘揭控採捨授捷權接檔棒探捺 排后等抗疾快挥捏搭接投投按照损搬摘擊摩操撒摸操擁擺擦支改攻放放政领权数 收收可取打收收款整文 斐斗料斜斤斥断新方於物地如早易旺昂昆地如早易旺昂昆兵吕古叫中下古昭是是昼昂晏晃時晋風晨晚景暑暖暢暮曆暫暴曼暖暢暮曆暫暴慢 瞪暗 出了丰富改誉月肌有肝肖香肩肯肢肥取朋防跑的骨朔脂朕胸跑胸骨朔脂朕胸 服 四川坑 間 同型 期朝服服陽服 腰膜 庸鄙城木札 各村 杉条東村 社 杏树 杉条東村 社 果 以 也 匹 東 杯 板 杖 林杵 荣架 枯 責棒 柔 染 柱 柄 棱 栞 桂 校 根 栽 桟 稜 栞 桂 校 根 栽 桟 殊栓桑桐桃梅栗被絕梓梢梨棺棋極検桓森椎楝棚棒椋橐棄業椿楠楓槐褐棒椸構棒 模模樣橫機権槽標機橋橋村檀欄欠次欧依欲款数飲歌飲止正置步歲歷死残殊殉殖 殴段毅毅毅毅母每毒比毛继氏民気水水米汁汀求污汗江汐地区决沙然又沖沈没冻 沿河江况治沼注泥波治泌拂法泡油泉泰海浩洪洗洲河净津浅洗湖涨洋浩消浸洪浮 浦沿流淚浪液涯揭渓混済洗淑淳着涉深清淡添涼渥温渦滅湖港滋湿測渡湯滴湧湾 滑運浪涛準淹沖漠臟溶演漁漬漆漸激滴漂漫漏潔問為密宣例鎖濁濃渗灌濫湃火灰 灯災炎欢炉為炭点鳥烈煮燒焦然無煙照懶熊熙熟熱腦炸採掉耀爆會父爽爾片版牛 物牧性持議紛犯状狂發發強豬猫猛猟猫酞馥微獸德之平王王叔珍珍珠班球現琢理 延琴琳珊瑞程建珊璃環爾瓶甘其生產用南甲申田中門門 田奈解飲留果略量養課 疑疫疾症疫病痛瘦痢病疾癖振発登白百的皆皇阜的及必<u>省益盛智盟監盟目直首看</u> 具盾省相眉冒真眼眼睛睡曾瞪魔旒厨子完如笼虹烧石研醪橡破碗硬桶硫基磁路 **税程推捻接毂捶箱格稿機構模模農官官官** 符笹筋策等咨简单等值曹军籍範集篇前簿籍器評粉網粘糖瓶精糖體系系紀級針紅 约被索轨约批素的物物软轻核相论学设治评准治累积给结构键稳战络触编级维椅 鋼貓 筋 寐 雜 課 纏 綾 綠 編練 緣 緩 緊 視 拝 編 肄 擬 評 繁 婚 鄉 緒 衡 面 敞 繕 侵 士 罪 署 羅芋芙薯菩萨腳翁習聖翔翠翼翻耀老者看耐料耗耳耶聖縣開聽職管內腐自臭互政 赖方舜舞必舒紛紛舶艇繼良色艶芋芝花芹芸芙芳英茄芽苦茎若茵茅菜茂荒苗草莊 苦茴辛黄蓟草葡萄堇菜菖蓍萌葵菽苹菜落蒔蒸蒼 香吞蓬 蔫蕉成薰新属浑栗 路藤藩 藍落繭虎虐虛虞虜虫虾蛋蚊蛍蛇蛮蝶肚血汞行術術衛衛衣表於表表被袈袋裁設 迪沙坦逆送退逆进达进造速逐通遍途法連说调進遠運過遇透達遲遭區跡選遭遭遭 遮遺通遺進選遠遠還避邑那邦邪邸郁郊郎郡郭鄉都部都面酌酒配醉酢酬酪醋醋酸 醇酰酸采秋里重野量全針釣鈍鉛鉱鉄鉢鈴銀鲩銭銑銅鉛鋭鋳錦銅錯靛鱹錬錄鍛韻 鎮鍊鏡鐘鑑長門開開間開間開開閉開的的阿阻阿限院陥降院褲陛陰險陳陶陪陸隆陵 階隔随隊陽隔隐陸障陵隸隼隻星集稱推雌推盤難離雨雪雲雰電雷響需慶靈霞霜霧 露青靖靜非面革靴胸音韻響頂頂順領領領預預領頭賴賴額顏題題類願顧風颯飛食 9 *noise* According to basic information theory as formalized by Claude Shannon in 1948, information can be mathematically modeled as a stream of variable amounts of noise. In essence, the noisier the stream, the more "information" there is. As a result, by application of a simple equation it is possible to show that an expressionist painting by Jackson Pollock has infinitely more "information" than a suprematist painting by Kasimir Malevich. Though this is an unsurprising result from an immediate perceptual perspective, it is inaccurate when considered from the perspectives of content and context. Meanwhile, the computer forces our society to think within the metrics of information its continually reported size in kilobytes acts as a constant reminder. We are implicitly guided by the belief that more is better, and as a result expect extreme chaos or any other mode of lavish detail to signify success in the digital medium. The shortest path to the destruction of order is to introduce massive irregularities induced by random noise—a process often glorified as intentional homage to the spirit of dada. Noise should neither be seen as noble nor as a necessary improvisational aid; it is a numerical color that can be quickly overused.

	Charles of the Charle	
	CONTRACTOR OF THE CONTRACTOR O	
	SALES TO SAL	
	A PACKET OF THE	
	A CONTRACTOR OF THE PROPERTY O	
	The second secon	
	Take the transfer of the second secon	
	March 1915 A. Charles Company of the	
	The second secon	
	COLLOS ACTIVATION OF THE COLLOS AND ACTIVATION OF THE COLLOS ACTIVATION	
•	The state of the s	
	The Sund of the digital and the sund of th	
	A State of the sta	
	The state of the s	
	Land A specific and Control of the C	
	The state of the s	
	The second secon	
	THE PARTY OF THE P	
	The second secon	

10 **now** After beginning my first reactive graphic experiments, I sent an e-mail from Japan to Muriel Cooper: "I figured it out!" She was notorious for never answering but replied, "Good. Show me." I was greatly saddened when I learned she had passed away just a week later, and I would be unable to show her what I had begun to uncover. A few years later, the head of the department, Whitman Richards, led a search to return the spirit of design to M.I.T.'s Media Lab. Considered a candidate, I was asked to give a job talk at M.I.T. The day before my talk I had met Paul Rand at his house in Connecticut and was in such high spirits that I cared little about the position. This must have been a useful attitude as I was subsequently offered the job. With my new teaching commitments, I worried that I wouldn't be able to continue designing, but the head of the lab, Nicholas Negroponte, reassured me that the job was to spend four days a week at the institute and the "other three days" to pursue my design career. "How nice," I thought. With the time left over from managing my research group, I continue to experiment in reactive, static, and online media. I hope to carry on.

As a graduate student at M.I.T., I stumbled upon a thin, nondescript book called *Thoughts on Design* by Paul Rand. At the time I was trying to build a reputation for myself as a graphical user interface designer. But as I flipped through Rand's book, I was humbled by the power with which he manipulated space and the clarity of his prose. I was immediately inspired to pursue the field of graphic design, not necessarily pertaining to the computer.

It was fitting that eight years later, I would return to M.I.T. as a professor of design, and that I would host a lecture by Paul Rand at M.I.T. The time for the lecture was set at ten in the morning. An early lecture in American universities is rare because students usually study late into the night and are less apt to attend early events. But Rand insisted that he speak in the morning. He said, "If someone isn't willing to wake up to hear me to speak, I don't want to speak to them!"

The auditorium was packed beyond capacity with people from all over New England, some waking up as early as five in the morning to arrive in time for the lecture. The Director of the Media Lab, Nicholas Negroponte, later remarked that during his career at M.I.T. he had never seen such an overwhelming audience for a morning lecture. Although the lecture hall was crowded, complete silence reigned as everyone's attention was completely focused on Rand.

The night before the lecture we had dinner together. Afterwards he asked me, "So, what are we going to talk about tomorrow?" My immediate reply was, "We?" He said, "Yes, it's boring if I just get up there and talk. So let's have a conversation first." Following Rand's request, I began with some very basic questions.

PR: I've waited eighty-two years to come to this place. I knew Gyorgy Kepes and Muriel Cooper, but they never invited me. I'm wondering why Mr. Maeda invited me at this late date, but I'll do my best.

JM: What is design?

PR: Design is the method of putting form and content together. Design, just as art, has multiple definitions, there is no single definition. Design can be art. Design can be aesthetics. Design is so simple, that's why it is so complicated.

JM: What is the difference between a designer and an artist?

PR: There is no difference between a designer and an artist. They both work with form and content. I try to create art, whether I make it or not is not up to me, it's up to God.

JM: What is the difference between *good* design and *bad* design?

PR: A bad design is irrelevant. It is superficial, pretentious ... basically like all the stuff you see out there today.

JM: What are the fundamental skills of a designer?

PR: The fundamental skill is talent.
Talent is a rare commodity. It's all
intuition. And you can't teach intuition.

JM: Most of your designs have lasted for several decades. What would you say is your secret?

PR: Keeping it simple. Being honest, I mean, completely objective about your work. Working very hard at it.

JM: How did you get started as a young designer?

PR: (raising his eyebrows) I think you should ask instead, "How did I get started as a baby?"

After his lecture, Rand offered to autograph copies of his books and there was a line that did not clear up until an hour later. I tried to shuttle him off to a private reception but he refused to leave until all the people in line were signed and served.

His lecture was so well received at M.I.T. that Dean William Mitchell and Negroponte suggested that Rand join the faculty at the Media Lab and we immediately began the process of appointing him. Negroponte wanted me to confirm Rand's interest in joining the Lab, after which we faxed Rand explaining the situation. He replied, "Of course I accept the position." A few days later he passed away.

Graphic design which fulfills aesthetic needs, complies with the laws of form and the exigencies of two-dimensional space; which speaks in semiotics, sans-serifs, and geometrics; which abstracts, transforms, translates, rotates, dilates, repeats, mirrors, groups, and regroups is not good design if it is irrelevant.

Graphic design which evokes the symmetria of Vitruvius, the dynamic symmetry of Hambidge, the asymmetry of Mondrian; which is a good gestalt, generated by intuition or by computer, by invention or by a system of coordinates is not good design if it does not communicate.

lawh suis

Yale University Professor Emeritus

Designer of many of the canonical identities of corporate

America including ABC, IBM, Westinghouse, UPS, and NeXT.

Paul Rand at the MIT Media Laboratory

November 14, 1996 10 am to 11:30 am

Bartos Theater MIT Wiesner Building

Open to the public and admission is free. For information call (617) 253-0356, or visit http://acg.media.mit.edu/rand.

LEARNING SEHVICES

TATEGUMI YOKOGUMI MORISAWA QUARTERLY 1997 50

GILBER'

BEGREAT

Gilbert Realm promotional book, pages 15 to 18 (gatefold spread)

Based on the electric typewriter as an homage to my mother's incredible typing skill, the fourth Reactive Book was entitled TAP, TYPE, WRITE. →

Sound as an effect, versus a necessity, is a difficult distinction to make. We expect most of our actions to result in reactions that are not only visual but aural. Without sound. one is distanced in reality from the reaction, making it more abstract. Once a sound is made, however, your body receives confirmation that the event is not imagined, but real.

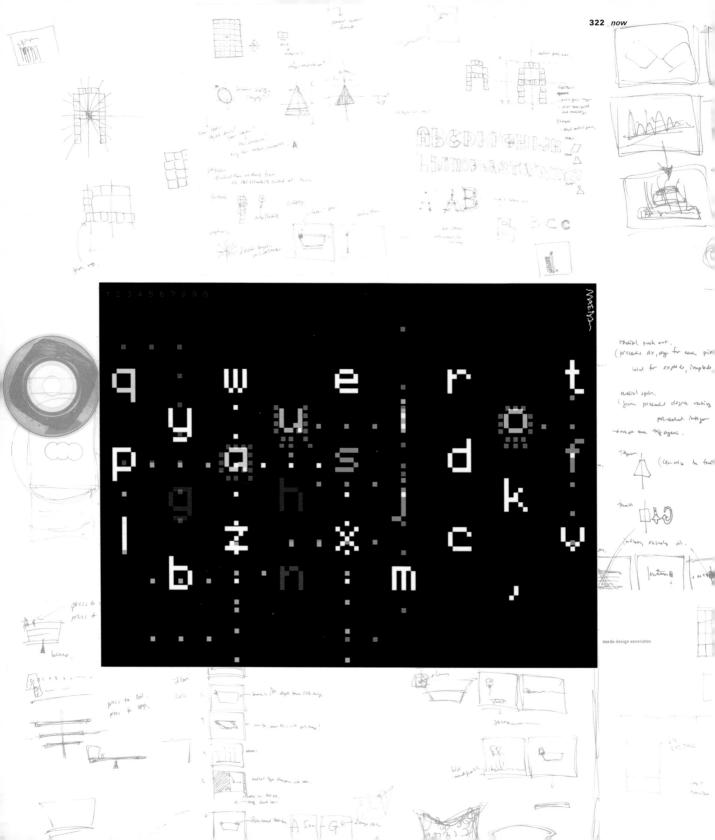

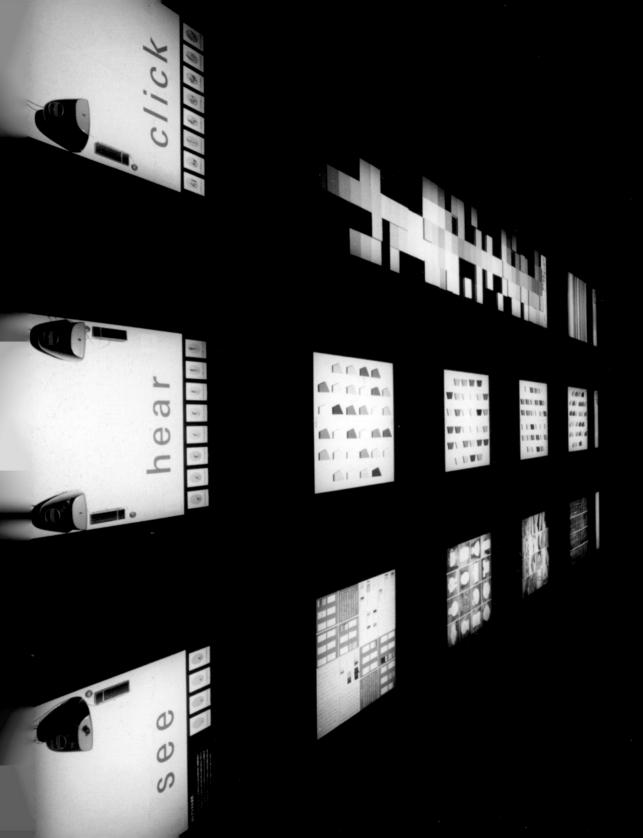

Cutting-edge content is most easily created under situations where great physical distances separate the client and artist. If the option to move farther geographically from the client is not possible, then achieving stature in one's field also appears to be a key factor. However, the latter approach is much less reliable, and often less meaningful than a healthy move.

Project for the Japanese paper company Takeo using three computers that respond to sound, mouse, and video input (see, hear, click), each of which generates related print-outs.

LIVERPOOL JOHN MOORES UNIVERSITY LEARNING SERVICES

Proposal for a new launch page for the Media Lab. It was turned down because "it doesn't do anything."

The New Hork Times Magazine

OCTOBER 10, 1999 / SECTION 6

NEWNEWNEWNEWNEWNEWNEWNEWNEWNFWNFWNFWNFWNFW

How Jim Clark taught America what the techno-economy was all about. By Michael Lewis

A core challenge of digital art is to establish the relevance of a physical place in relation to virtual space. Drawing on the inherent similarities between the two spaces is a tiring theme that reveals nothing more than what is presented. Within their respective contexts, each space presents the differences as honest facts versus forced fiction.

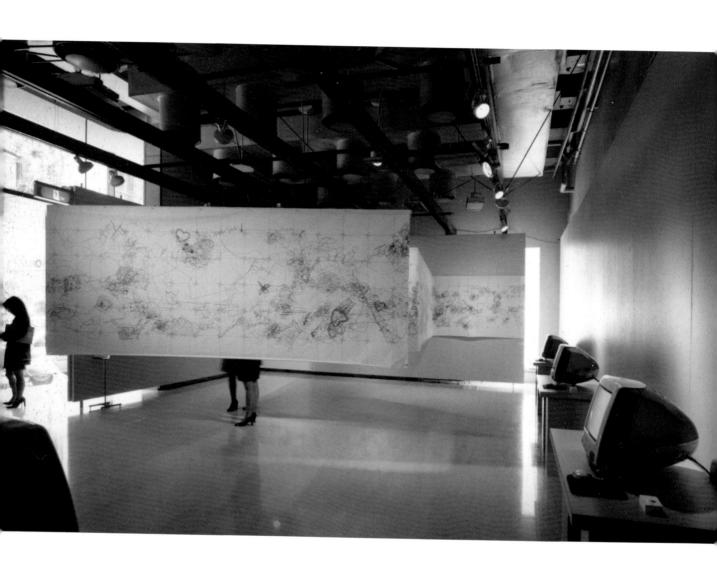

In August 1999 the status of the One Line Project was presented at the Ginza Graphic Gallery. An 80-meter-long printout was displayed together with ten computers showing digital interpretations of the One Line Project data. →

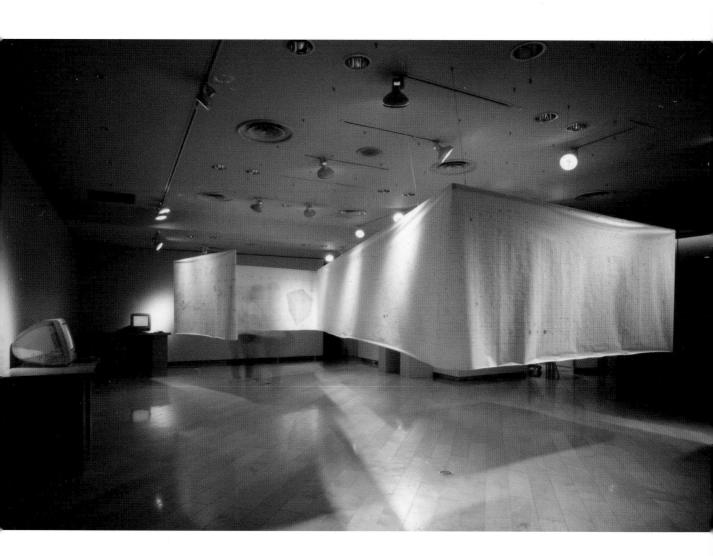

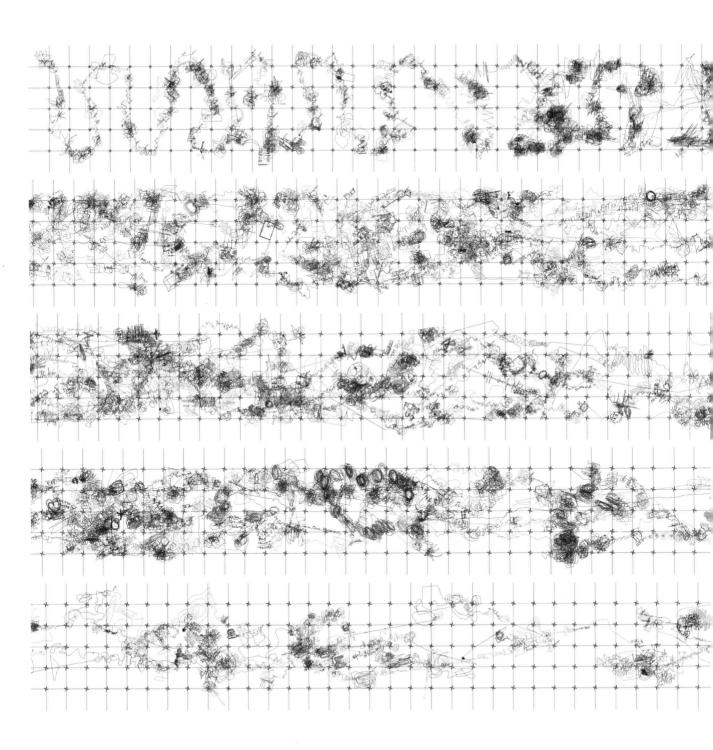

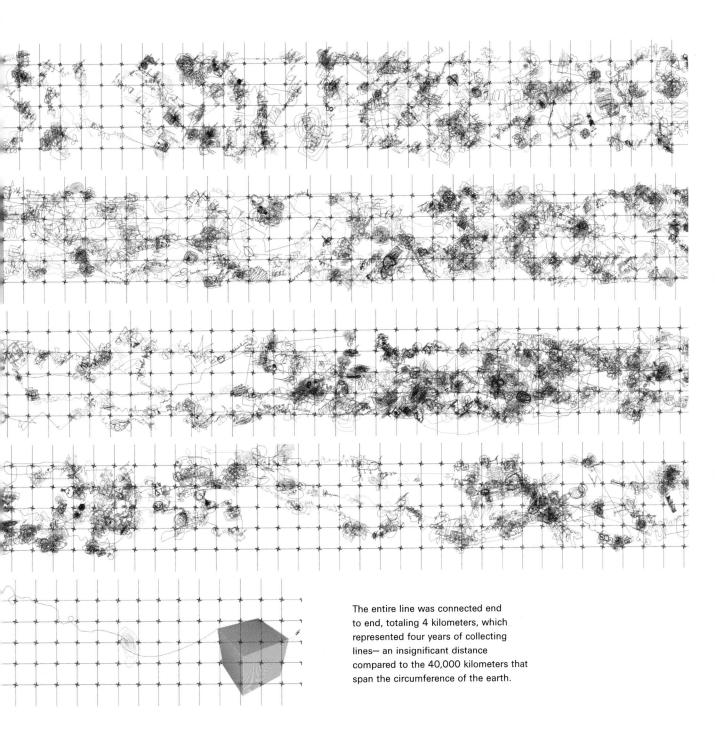

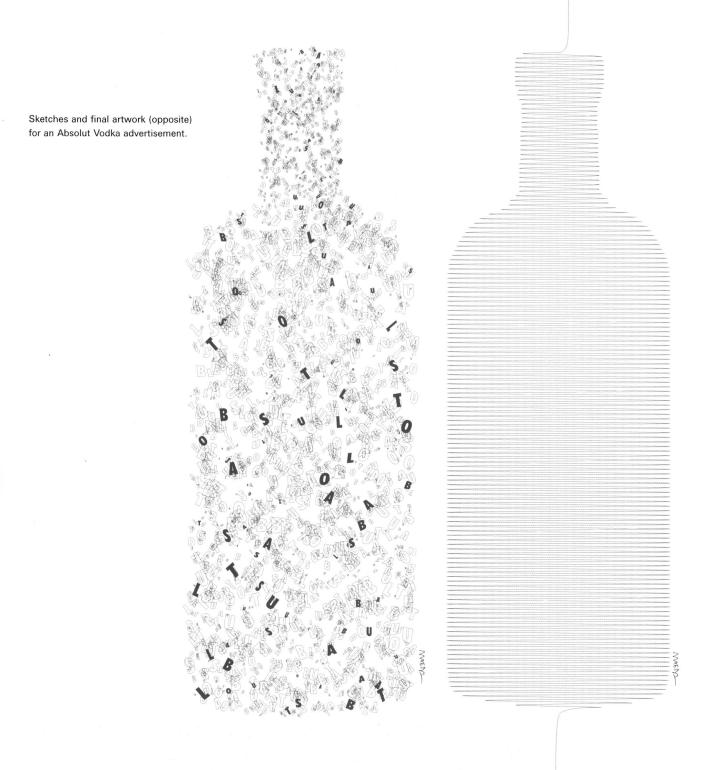

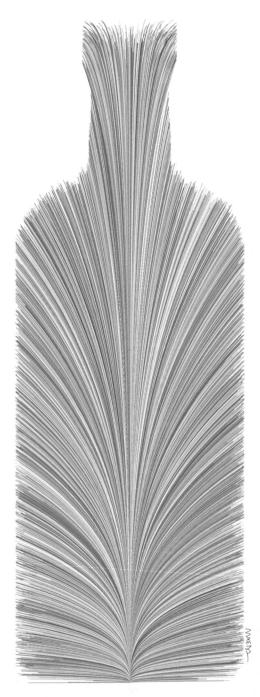

ABSOLUT MAEDA.

AS OWNED BY VAS VAN & SPHIT AND O1999 VAS VAN & SPHIT AND ONE SPHIT AND ONE SPHIT AND VAN WAS VAN AND VAN WAS VAN AND VAN WAS VAN AND
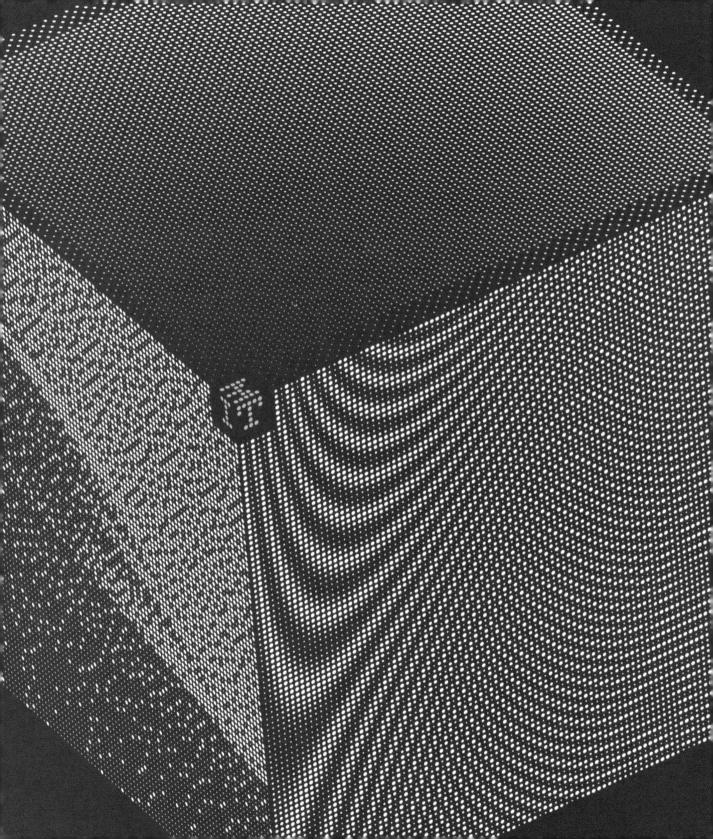

M.I.T. shirt created in reaction to the substandard generic collegiate T-shirts that prevail everywhere today.

11 space In the religion of book design there are many interpretations of the truth, many faiths, many sects that silently clash in regard to proper margins, proportions, and, most importantly, the holy science of typography. For a time I was blissfully brainwashed to follow the absolute laws of the Swiss layout mantra-the Grid. Whenever I committed a sin such as the lackadaisical placement of a text block without exactitude, I was prepared to be struck down by lightning. Heaven forbid that I should rely solely on my intuition! Over time I realized that with consistency the lightning never came, and I further discerned that my .01-point precision wasn't worth anything unless I was willing to print and trim every single page of paper by hand. Perfection is an exciting goal, but the imperfect nature of the mechanical production process suggests that you seek more realistic thrills than perfection. Such excitement always lies beyond what is known to be creatable; it exists in the conscious expansion of creativity itself. Look deeply into a set of tools and materials and coerce them to reveal their hidden potential. Discover their core abstract properties by ignoring the constraints dictated by uncreative conventions.

start here

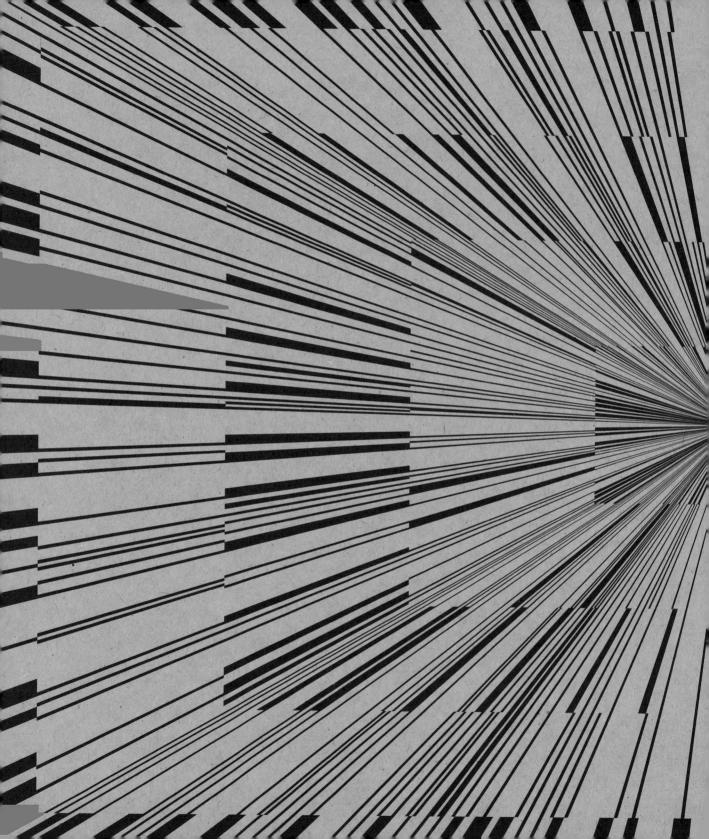

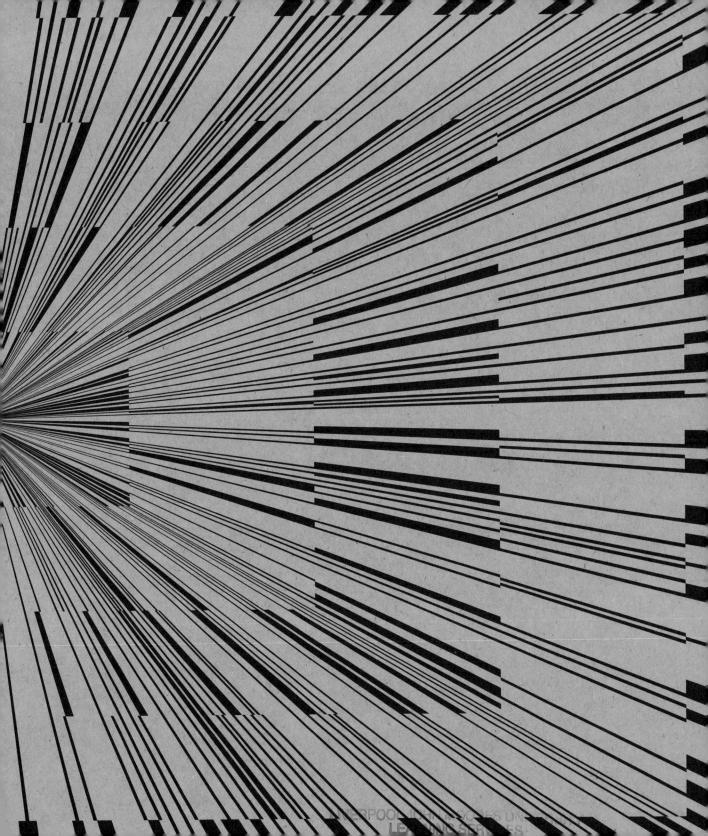

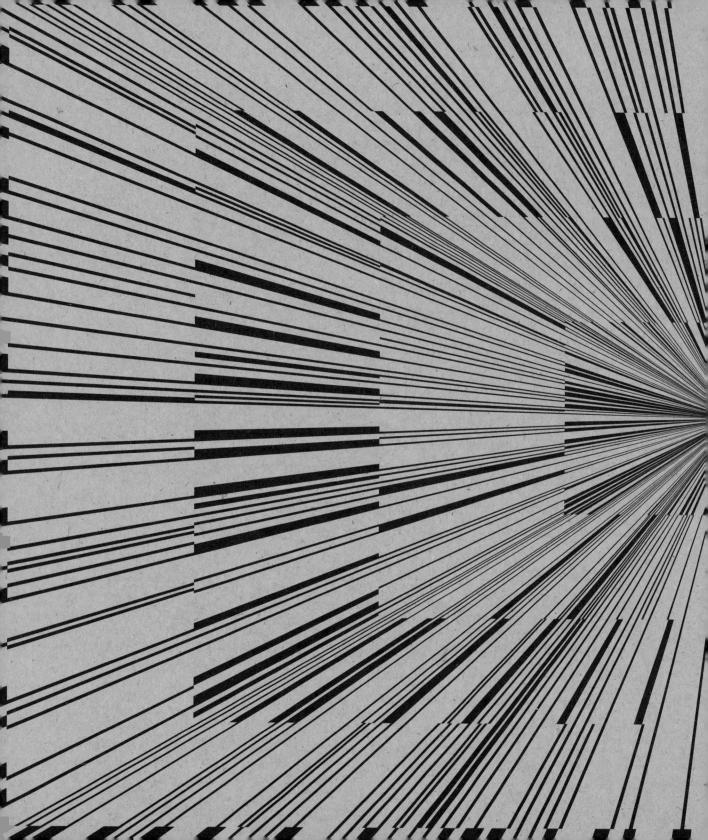

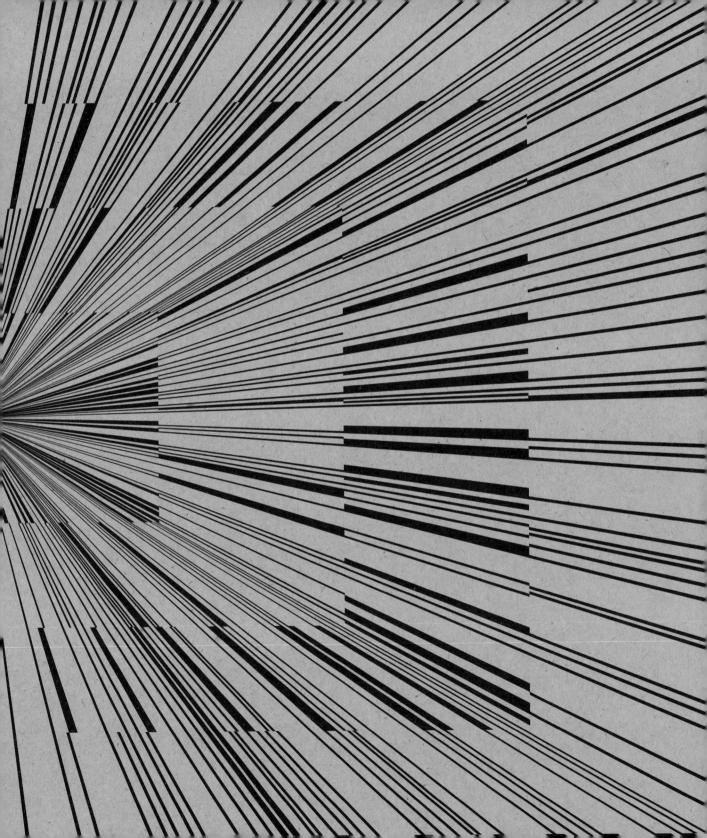

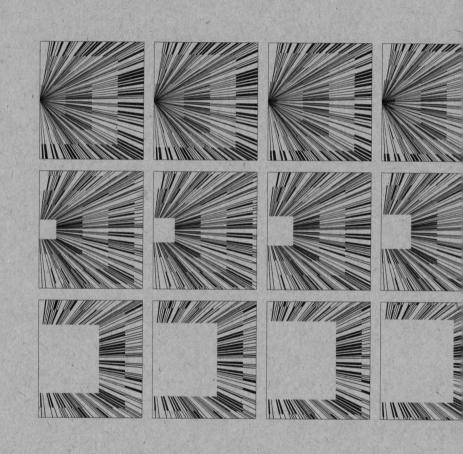

TIME I HERITI I HILL

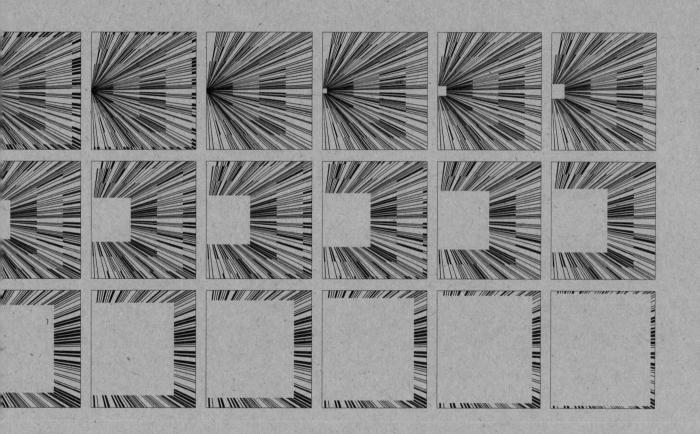

12 *computer* In Japan a *miyadaiku* is a carpenter trained in the ancient art of Japanese temple carpentry who attains special status from the emperor if the temple he builds stands for more than a thousand years. "Such temples," said one of the last miyadaiku, the late Tsunekazu Nishioka, "stand not because of the magnificence of their design, but because the *miyadaiku* goes to the mountain, and selects trees from the south face of the mountain to be used for the south face of the temple, trees from the west face of the mountain for the west face of the temple, and so on for the other two sides." Because building materials are carefully selected to respect the laws of nature, the temple coexists in harmony with nature. Both the extrinsic and intrinsic qualities of the temple radiate its overall strength and beauty. Meanwhile, in the field of digital art, an entire generation of creators shop at the equivalent of home improvement megastores, eagerly acquiring all kinds of prefabricated components and add-ons. Blissfully unaware of-or even worse, uninterested in-the basic nature of the technologies they are using as tools, the creative élite oversee the assembly of substandard digital objects and experiences.

I was inspired to creatively explore software in 1988 by the work of the incomparable animator-hacker Bob Sabiston. The result was a year-long immersion in an animation system motivated by ideas in sketching versus finished animated work. →

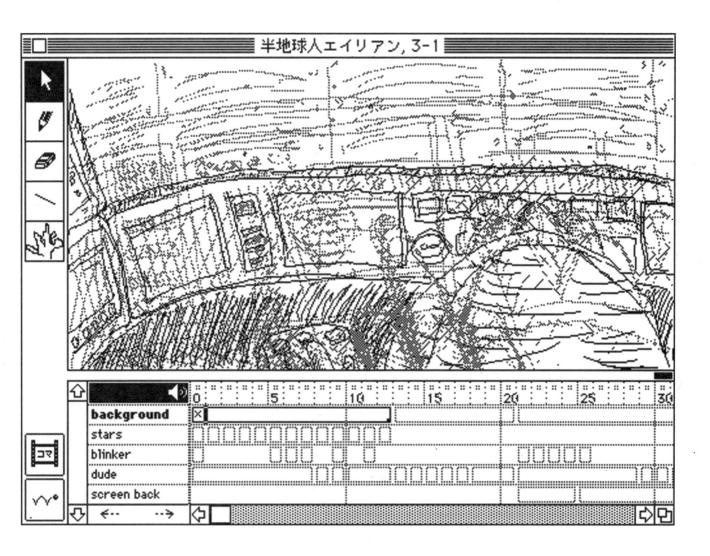

The dilemma for a person who builds tools for others is that she rarely learns how to use it for herself. As a selfless virtue, creating new tools for others is a commendable public service that has its own set of rewards, sometimes monetary, in which case the virtue value lowers proportionately. One can argue that the design and implementation of a software tool is by itself an extremely creative, artistic activity. History shows, however, that it is the artist who first effectively uses a new tool, not the person that makes the new tool, who is remembered.

The intent of devising a tool for animation was to create images I had in mind. But by the time I had completed the tool, I had lost interest in making an animated feature altogether.

The process of programming is to unerringly describe the structure of a machine as a sequence of textual codes, which when brought to life in the mind of the computer performs a specific processing task. A major flaw in programming methods is the vast chasm that separates the program's cryptic codes and its graphic output. There is no greater need for visual design than rethinking and redesigning programming itself.

Inspired by early computer artist A. Michael Noll's programmatic adaptation of an artwork by Bridget Riley, I further interpreted it as a small program in the PostScript language.

```
/nollcurve {
 /stepamp exch def /numsteps exch def /cycles exch def
 /xscale exch def /amp exch def 0 amp moveto /curx 0 def
  1 1 cycles {
   /i exch def /radbase 180 i 1 sub mul 90 add def
   /numinors numsteps stepamp i mul mul def
    /dx 180 numiners div def /x radbase def
    1 1 numiners {
     pop curx amp x sin mul lineto /x x dx add def
     /curx curx xscale add def
    } for } for stroke } def
/noll90 {
 .7 setlinewidth 0 setgray
 1 1 90 {
  gsave 3.4 mul 20 add 0 exch translate
  15 1 9 8 1.25 nollcurve grestore
 } for } def
noll90
```

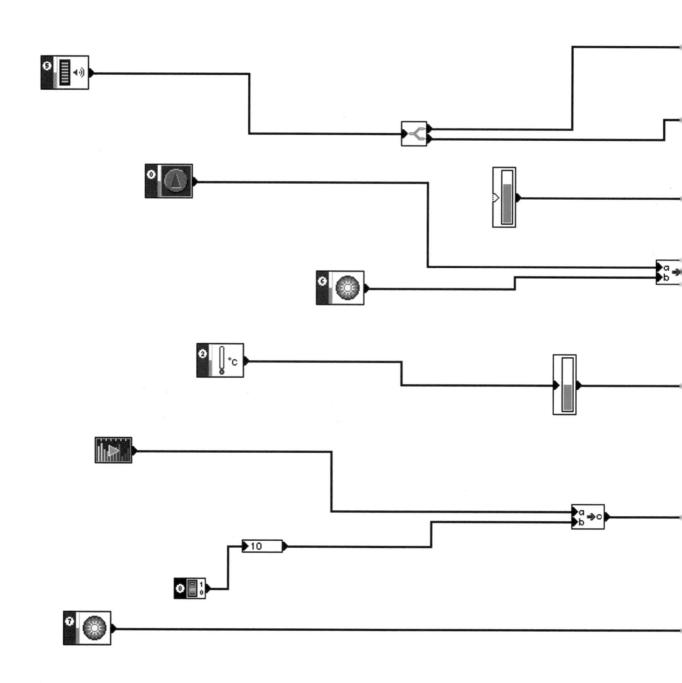

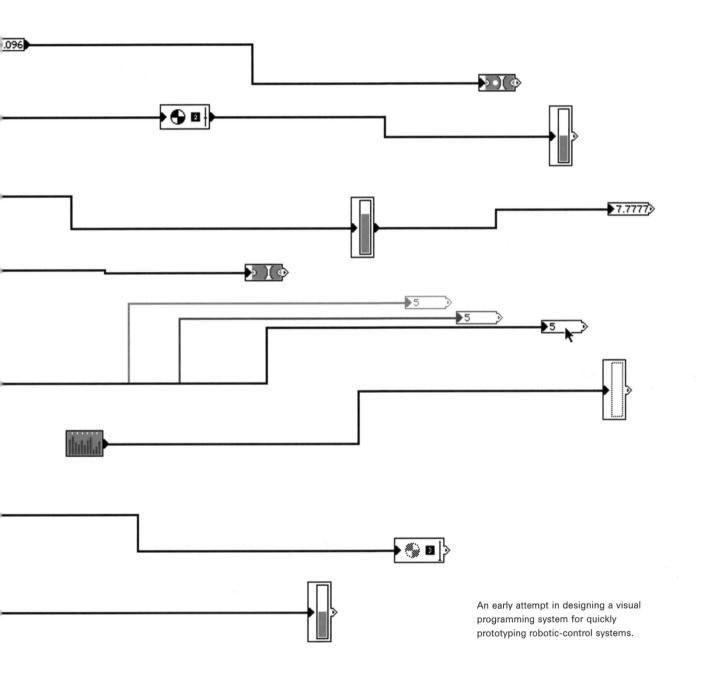

LIVERPOOL JOHN MOORES UNIVERSITY LEARNING SERVICES

A-Paint, or "Alive"-Paint, suggested a way to program an illustration based on the properties of pen strokes, and how these different strokes might interact both temporally and interactively.

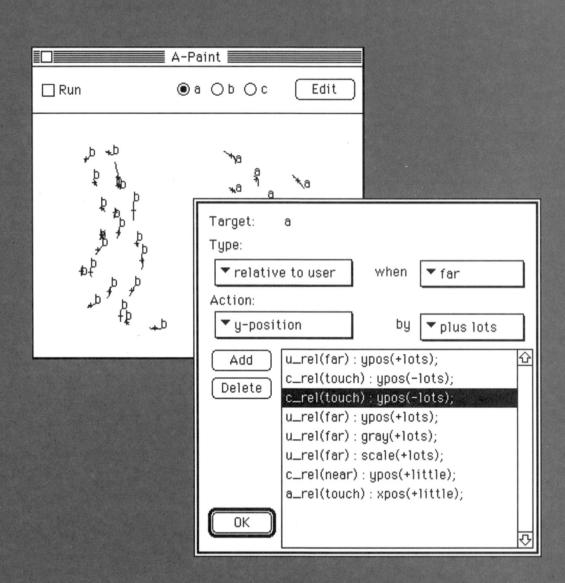

When investigating new architectures for expression, a key source of discouragement comes from one's subconscious denial of the illogic presented before her. It is important not to forget that your conscious actions represent the courageous act of reaching deep into the chaotic mist of possibilities and extracting a small, discernable volume of hope.

Computer languages are unique examples of the maxim in which "form follows function" is only indirectly applicable. There is indeed the form of the computer program, which is translated into other programs that map better to the computer's way of thought. It is only at the bottom level of translation—machine code—that a software form reveals its true functions.

Thirty-two patterns of before-after behaviors. The first statement is read, "If a black cell is surrounded by black cells, then in the next cycle the cell stays black." The second statement is read, "If a white cell is surrounded by black cells, then in the next cycle the cell turns black." →

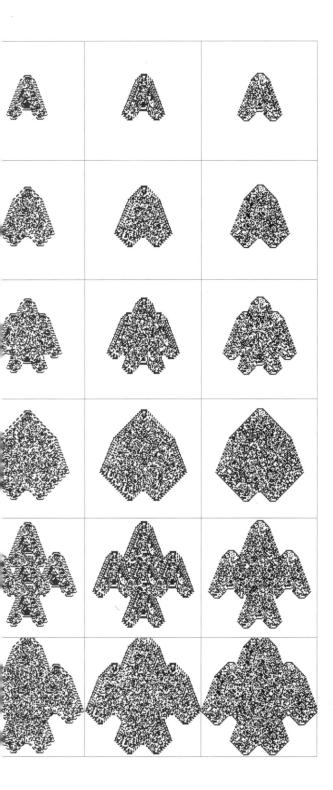

The thirty-two-patterned program is applied to a cell grid containing the uppercase letter "A." The resulting transformation is completely defined by the simple before-after patterns. →

Succesive transformations on a single theme have an entertaining quality that decays as the monotonies of the process are identified. The entirely deterministic style of conventional programming is at fault, but this should not suggest the alternative of randomizing the process in any way as the sole method for escape.

Drawing on the cellular automata experiments, a semiproduction version capable of generating Photoshop plug-in filters was created and later discarded. →

When a tool is fully developed and then immediately discarded, it assures the artist's freedom to continue to explore rather than be stuck in a trap of her own making. Finding a method to broaden one's thinking processes to acquire the expansive shape of the computer's processing envelope requires the ability to pipeline, scale, and visualize every subprocess that might be active in the past, present, and future all at the same time.

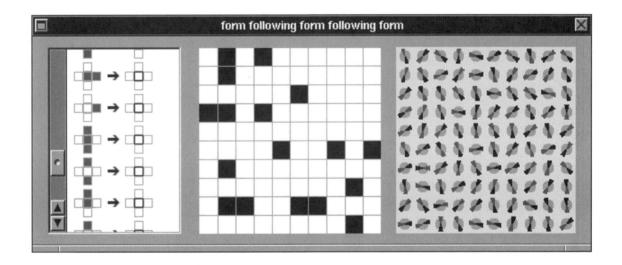

Continuation of cellular automata experiments as a visual form system that synthesizes one form that in turn drives another.

The human-powered computer, as earlier presented in this book (page 54), represented a return to the basic principles of computer programming. →

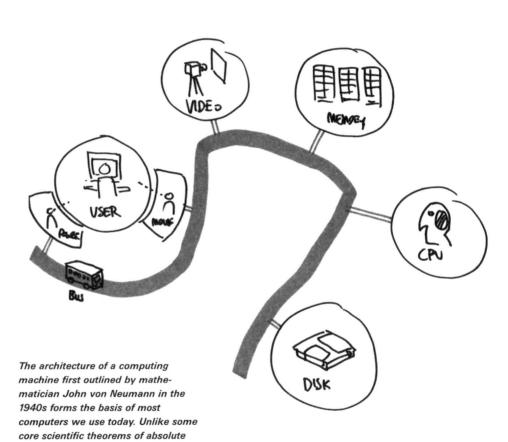

physical fact, von Neumann-style computers do not necessarily represent the fundamental means for

computing. It is akin to our society's

means to propel our cars: Even when

cient or limiting it may ultimately be.

reliance on the gasoline-driven combustion engine as the primary

there are superior means to accomplish a task available, we tend to take comfort in a method that already works, no matter how ineffi-

CUFAR SCREEN

MOLE

A handwritten program inscribed on a cardboard floppy disk guides the execution of smaller programs distributed among the various subsystems such as disk drive, power, video, memory, mouse, etc.

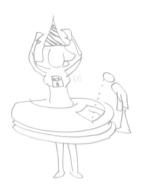

When activated, a human-powered computer is like a playground of colorfully clad human machinery. Although each actor plays an integral part in the system's operation, there is no one more busy than the bus, whose job is to transport information around the computer. After a few hours of operation, the central role of the bus becomes most clear as she begins to move more slowly and the performance of the computer drops significantly. A special moment of fine humanity occurs as the other parts of the computer offer to take up the work of the bus so that she can get a rest. From this elaborate contraption, the most important lesson is the importance of team work.

DISKの内容

- (1) DO "MOUSE" (DEND TO MOUSE)
- @ WAIT "DONE"
- (3) SET REG A → NOO
- (4) WRITE O TO # [REGA]
- B) NAMBRE INCREMENT REG A BY [
- (6) (# REGA == [~16] 500 8.C. 108
- (F) GO SET P.C. TO 4
- (8) READ #[Maxx) to REG. A
- (9) REIN # [MOINEY] TO REG. B.
- (1) MULTIPLY REGA AND REGR -> PUT IND REGA
- (IT) DEGREMENT REG A MY 1
- (E) PUT RE WRITE REST TO # [REG A]
- (13) Do "JORGEM" (SEN) TO SCREE,)
- (WALT "BONE"
- (5) SET P.C. 1

POWER MANAGER

* WHEN ON

(B) TURN ON CIGHTS

OTURN EVERYTHING ON

@ READ DISK

TELL DISK READ #0

WALT PAR DATA

TELL MEMORY TO WRITE DATA

WALT FOR MEDONE.

3 WRITE TO MEMORY

1 TELL COU TO STAPT

S WAIT FOR "OK"

VIDEO MGR *TURN ON -> WAIT

COTURN ON MONETER

• WAIT FOR "UPDATE SCREEN"

(1) READ VALUES FROM MEMORY

® BET S.C. № 0
SEND MEADE VIDES & TO MEMORY

WHAT REPM

MINITE DATA (O A' 1)

© LACKENEUT S.C.

© 16 SECTION S.C.

THE SEC. FINING? SELD DONE

3 PLOT SCREEN

@ F S.C. FINILY? SEND DON

3 SEND DONE TO CPU

XTURY OPF

(A) TURN OFF MODILITOR

Creating a tangible example of a concept from the virtual domain instills the illusion of comprehensibility borne of the ability to literally grasp a concept. As concepts become more abstract, physical metaphors reveal their brittleness as their distance to the reality of the abstract makes them significantly unreal.

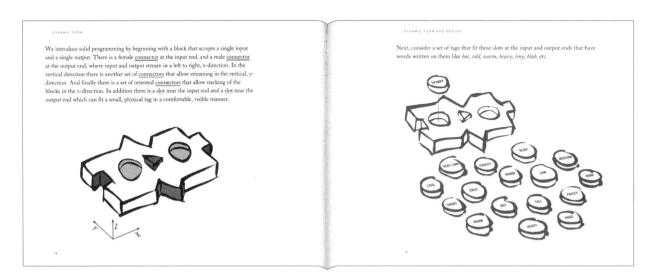

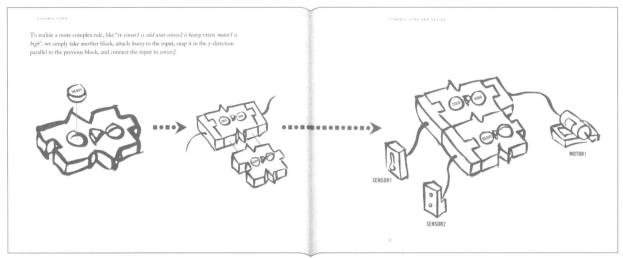

A computer language based upon the handling of actual blocks replaces many cumbersome interactions with mouse and keyboard.

Much rhetoric and a lot of money are spent on realizing the classroom of the future. Surely, they say, there is a computer for both the lecturer and individual students, and it could not be built without having a high-speed network that ties the classroom together, and in turn connects it with the world. Although my research team at M.I.T. and I develop technologies to aid the education of artists and designers, we keep a backup perspective of what to do in the event of a power blackout or dropped network. This way of thinking might seem obvious at once, in which case you understand that we are all at the mercy of systems that have nothing to do with our abilities to think, create, and relate, and everything to do with a new mischievous god of the earth who stands next to fire, wind, and water-technology.

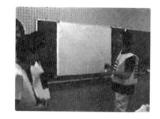

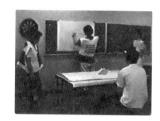

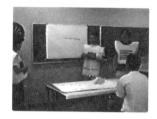

A student sits down and asks the blue pen to draw from the right side to the center. Whoops, he meant the exact center.

More careful this time, he asks the green pen to draw from the exact upper right-hand corner to the exact lower left-hand corner.

Successive pens are asked to draw in relation to the intersection of line points, and exact offsets from the corners and edges.

The exercise of drawing without one's hands requires concise communication skills in relation to the human pens. The creative problem of how best to grip the entirety of the space through solely vocal commands presents a unique challenge. →

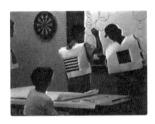

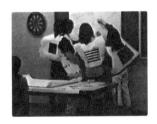

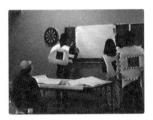

A variety of methods to speak to the paper are devised, the potentially most exciting is the suggestion to create a grid.

Yet although positioning of marks becomes significantly easier, the result is early-computer-style house graphic.

Subsequent homework is administered in the form of two sheets of paper, one with a written description of a figure, the other with the rendered figure. In class students exchange instructions and hand-render each other's program. The results are compared with the intended figures to reveal the lack of skill on both the programmer's and computer's part. →

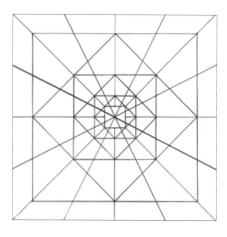

Writing programs to create illustrations never makes much sense to students because they can be drawn much more easily by hand. However, as interactions are introduced, the differences between paper and computer become clear to students of any level.

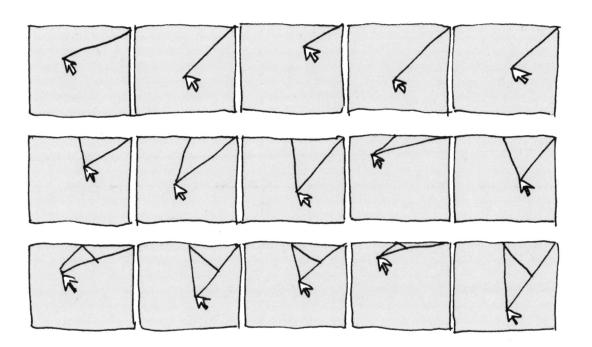

The task of rendering quality static illustrations, no matter how complex, is best done by hand, when time permits. Creating a program to create a static drawing is in many senses overkill because it is like drawing a million similar illustrations just to achieve one.

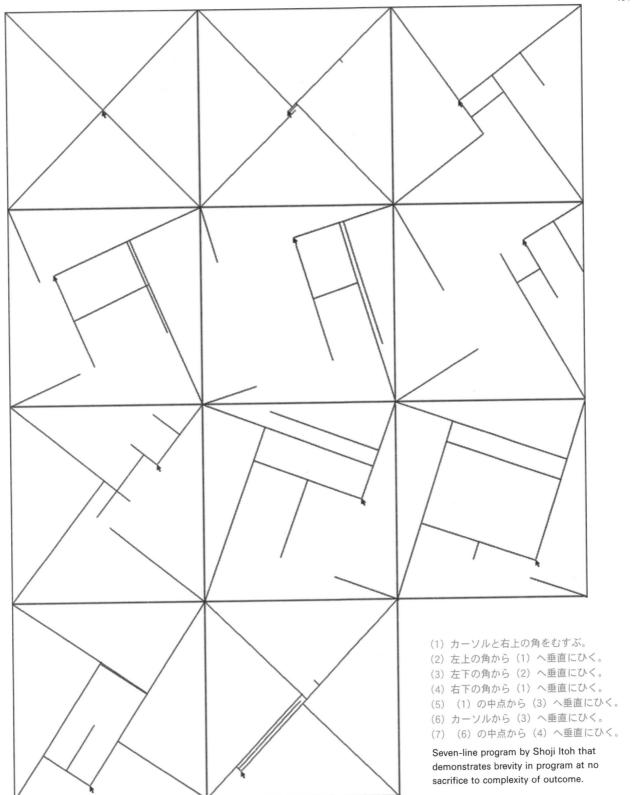

@ nd 1	300	Mary (A	(8)	
9 0 400 12				
890 10 10 E 0 590 400 1	70			
0.20 10 540				1
0 20 100 10				- 1
	10			
				- 1
20 40 10 30				- 1
10 40 140 1				- 1
\$50 40 10 21 \$50 60 10 21	10			- 1
X10 80 10 J	10			- 1
200 100 10	70			- 1
270 (20 10)	30			
250 140 10 1				- 1
40 60 500 11				- 1
60 60 260 12				- 1
199 140 100				- 1
40 320 320				- 1
10 800 780				- 1
90 280 140	0			- 1
100 240 200	10			- 1
128 240 160	10			- 1
40 60 10 280				- 1
80 100 10 12	10			- 1
Chatters				

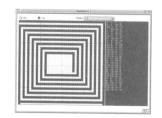

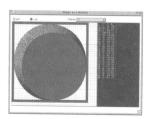

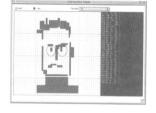

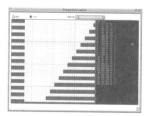

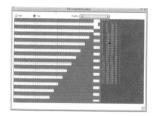

A good mentor is someone who patiently tolerates you when you are blatantly wrong, knowing with minimal smugness that in two to three years you will eventually see it their way. A good mentor is someone who leaves a legacy of possibilities that do not constrain younger people's lives, but instead gives them the tools by which they can surpass their mentor.

Workshop at Tokyo Design Center using five series of java-based systems created to investigate visual aspects of computational constructs.

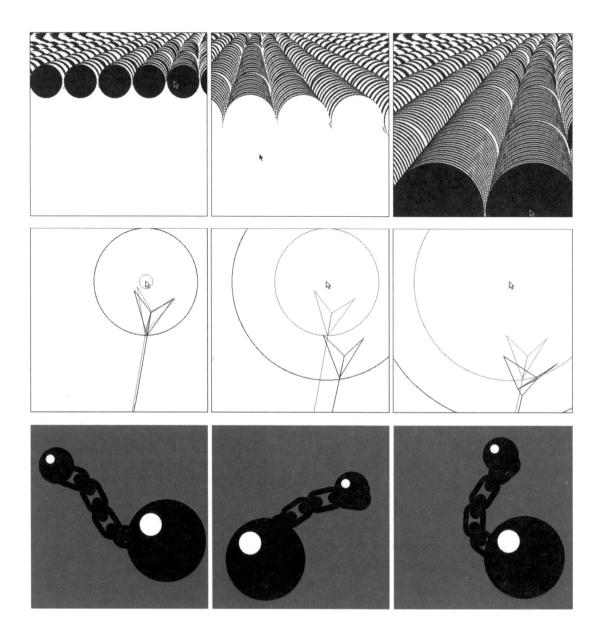

Exercises in computational form by Peter Cho (top), Reed Kram (middle), Matthew Grenby (lower), and Tom White (opposite).

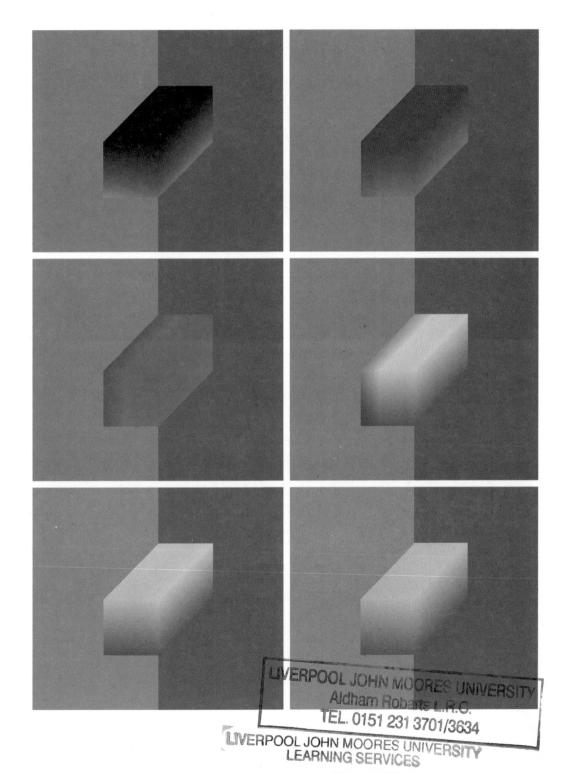

The quick brown fox jumped over the lazy dog.

Typography at its best is a visual form of language linking timelessness and time.

The quick brown fox The quick brown fox jumped over the lazy dog.jumped over the lazy dog.

Typography at its best Typography at its best is a visual form of language is a visual form of language linking timelessness and time.linking timelessness and time.

The quick Thhreo wqnu ifcokx brown fox jumped over jtuhmep elda zoyv edro gt.he lazy dog.

Typography Taytp oigtrsa pbheys ta t its best is a visual foirsm ao fv ilsaunaglu afgoer m of language linking timeleslsinneksisn ga ntdi mteilmees.sness and time.

ThTeh eq uqiucikc kb rborwonw nf ofxo x jujmupmepde do voevre rt hteh el alzayz yd odgo.g.

TyTpyopgorgarpahpyh ya ta ti tist sb ebsets t isi sa av ivsiusaula lf ofromr mo fo fl alnagnugaugaeg e linlkiinnkgi ntgi mteilmeeslsensessnse sasn da ntdi mtei.me.

Classroom exploration in the visual possibilities of the computer mediated through existing tools results in a predictable set of elements and constructions that reveal the unfamiliar personalities of the students through the familiar personalities of the tools. When the constraints of expression are relaxed and students start from absolutely no known digital assumptions, the outcomes are surprisingly varied and witty in ways that more effectively communicate the spirit of the students, rather than of the computer.

Exercises in computational typography by Peter Cho (opposite, above and below) and Tom White (below).

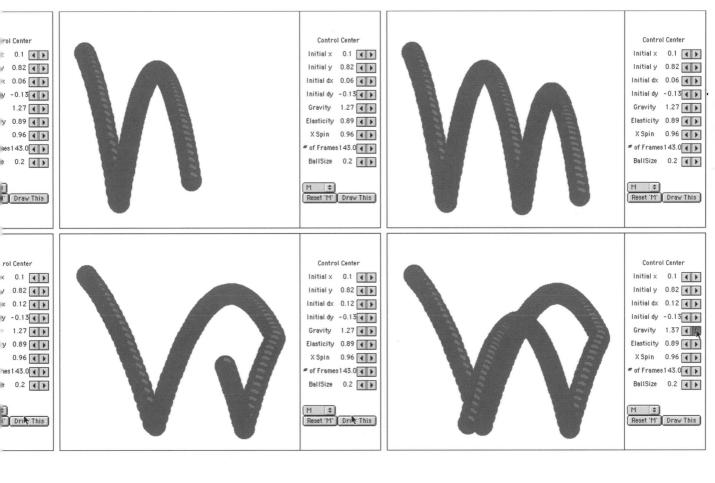

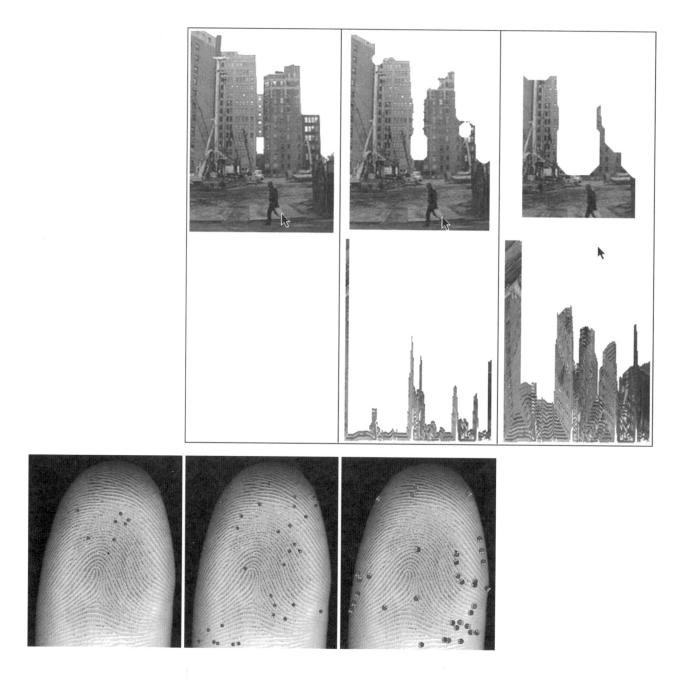

Exercises in numerical photography by Elise Co (top), Golan Levin (above), and Benjamin Fry (opposite).

In the hands of students who treat the computer as a truly plastic medium, the creations are as varied as you might expect when metal, plastic, and plywood were introduced into the artistic realm. Fostering people's creativity in this manner can clash with society's unfortunate push to manufacture two distinct types of thinkers: one who is technically adept and humanistically inept, the other who is humanistically adept and technically inept. It seems unproductive that such boundaries should exist when now more than ever we need people who can lead humanity toward technologies that improve society rather than technologies that simply show improvement over technology itself. When asked what kind of students I create, I say they are a new type of person: "humanist-technologists."

A new undergraduate course was developed together with Tom White and Jared Schiffman to introduce students simultaneously to concepts of computation and traditional visual art.

When the output of a visually oriented program is a single animation, its true multidimensional nature is hidden from the viewer because of the perceived limitations of the display screen. With a slight change in visual language, a programmatic form can be read closer to its native set of dimensions. In which case you stare at what unravels before you and scream, because you realize it is not your eyes that limit your thinking, but your mind.

mas110-fundamentals of computational media design

Given two parameters, 'mx' and 'my' both ranging from 0 to 100, create an animation that lasts exactly 2.5 seconds valued in UNITY and FRAGMENTATION.

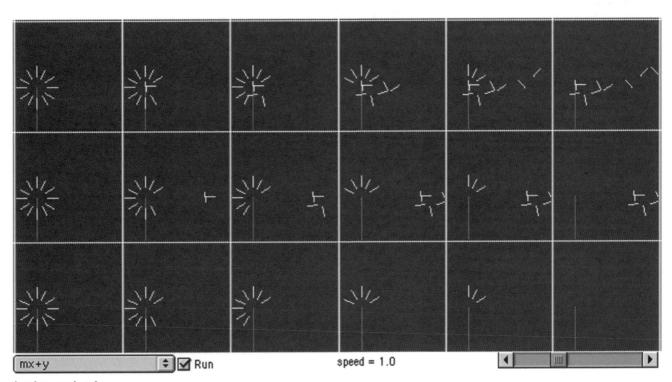

jocelyn_ps4_p4

Exercise in temporal form by Jocelyn Lin unfolded in a five-dimensional display.

A comprehensive system was developed with sufficient limitations and subtle extensibilities to enable a wide range of digital expressions for the beginning computational art student. The result was the Design By Numbers system. →

. dowline . setvar (set) · setvar (set) . Stepene (100) · drawline (sine) -> drawline [8 x]. drawle (4 0) - using inper (the lines online then (clear) bits the lines enjoyr 64? .dawlm dauline 2007) (10(0.20) oung her visual (couling company) stypne A 3 10 · his to traderior (to to) [14 trader pole coordinates?] Lotate (SCAL) translate filed areas. pixel use? anh. } { No st?) drawline X, y, x2 y2 dauline drawnotline Sur [x y] xs

Distilling a basic vocabulary of computational visual art requires years of experience in practice and instruction of basic principles. Considering that I only have some twenty years of experience in working with this material and that it is relatively recently that they have become conceptually clearer to me, I hesitated before undertaking the definition of a basic programming language for art and design education. However, having seen java and c++ (languages that would easily discourage the most ardent of young futurists) take hold as the de facto method for students to acquire computation skills, I chose to prescribe a minimal degree of knowledge in the ongoing Design By Numbers project. →

Draw a Line You can now write a three-line program, which is your first major graphics program, if only a single black line on white paper. (Note: all drawings are rendered at half their original scale for enhanced page balance.)

Paper 0 Pen 100 Line 40 20 80 60

> The line is 40 over and 20 up, to 80 over and 60 up-not a particularly exciting line, aside from the similar lack of smoothness in the opening example. The reasons for this jaggy characteristic will be discussed in Chapter 8, but for now understand that the paper we draw upon (not to be confused with the actual paper used in this book) is coarse in a virtual sense. Therefore, any mark left on the paper will have a rough, textural flavor, the classic signature of digital artwork. In some cases, the texture will not be apparent, such as in a perfectly horizontal or vertical line. In these cases, the lines are smooth because they essentially fit into the perfect horizontal and vertical grooves in the texture of the page. But in general, the lines will be coarse.

You can now draw a variety of lines on different

Where Is the Line? There are some cases where you draw a line and do not see the intended result. For instance, imagine what happens when you draw outside the paper?

30 83 56 27

0

0

0 0 10 11

5 100 4

) 40 90 90

80

8 0 50 84

Paper 0 Pen 100 Line 20 30 200 300

The line starts from 20 left and 30 up to 200 left and 300 up, but you never see the line as it leaves the 101-point square. Any portion of a line drawn outside the space will be ignored and clipped to the edges in this f

Also, what happens when you draw in the same shade as the paper?

Paper 66 Pen 66 Line 0 0 100 100

Since the digital medium is exact, drawing a diagonal line in the same shade as the underlying paper appears to produce nothing, even though you might expect to see some faint impression of the line as is common in a double hit of ink.

Another surprise occurs when you draw a line and then request a new sheet of paper.

Line 0 50 100 50 Paper 50 Pen 0

In this case, the intent is to draw a white horizontal line across the center of a gray sheet of paper, but the new sheet of paper is placed on top of the line. Thus the line is not visible. Finally, there is the case where the Pen is not explicitly set and a Line is drawn.

Paper 100 Line 3 33 97 66

When the Pen is not set, the default setting is 100 percent black. As an additional convention, when the Paper is not set explicitly, the default setting is 0 percent black, meaning white.

With the exception of the first example, nothing appears to happen in the visual output. But be aware that something has indeed happened from the viewpoint of the computer. The computer has labored to create a line, just as if the line were visible. The computer does not know when it has done something completely useless, such as drawing a black line on black paper. Only you do.

Summary The process of drawing requires a means to establish where the pen is to be placed on the paper. Otherwise, the computer cannot know where to draw. Your hands usually serve as the means to locate points in space; however, in the computational model of drawing, the only purpose your hands serve is to type commands. The constraint of measuring horizontal and vertical dimensions from the lower-left corner was introduced as a way to make dimensions consistent. Dimensions are always in units of points.

The Line command is followed by two points, where each point is a pair of numbers, always horizontal then vertical, and separated by spaces.

33

The *Design By Numbers* book (1999) describes personal perceptions of the relationship between computation and digital form with working examples in a freely available language called DBN.

"Programming is the process of abstracting a graphic form into its fundamental geometric components."

223.22 297.33 moveto 235.54 297.33 244.48 306.27 244.48 318.59 curveto

244.48 330.91 235.54 339.85 223.22 339.85 curveto 210.90 339.85 201.96 330.91 201.96 318.59 curveto

201.96 306.27 210.90 223.22 223.22 297.33 curveto

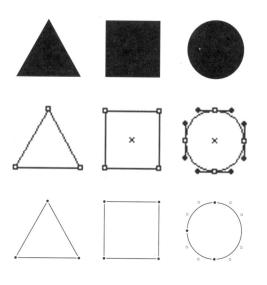

136 77 339 85 moveto

179.29 339.85 lineto 179.29 297.33 lineto

136.77 297.33 lineto closepath fill

newpath 68.45 297.33 moveto

92.83 339.85 lineto 117.21 297.33 lineto

closepath

I wrote these words in 1995 and drew this diagram, believing at the time that programming was simply a form of visual math, a skill of seeing the world and decomposing what you see into mathematical primitives. I later understood that it is no different from drawing a picture, except that no picture is actually drawn. The essence of what exists—i.e., the entire set of possibilities generated from a core idea—is rendered into reality as computational structures. Having established this basic fact, my next thought was, "So what?" →

A moment of clarity presented itself five years later. I created a simple painting tool in the image of one of my first inspirations, the software system originally bundled with the Macintosh computer called MacPaint, credited to Bill Atkinson. I wondered, "What if in 1984 MacPaint were designed in such a way that it was incomplete—much like a piece of unfinished furniture or a pen-making kit."

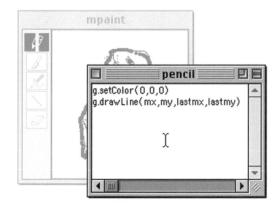

By cracking the icon for a tool open, you would reveal the programming code that realized that specific function. By changing the code, the user could change the way the pencil behaved at will, much in the same way a real pencil might be customized. I believe that such approaches are the basis for fine artistic control over a system. We must have the ability to dig into the tools and materials, whether they be pencil, paper, metal, oil paints—whatever—to reshape, manipulate, and recast them into something either new or at least relevant to our individual styles of thought.

The responsibility to make the computer a better space for visual thinkers is currently in the hands of large software companies with limited imaginations. As a result there are few real choices in operating systems and their related software-I count three or four. In contrast, if you had to select a cup or other object of daily use, there would be hundreds, perhaps even thousands, of diverse items from which to choose. Some of the artifacts would be unsuitable, of course, some would be acceptable, and if you were lucky there might be something truly exquisite. Through quantity emerges quality, and for quality to emerge there must be more visual thinkers who seize control of the computer's future by contributing their personal visions. Not as mere written words or editorial complaints but as working artifacts and architectures that can inspire the development of computing spaces painted through and through in the joyous colors of humanism.

acknowledgments

I had just completed the writing, design, and production of *Design By Numbers* when a curiously enthusiastic gentleman from London proposed the absurd undertaking of a new book. Perhaps it was my weakened state and associated stupor that gave in to the seemingly infinite energy of Lucas Dietrich of Thames & Hudson. Whatever it was, this book somehow now exists, and I am grateful for Lucas's infinite patience, fastidious attention to detail, and sincere concern for high artistic values.

I was deeply honored that Professor Nicholas Negroponte agreed to write the foreword to this book. His intensity, coupled with a unique sense of style, was evident the first time I leafed through his influential book *The Architecture Machine.* The notion that the spirit of architecture, technology, art, and design could combine in a single person has been exemplified by Professor Negroponte from the very beginning.

By creating this book I am now properly able to thank the many people, companies, organizations, and institutions that have fundamentally affected my thought patterns in a direct way.

First I must thank Tadashi Morisaki for his early influential mentorship, for teaching me how to see and create in a way that is most natural, yet not out of touch with the comedy of everyday life. After his tutelage, my work would have never reached the public without the help of three unique risk-takers: Michio Iwaki, Naomi Enami, and Taiji Watanabe. Michio Iwaki, of Shiseido, gave me great leeway in creating a variety of constructions that were beyond the scope of conventional commercial design; Naomi Enami produced and published a series of my books that to this day have not made a profit; and Taiji Watanabe permitted me to explore a number of printing concepts without concern for cost and only concerned with quality.

I have been fortunate to have a series of direct encounters with exceptional educators that have provided not only myself but all those with whom they come in contact with profound inspiration that will last a lifetime. Paul and Marion Rand and Ikko Tanaka showed me a pure way of existence that embraced a sincere dedication to form and the happy, beautiful moments of life. Katsumi Asaba and Takenobu Igarashi represent the complex two sides of the Japanese psyche. Muriel Cooper inspired me to leave M.I.T. to run away from technology. Whitman Richards cursed me by bringing me back to M.I.T. William J. Mitchell made me feel it was okay to be back at M.I.T. Bill Verplank kept track of me from the very beginning and led me all the way. Gillian Crampton-Smith set the world straight with true attention to the finer details of design and technology. Daniel Boyarski made me feel it was okay to be a professor. Wolfgang Weingart showed me that even with a glass of wine or stein of beer you could still be completely coherent and inspiring. Donald Knuth and Gilbert Strang make mathematics and computer science look truly extraordinary and graceful, from any perspective. Chris Pullman was a voice of reason in the Boston area. Matthew Carter on his perch only a few miles from M.I.T. made me act responsibly in a typographic sense. Although we spoke together at a conference, I did not know Scott Makela, but through his many students I hear his voice. Richard Farson scared me with email regarding the weight of fame. Like my father, Masami Shigeta, upholds the unvielding, quintessential spirit of a poorer, yet proud, Japan. Finally, my teachers at Tsukuba, Kiyoshi Nishikawa showed faith in my early ideas in the face of constant debate, and my dear advisor Akira Harada was a strong voice for innovation in all things.

A cluster of old-timer professors at U.C.L.A., Mitz Kataoka, John Neuhart, Vasa, and Jim Bassler, encouraged me to return to the United States. Their unique perspectives, especially the Japanese-American juggernaut Mitz, taught me about the fine line that separates design and art, which is a thicker line than I expected.

When I moved back to the East Coast of the United States, I did not know any designers besides Paul Rand, who had just passed away. I was fortunate to meet Tibor and Maira Kalman when they visited M.I.T. Tibor kindly introduced me to the New York design community. Katherine Nelson and Peter Hall subsequently published an article in *Print* on my activities in Japan, which greatly helped to generated interest in the U.S. on the issues that I represent.

Paola Antonelli, Chee Pearlman, Myrna Davis, Aaron Betsky, and Ric Grefé have been key supporters in my attempts to destabilize common notions of segregation in design and technology. Their compassion and criticism have led to a much clearer navigation of concepts that I have struggled to understand. Ellen Lupton, Christopher Mount, Janet Abrams, Rick Valicenti, Kathy Merckx, Claudia Dreifus, Janet Froelich, Liz Faber, Karrie Jacobs, Takako Terunuma, Kaoru Matsuzaki, Fumi Iwane, Kikuo Morisawa, Takeshi Morisawa, Nobuo Tomita, Tomitsugu Tachibana, Yutaka Itoh, Yoshio Hirayama, Hiroko Sakomura, and Maria Grazia Mattei presented unique opportunities to convey the themes that I (and now my students) attempt to reconcile.

A small group of people in the Cambridge-Boston area make the place a relevant community of design excellence: Al Gowan, Jan Kubasiewicz, Yasuyo Iguchi, Ori Kometani, Robert Prior, and the staff at the M.I.T. Press Bookstore, led by Mo and John.

I am grateful to the many designers and artists that have given me encouragement, discouragement, and embarassment: Mitsuo Katsui, Yoichiro Kawaguchi, Toshio Iwai, Gento Matsumoto, Kenya Hara, Katsuhiko Hibino, Minoru Niijima, Norio Nakamura, Noriyuki Tanaka, Masaki Hagino, Shuichi Ono, Masaki Kimura, Yayoi Kanbayashi, Keizo Matsui, Ken Miki, Shinnoske Sugisaki, Giorgio Camuffo, Yumie Sonoda, Paul Davis, Alexander Gelman, Just van Rossum, Erik van Blokland, Peter Girardi, Erik Adigard, Stefan Sagmeister, Gong Szeto, and Lisa Strausfeld.

At M.I.T. a special clan of similarly aged thinkers have deeply inspired me from the start: Bob Sabiston, Suguru Ishizaki, David Small, Mike McKenna, John Underkoffler, and Kevin McGee. I am also indebted to the guidance of two professors that remind me of the intense themes that we should uphold: Hiroshi Ishii and Krzysztof Wodiczko. My daily life at M.I.T. is deeply augmented by the help of Connie Van Rheenen. Her clearmindedness continues to give me inspiration. Linda Peterson, Deborah Cohen, and Ellen Hoffman provide me with sanity (in their own insane way) at crucial moments.

Intel Corporation has aided me at many times. In particular, the help of super-hacker John David Miller and his boss, Dr. Carmen Egido, has been always greatly appreciated.

While a student in Japan, for four years Tamon Hosoya and I would have lunch regularly to debate issues in art, design, and technology. Those intense conversations made us both stronger. Kazuo Ohno, of the International Media Research Foundation, kept the momentum going at a rate that continued to surprise me, despite his insistence that his life was "finished at 40."

The indirect and direct support of Yoshiharu Fukuhara, Ryuichi Sakamoto, and Nobuyuki Idei have been pivotal.

I thank the many institutions and organizations that have supported various facets of my activitites: Misawa Homes, Shiseido, Sony, Yamaha, Digitalogue, .Too, Dai-Nippon Printing, Grapac Japan, Morisawa, Seibu, Tokushuu Seishi, Tokyo Type Director's Club, Art Director's Club, Gilbert Paper, Takeo, Seagrams, The American Institute of Graphic Arts, San Francisco Museum of Modern Art, MdN, Axis, IDEA, Nikkei Design, Print, I.D., Technology Review, Creative Review, Eye, ArtByte, and The New York Times.

My very first students, Rie Komuro, Akira Yamanaka, and Yoshihisa Sawada, introduced me to the complexities of research management. Those early experiences suggested that it might not be such a bad full-time job. My research group at M.I.T. has evolved in positive directions over the years thanks to Tom White, Peter Cho, Ben Fry, Elise Co, Golan Levin, Jared Schiffman, Casey Reas, Axel Kilian, Bill Keays, Reed Kram, Matt Grenby, Chloe Chao, and Doug Soo who have all contributed to the concept development of the Aesthetics and Computation Group at the Media Lab. I look forward to their many ground-breaking contributions in the future.

In my on-the-way-home conversations with Brian Smith I have learned a great deal on subjects that would not be appropriate to espouse in this book. His many insights give me courage where I would have none.

My informal extended family of Mitsue, Nobuyuki, Nobuki, and Mitsuki Ueda have always been enthusiastic supporters in innumerable ways.

My parents, Yoji and Elinor Maeda and Matthew and Elizabeth Sheahan have given me more love than any son could deserve.

Most importantly, my daughters, Mika, Rie, Saaya, and my wife, Kris, have given me the greatest gift of all—the inspiration to make the world a better, happier place. How this Book was Produced When it was suggested that a new book could be created within a year, my immediate reaction was that I needed to design software to enable the automatic layout of the entire book. Since I had imagined that this would be possible, I envisioned a book of at least five hundred pages. Considering that designing for the computer screen entails conceiving thirty frames per second, I reasoned that five hundred pages was equivalent to around 17 seconds of animation, which didn't seem so difficult. I thus spent about seven months developing a

special system in java and python to enable the rapid design and prototyping of pages. As the deadline neared, it began to dawn on me that it would be impossible to realize such a mythical luxury. So I turned to the conventional, old-fashioned solution of "just doing it."

Sifting through all the material, it became clear that I would have to recreate a majority of the artwork to be printable in a smaller form than the sizes for which they had been originally made. Furthermore, many of the timebased pieces had to be condensed into a cogent static form. With a huge mass

of work before me, I spent at least three weeks thinking that it would be impossible to reformat everything within a reasonable amount of time. Fear led to depression, until a glimmer of hope appeared when I gradually was taken by the idea of never having to talk about this work again in public. Presenting my work was getting so laborious that each moment of reliving the past weighed down my thinking and kept me stuck in the past. I needed to be renewed.

This epiphany brought about a surge of strength. I spent late nights and early mornings scanning, rendering, tweaking,

until it all began to finally materialize as something semi-worthy of printing.

The issue of the book's layout was approached by writing on the back of the large press sheets from my first book, which I had kept as souvenirs to sleep upon. Once the map was built, the layout gradually took shape, and I allowed space for the fictional "new" material between signature, hoping that it might magically take form during the layout process. At first, the sections began to fill in very slowly, but near the end they came at a much more rapid pace and everything began to cohere. I

don't have the luxury of a production assistant, so any infelicities in this books are impardonably mine. Sigh.

My process for creating the new artwork in this book differs from work in the past with respect to speed. I used to think of everything in the C language, which was necessary because the computers I used were very slow and I required the maximum speed possible. This time I used primarily high-level languages to create the new images, but at times there were things I simply could not do, in which case I created special codes in C to break free.

Many people continually ask, "What programming language do you use?" I have never been fond of this question. It is like asking someone, "What kind of paper do you use?"—indeed a question that people do ask. A good idea can be rendered as a digital construction in any available computer language, as an illustration in any ink on any paper, or as a mammoth skyscraper of any metallic alloy or building compounds. It must be realized with the utmost quality and care—a poorly constructed object usually gives away a poorly constructed idea, regardless of the materials used.

	250 mm Jaure. Th
eith	
	- he foldown as planed as cause for much paper crumpling at bounding. - 6 color in Signatures, will plan coround this. Combitation of 2,4,6 is fine.
	CONKLUSION: (D) 12" x 250mm book size. 12" Stacked 3 high: I yourd siderby cide 4 wide = 1 m. (D) paper is Matter (pretrolly Mohouk superfine) (D) no special paper gymnastics (mentional clease gate folds before but too difficult perhaps (D) combination of 2, 4, and 6 color pages. Can design around a given spec. (D) jacket: pretr to use transluent matriol yupo with silkscreened texture. (D) length: appex. 200 to 300 pages.
	(302) (B) NEW WORK, NEW DIRECTION S. + WRITINGS + (MAGE) (602) (C) 2DUCATIONAL WORK AT MIT > COMMENTARY + (MAGES (107)) (D) TITUS (UIC: "MAEDA@ MEDIA", "THINKPAINT" "THOUGHT PAINT" MAEDA@ MAEDA@

the for a contin at paper Maign lackgrounds. Fli · Whaten som. " mentes illasion of - Kn · paper has proposed by the imprint of of light the loss + example is the sou of the proitself forstand into sculpture they had 11,7 Thingt folks Jan i telantit. aguires a visible welling for dight soul. tw yes any then wh Wer hear have possible through the winder of stillings, the report want a tirel of the atmost to lowelen that

(1) " (am here . Was I fe 4106 but account when he were the familia nuste " continued. The plump anatem + as ho sun barren white her how po Atte pinh - theyest to being green, man of our with the system pealing the same ved that the poxel classes The total ake A port to he wall. not has so leave which 4.9 That the the town for well to Just before the The Charited ales the the west & how dee lite veally was to he to retain her though the print wished 11) Renegrated as a less the squere with a a her might that the might exist. And beg her with min it. a tuny this Leppent. & truit come Lecun for blue squere. I can texper and centres: very chearing color. Charles ruly la Charles change to a trong that her lit as The bos offer and ke of the de of around that Never when the Las Significent that the this we have the same blue squeez She know fort as with new rend was rigite and that photostop are The dishit exist. And Lychin, curso boxely

10 is like writing a solar coase (train (elevane, no I don () and wrong (when the elimo of nom. with, warm on. 3) is heir Jahnanke or air plane or blimp (16m) and it light lot prom 170 pm prop. go grow purs, speed. le colors. amousal to Sphirtical the distr eltablish the reservent . tool is not self-describedle - language is ask to be itself

HEAD-MOUNTED CITIES

LIVERPOOL JOHN MOORES UNIVERSITY LEARNING SERVICES

references

Ammeraal, Leen, Computer Graphics for Java Programmers (John Wiley & Sons, 1997)

Antoniades, Anthony C., Poetics of Architecture: Theory of Design (Van Nostrand Reinhold, 1992)

Arnheim, Rudolf, Visual Thinking (University of California Press, 1989)

Banham, Reyner, Theory and Design in the First Machine Age (MIT Press, 1981)

Burnham, Jack, Beyond Modern Sculpture (George Brazelier, 1968)

Conrads, Ulrich, Programs and Manifestoes on 20th Century Architecture (MIT Press, 1971)

Dondis, Donis A. and P. A. Dondis, A Primer of Visual Literacy (MIT Press, 1973)

Foley, James D. and A. Van Dam, Fundamentals of Interactive Computer Graphics (Addison-Wesley, 1982)

Forty, Adrian, Objects of Desire (Cameron Books/Thames & Hudson, 1986)

Garratt, James, Design and Technology (Cambridge University Press, 1991)

Gerstner, Karl, Kompendium für Alphabeten (Arthur Niggli, 1990)

Gill, Eric, An Essay on Typography (David R. Godine, 1988)

Gombrich, E. H., Art and Illusion (Princeton University Press, 1969)

Gropius, Arthur and A. Wensinger, The Theater of the Bauhaus (Johns Hopkins University Press, 1996)

Henderson, Linda D., The Fourth Dimension and Non-Euclidean Geometry in Modern Art (Princeton University Press, 1983)

Lucky, Robert, Silicon Dreams: Information, Man, and Machine (St. Martin's Press, 1991)

Krauss, Rosalind E., Passages in Modern Sculpture (MIT Press, 1981)

Knuth, Donald E., Surreal Numbers (Addison-Wesley, 1974)

Laurel, Brenda, Computers as Theatre (Addison-Wesley, 1991)

Levy, David, Computer Gamesmanship (Simon & Schuster, 1983)

Lutz, Mark and D. Ascher, Learning Python (O'Reilly & Associates, 1999)

Maeda, John and K. McGee, Dynamic Form (International Media Research Foundation, 1994; http://www.imrf.or.jp)

Maeda, John, Design Machines (International Media Research Foundation, 1994; http://www.imrf.or.jp)

Maeda, John, Design By Numbers (MIT Press, 1999)

McCloud, Scott, Understanding Comics (Kitchen Sink Press, 1994)

McCorduck, Paula, Aaron's Code (Freeman, 1990)

Meggs, Phillip B., A History of Graphic Design (Van Nostrand Reinhold, 1991)

Müller, Lars, Josef Müller-Brockmann: Pioneer of Swiss Graphic Design (Lars Müller Publishers, 1995)

Myerson, Jeremy, D. Gibbs, R. Poynor, Beware Wet Paint: Designs by Alan Fletcher (Phaidon Press, 1996)

Nicolaïdes, Kimon, The Natural Way to Draw (Houghton Mifflin, 1941)

Norman, Donald, The Design of Everyday Things (Basic Books, 1990)

Rand, Paul, From Lascaux to Brooklyn (Yale University Press, 1996)

Schodek, Daniel, Structure in Sculpture (MIT Press, 1993)

Shannon, Claude E. and W. Weaver, The Mathematial Theory of Communication (Illinois University Press, 1963)

Sharff, Stefan, The Elements of Clnema (Columbia University Press, 1982)

Simon, Herbert A., The Sciences of the Artificial (MIT Press, 1981)

Snyder, Gertrude and A. Peckolick, Herb Lubalin: Art Director, Graphic Designer, and Typographer (American Showcase, 1985)

Strang, Gilbert, Linear Algebra and Its Applications (Academic Press, 1980)

Tanchis, Aldo, Bruno Munari: Design as Art

Toffoli, Tommaso and N. Margolus, Cellular Automata Machines (MIT Press, 1987)

Tomura, Hiroshi, Jikuu No Tsumiki (Nihon Hyoron-sha, 1992)

von Moos, Stanislaus, Le Corbusier: Elements of a Synthesis (MIT Press, 1979)

Wall, Larry, T. Christiansen, R. Schwartz, Programming Perl (O'Reilly & Associates, 1996)

Wichmann, Hans, Armin Hoffman: His Work, Quest, and Philosophy (Birkhaüser, 1989)

Willberg, Hans Peter and F. Forssman, Lesetypographie (Verlag Hermann Schmidt, 1997)

Williams, Robert, The Geometrical Foundation of Natural Structure (Dover Publications, 1979)

(1) PERISSETHA SPACE Claring) NEW 3 MAMPINE SPACE Clapes 1 Mora 3 FY FINNIK SPACE (NEW STUFF) meo 4 GUNUTORD RAVE ((ununter)

O TNAKAN